ANTONY GORMLEY BLIND LIGHT

ANTHONY VIDLER
SUSAN STEWART
W. J. T. MITCHELL

SOUTHBANK
CENTRE
HAYWARD PUBLISHING

Body & Soul, 1990

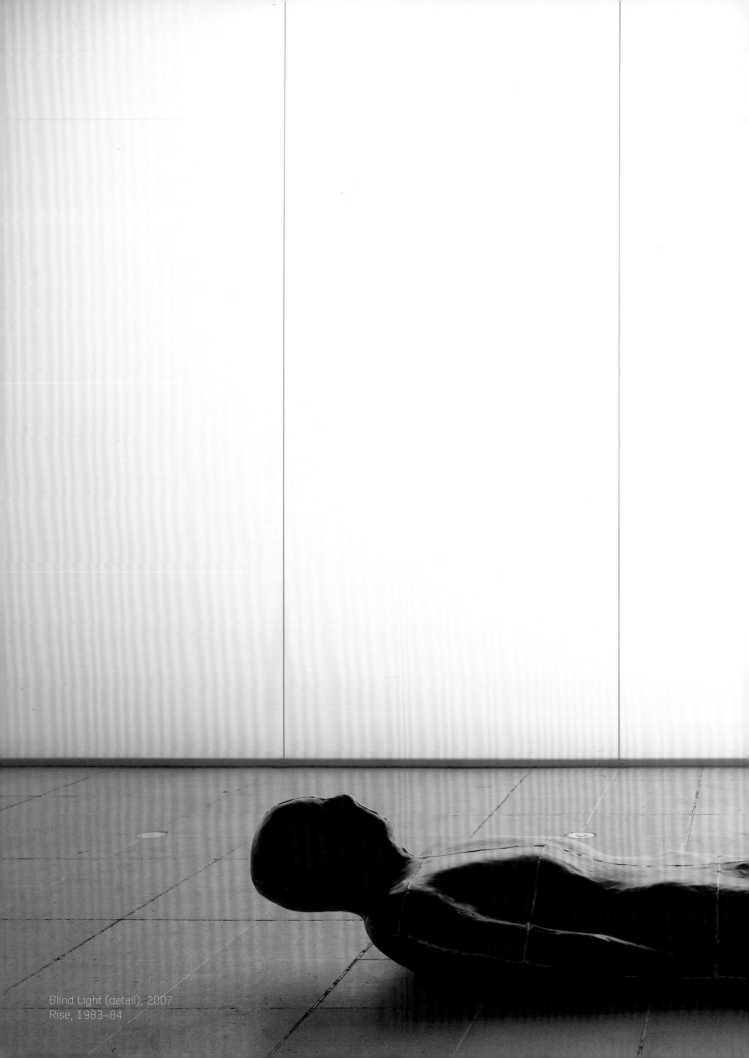

Blind Light (detail), 2007
Rise, 1983–84

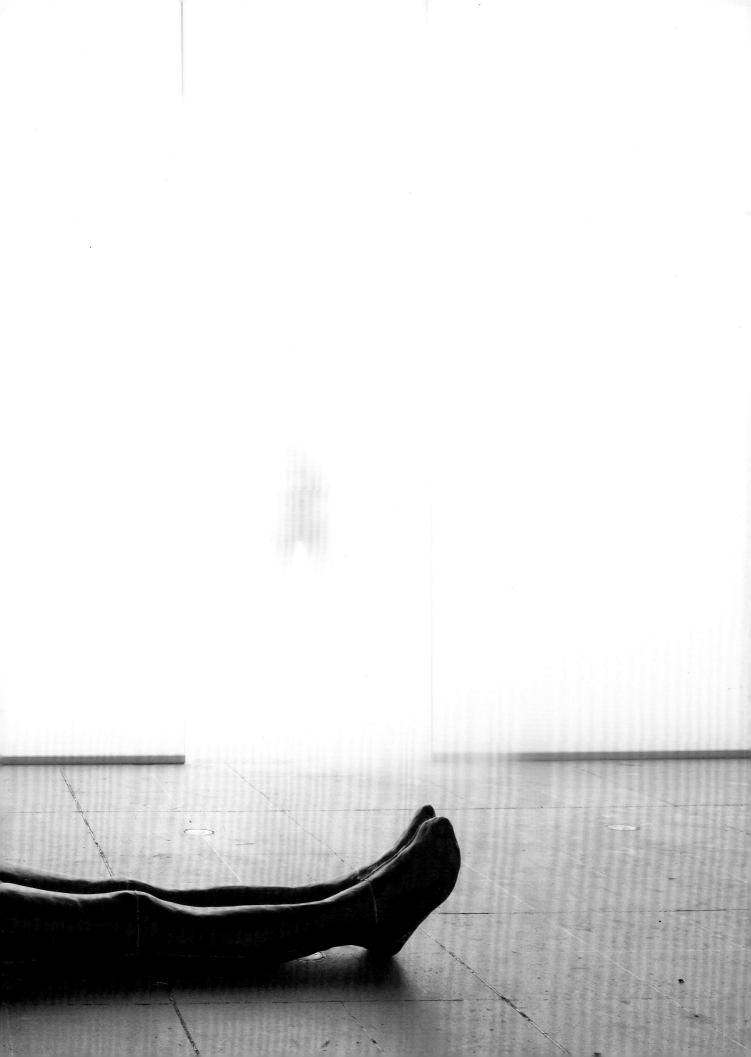

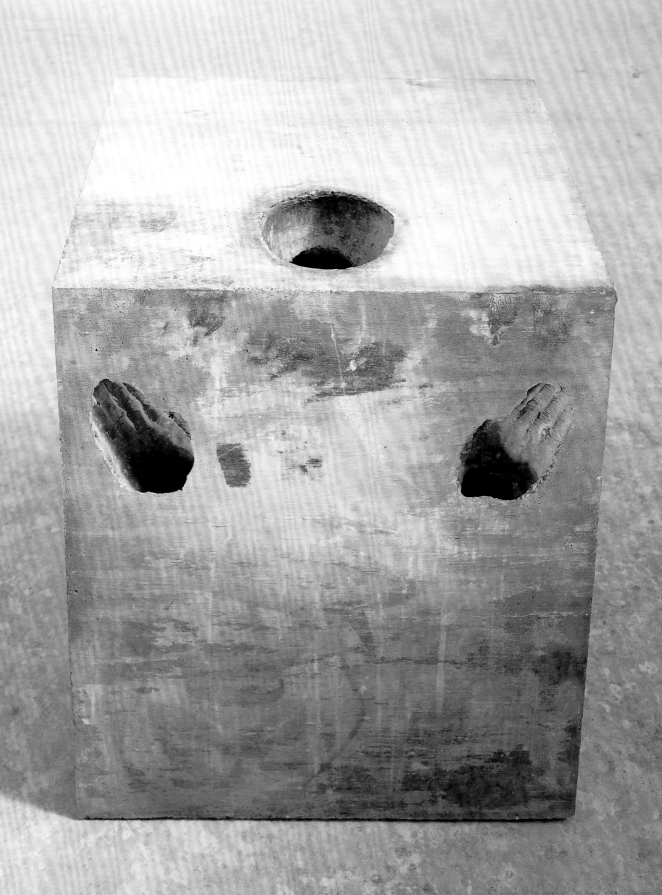

Sense, 1991

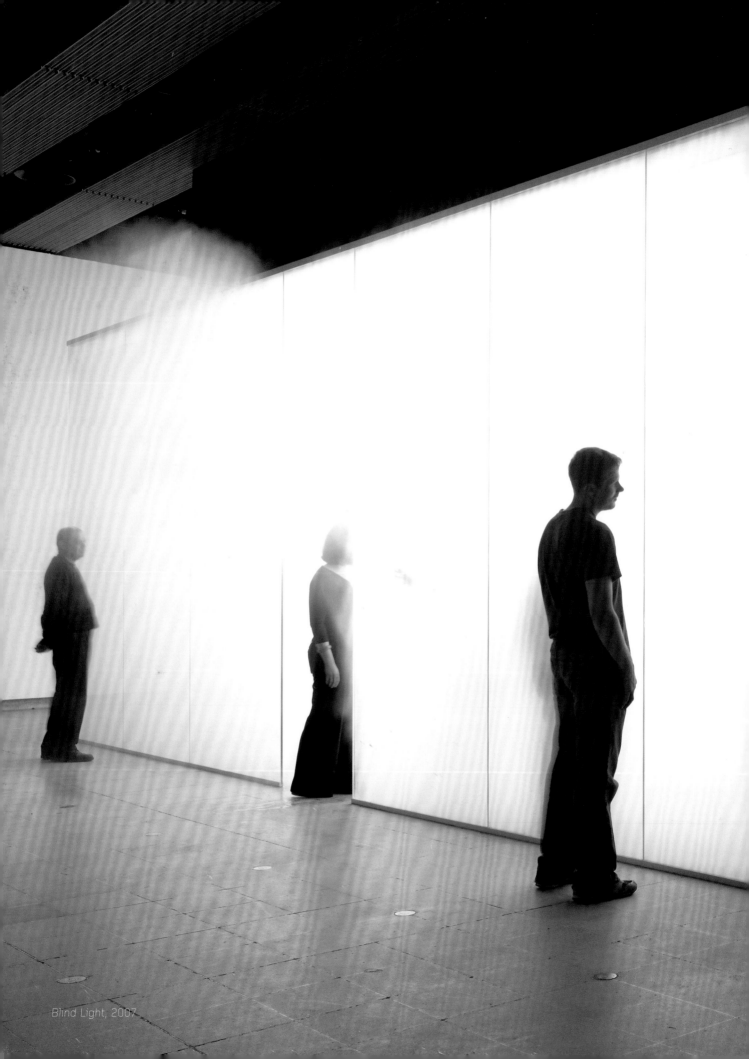

Blind Light, 2007

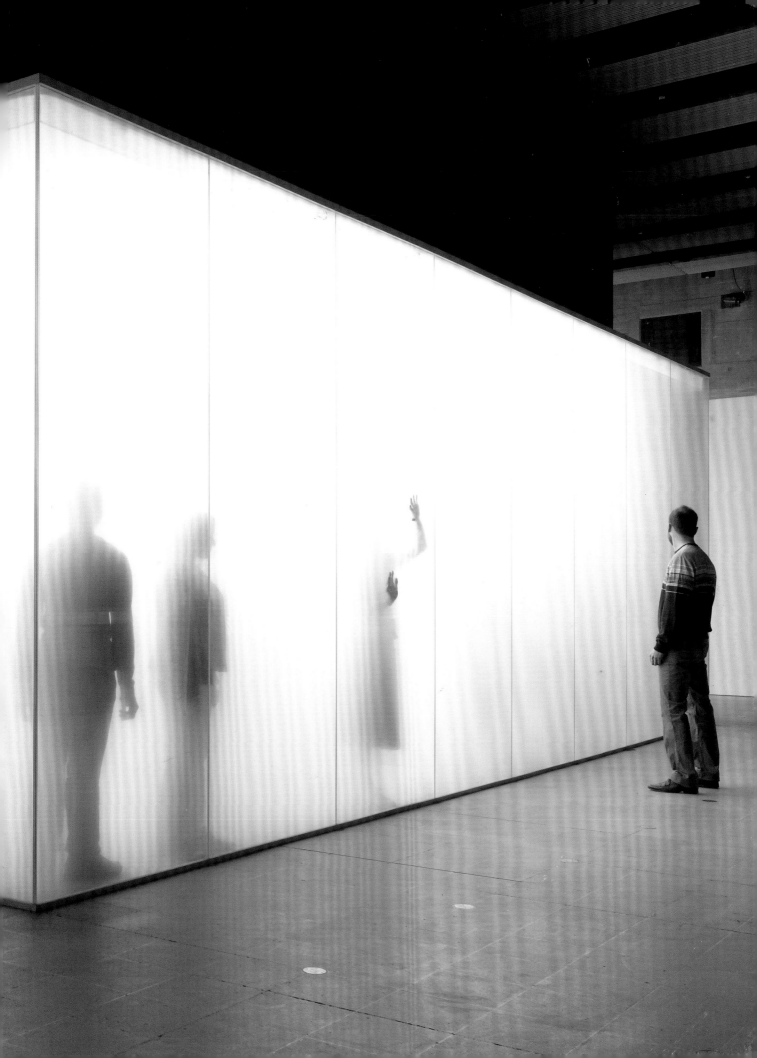

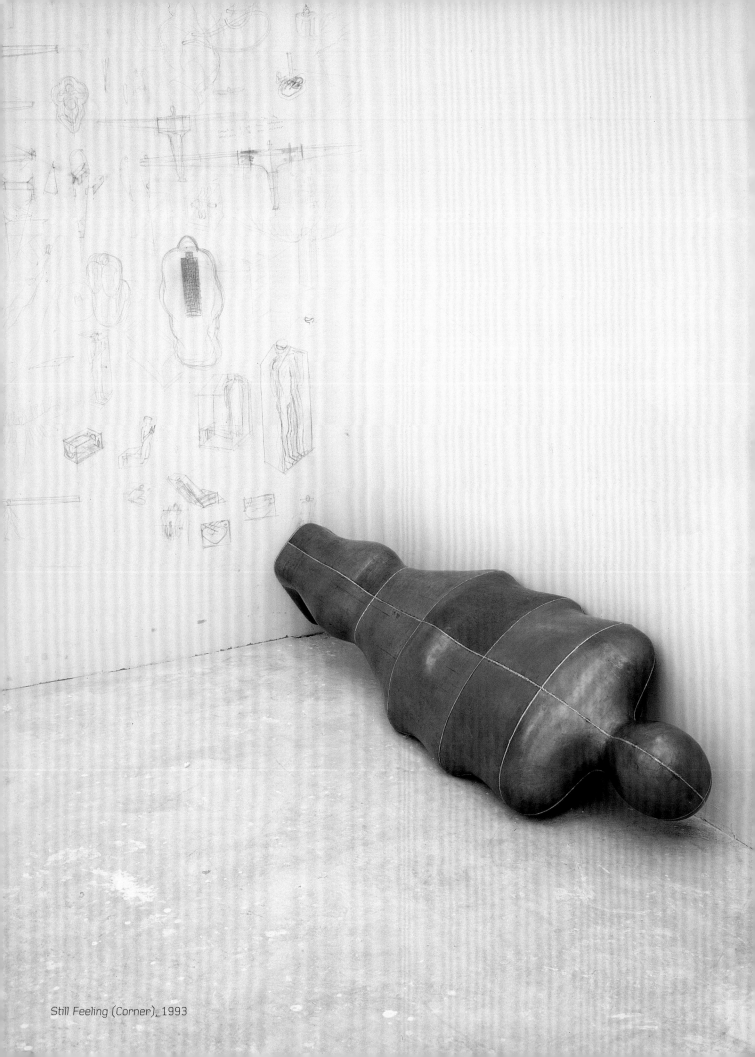

Still Feeling (Corner), 1993

ANTONY GORMLEY BLIND LIGHT

PREFACE

RALPH RUGOFF, DIRECTOR, THE HAYWARD

Organising an exhibition such as this offers an opportunity to reassess the trajectory of an artist's development. For this occasion, Antony Gormley's first major solo exhibition at a public London gallery in over 25 years, The Hayward has encouraged the artist to evolve and develop his enduring concern with the body into an exploration of architecture – specifically, the gallery's internal spaces and external form as well as its position within the surrounding city. The result is an exhibition (and publication) that tests familiar limits and risks asking fundamental questions about how art co-exists with the world in which we live.

Developing his work in surprising new directions, Antony has created a series of ambitious sculptural projects that abstract the figure to the very limits of readability and at the same time implicate us in an expanded visual field. A colossal six-metre-high steel mass slowly reveals itself as a human form curled into a foetal pose; a spectacular series of hollow body forms hang suspended from the ceiling in light-infused webs of steel; a luminous glass chamber filled with mist creates a disorientating, immersive environment and at the same time creates a living frieze composed of the figures of the gallery visitors who occupy it. This provocative engagement with our physical and perceptual space continues outside the gallery walls with *Event Horizon*, for which the artist has placed approximately 30 figures, made from casts of his own body, onto rooftops and public walkways around Southbank Centre and beyond into the heart of London. One of the most significant public art commissions of recent times, *Event Horizon* plays with tensions between appearance and disappearance, inside and outside, while raising fundamental questions about

how we occupy and perceive the built environment.

In addition to these compelling new projects, the exhibition includes a selection of earlier works that reveals the underlying continuity of Antony's artistic concerns. Dating back to the early 1980s, these pieces – made in a diverse range of materials from bread to lead to concrete – are acutely responsive to the varied spaces of The Hayward's uniquely volumetric galleries. Whether single figures or a vast installation like *Allotment II* (which includes 300 individual forms), each work challenges us to use our bodies as instruments of perception, and to discover how our confrontations with objects can activate our relationship to an expanded visual and architectural field. It is my deepest hope that this exhibition should finally make it clear that Antony, rather than being an artist who represents the body in his work, is chiefly concerned with engineering experiential encounters that intimately engage us in negotiating the meaning of his art.

Combining artistic vision and considerable technical achievement, this exhibition could not have been realised without the dedication and commitment of a large number of people. Our thanks go firstly to Antony himself. His energy, passion and thoughtfulness have rightly made him one of the leading figures in contemporary art in the UK. Eversheds LLP have generously provided exhibition sponsorship and we are most grateful for their invaluable support. Thanks also go to the Henry Moore Foundation for providing additional funding for the exhibition. We are very grateful to Quercus Trust, Miel de Botton Aynsley, Allison and Harvey McGrath, Midge and Simon Palley, Andrée and Howard Shore and those Patrons who wish to remain anonymous for their enlightened patronage

of the new commissions. We are also indebted to Jay Jopling and White Cube for their great generosity and support in every stage of producing this exhibition. We are grateful to those who have generously lent works to the exhibition: the Museum Würth, Künzelsau, Germany; Collezione Longo Cassino, Italy; Galerie Thaddaeus Ropac, Paris; Galerie Xavier Hufkens, Brussels; Rita Rovelli di Caltagirone; and the artist himself.

At Antony Gormley's studio we would like to thank Isabel de Vasconcellos, Catherine Bonney-Murrell, Oscar Wanless, Will Shannon, Adam Humphries, Giles Drayton, Balint Bolygo, Robert Moule, India Carpenter, Tom Woolford, Filipa Cardoso, Tom Rowbottom, Rupert Bagenal and Lynsey Harrison for their tireless dedication to the exhibition, and Vicken Parsons for all her help and support. Our sincere thanks go to the extensive teams who helped to design and fabricate *Space Station*: Tristan Simmonds of Arup, Dave Mason of Sheetfabs and Adam Lowe of Factum-Arte. Klaus Bode, Adrian James and Alan Harries of BDSP Partnership, Andy Groarke and Kevin Carmody of Carmody Groarke Architects and Professor Ken Bignell of Imperial College generously supported the development of *Blind Light* with the donation of their time and expertise, and our thanks go to Zumtobel Lighting Ltd for the donation of the lights. We owe them all a special debt, along with Tom Robertshaw of Techniker and HB Source Ltd (particularly Tim Manning) as fabricators of the work. We would like to thank Sean Hanna for the digital development of *Hatch* and the bubble matrix expansions. For the casting of *Drawn* our thanks go to Michael Hinchliffe and all at Hargreaves Foundry. Structural engineers Elliott Wood advised at all stages on the structural

design of the show, while Sam Forster led the exhibition build, and John Johnson and the Lightwaves team designed the lighting solutions for the exhibition.

Our sincere thanks go to all of those who have helped to realise *Event Horizon*, from the numerous sites who have taken part in the project and so generously given their time and commitment (see p. 130), to the agencies across the city who have lent their support, including the planning authorities and highways officials at London Borough of Lambeth, Westminster City Council and Camden Council, Sheila Stones at English Heritage and the Mayor's office. We would also like to thank RPS planning consultants; architects Toh Shimazaki; Pinsent Masons; the installation team at Mtec Warehousing Ltd led by Dave Williams; structural engineer Robert Nilsson at Price & Myers; and the fabricators of the works, Steve Haines at Arteffects and Andrew Siddons at Siddons Foundry, without whom the project could never have been achieved.

At The Hayward, Susan Ferleger Brades and Martin Caiger-Smith began the conversations that led to this exhibition. Imogen Winter the gallery Registrar co-ordinated all of the loans and transport, and Keith Hardy, Eddy Smith, Mark King and Hilton Wells, along with Alex Duke of Elstree Light and Power, were instrumental in leading a complex installation, ably co-ordinated by Rachel Kent and Dana Andrew. Across Southbank Centre a number of colleagues have been essential in making the exhibition a success: Sarah Davies in the Press Office, aided by Jane Quinn at Bolton and Quinn; Karen Napier, Sarah Sawkins and Dominic Parker in the Development team; Helen Faulkner in the Marketing team; Helen Luckett, Katie

Arnold and the Public Programmes team; Mike McCart and Melford Deane who advised on a number of legal and planning issues; Mark Foster, Head of Security; and Jenny Robinson and Katherine Walsh in the Commercial department who worked closely with Kit Grover of Kit Grover Ltd on the exhibition merchandise. Charlotte Troy, The Hayward Publisher, and Oriana Fox worked closely with the artist and SMITH design, along with the photographers Stephen White and Gautier Deblonde, to produce the exhibition catalogue. Laura Stevenson, Deputy Director of The Hayward, provided a steady stream of invaluable advice.

Finally, it is a great pleasure to thank my co-curator Jacky Klein for all of her insights and for rising to the myriad challenges of this exhibition with a selfless and passionate commitment. Working with her Rachel Kent has provided stellar support; this show would not have been realised without her very significant contributions. Charu Vallabhbhai, who joined the exhibition team in its final months, also helped ensure that this exhibition – the most logistically complex in the history of The Hayward – has reached such a happy result.

I am delighted that Eversheds' close relationship with The Hayward has given us the opportunity to support this first major public exhibition of Antony Gormley's work in London.

Eversheds has a long-standing commitment to supporting the arts and the communities in which we live and work. We share with The Hayward a passionate belief in the benefits of broadening public access to art. We could not express that belief more clearly than by sponsoring an exhibition which includes, in *Event Horizon*, a public project which takes Gormley's work out of the gallery and into the heart of London. I suspect that the impact of the exhibition will be felt far beyond those who would normally visit The Hayward – or indeed any other gallery – and the work itself will be remembered long after the exhibition ends.

Once again The Hayward has demonstrated its knack for bringing art to the people of London in new and exciting ways. It was this knack, and The Hayward's reputation for innovation and freshness of vision, that drew Eversheds into partnership with the gallery in the first place. It is a reputation – coupled with a passion for excellence – with which we are proud to be associated.

Feeling Material XXIX, 2007

FIELD ACTIVITIES

A CONVERSATION BETWEEN ANTONY GORMLEY, RALPH RUGOFF AND JACKY KLEIN

RALPH RUGOFF It seems to me that your work has often been misunderstood. It was generally received as belonging to a return to the figure in sculpture that occurred during the 1980s. While I would not describe your sculpture as 'figurative' in any conventional sense, you have often used the figure as a reference point, yet in ways that separate your approach from that of many of your contemporaries.

ANTONY GORMLEY I think we have to go back to the end of the 1970s and understand the context in which my work emerged. Among many of my colleagues there was a new urban sensibility that was keen to react against the conceptual pastoralism of Richard Long and Hamish Fulton and deal with process and the gathering of city flotsam. Somewhat contrary to this context I went to the body as a site of direct experience, trying to make something personal that, while resulting in an object, was action based. I was interested in the Viennese Actionists, particularly Rudolf Schwarzkogler, and also the Situationists and their legacy on the New York scene of the late 60s and 70s that extended to dance, as well as to artists like Vito Acconci and Bruce Nauman.

But I wanted to make something that was not a performance, or where the performative element was not public, just part of the work. While my peers, like Tony Cragg and Bill Woodrow, were using bits of found plastic and washing machines in tribute to the legacy of Duchamp, I used (and continue to use) my own body as my found object, which was in fact the lost subject that had been rejected by Modernism. When I look around now and recognise all the issues that the body raises – our attitudes to death, time and memory as well as identity, sexuality and power – and see how they are addressed by younger artists through the body, I feel somewhat vindicated.

Yet I have trouble with this word 'figure' because it suggests either academic notions or a kind of known use. I prefer 'body', but this has to do with a bigger question about how I deal with representation and the representative. There are not many opportunities available if you want to look at the body again. Either you work with art-historical references or accept the alternative traditions of the double in the mannequin, puppet, cyborg or ventriloquist's dummy. I tried to find a more direct route, using my own body, the only 'thing' in the studio, as an example of a collective condition. Perhaps more importantly, this allows me to make work from inside my material, as it were. The activity of moulding is the capturing of an event, an embodied moment of human time captured in matter.

RR A number of 'figurative' sculptors who emerged in the 1980s, such as Jeff Koons and Charles Ray, were really dealing not with the figure *per se* or with body-related issues so much as specific sets of conventions. Ray, for example, denatures the conventions of the mannequin by making a mannequin-like sculpture with

Trisha Brown, *Roof Piece*, 1973, New York
Bruce Nauman, *Dance or Exercise on the Perimeter of a Square*, 1967–68, New York

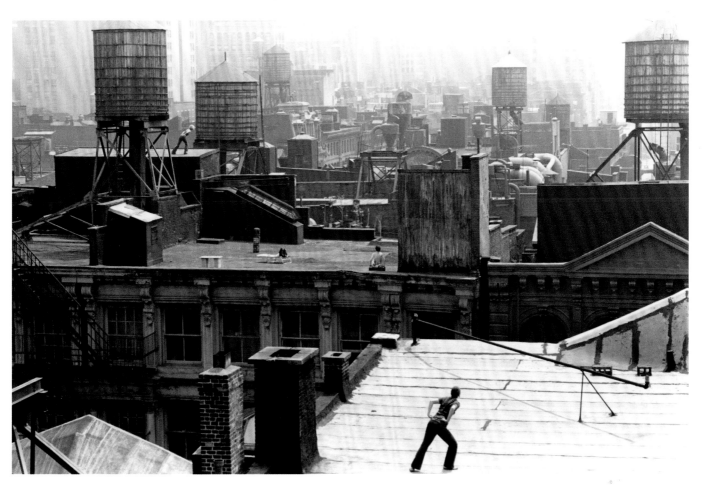

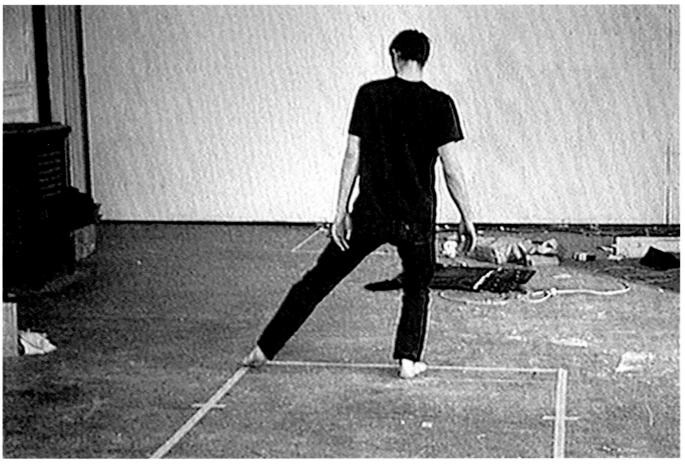

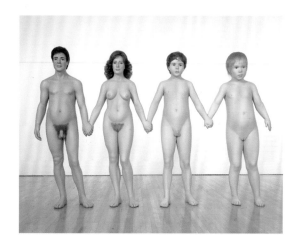

lifelike genitals, while Koons plays with the codes of kitsch, estranging them by dramatically scaling up from his source material. This kind of work calls attention to the degree that arbitrary conventions determine the meaning that objects have for us. How do you see your work in relation to that kind of culturally specific conversation?

AG I'm not so culturally specific or concerned with declaring my position in relation to contemporary semiotic issues. My concerns are existential and anthropological. I'm not so interested in the status of the art object *per se*. In many ways my work is closer to the plaster casts of people that were incinerated in the pyroclastic cloud of Pompeii, or to the hands painted on the wall of a palaeolithic cave, than it is to Koons. I look as much to anthropology and archaeology as to art: they open up possibilities. Who art can be for, why it's there at all, who can feel connected to it, how it might work – these are more important questions than the evolution of sculpture for its own sake.

This is not to say that I haven't learned and continue to learn from other artists. Walter De Maria was very important as a friend and an influence on my work. I learned a lot from and admired Joseph Beuys very much. Bruce Nauman and Carl Andre are important to me. That practical American down-to-earth, get-things-done attitude I really admire. I also respond to the visceral quality of the work of Kiki Smith – although I have never wanted to deal with the body in pieces or use Gray's *Anatomy* as a blueprint for analysing gender politics. In more general terms, I see myself as belonging to a generation of sculptors that includes Katarina Fritsch, Thomas Schütte, Juan Muñoz, Stephan Balkenhol, Robert Gober, Charles Ray, as well as Kiki Smith, though I am older than most of them and only know Ray well.

RR It seems, though, that your interest in the figure has been motivated by a different set of concerns, including architectural relationships. In any case,

ANTONY GORMLEY, RALPH RUGOFF AND JACKY KLEIN

Charles Ray, *Family Romance*, 1993
Kiki Smith, *Euro Genital System (diptych male and female)*, 1986

the bodies you make are usually not especially expressive; you seem more interested in how they punctuate and define space than in endowing them with meaningful gestures.

AG I am not interested in dramatic tableaux or expressionism in terms of gesture, but I am interested in bodies as carriers of emotion and potency. I'm intrigued by how the different ways that a body can be registered in material can change our feelings about it. We live in a visual culture – images of the body abound and in many ways we are captured and captivated by them. In trying to deal with what it feels like to be alive, dealing with the body the other way round – from the inside, exploring it as a place rather than an object – I am countering both the contemporary obsession with bodily appearance and the historical one of idealisation. The notion of the body print, the direct trace, the shadow or the echo is important. For me, taking an impression and registering it in other structural matrices like rhizomes, crystals, bubbles or even structures not apparent to the naked eye, such as subatomic particles or waves, can change the feeling of where we are in our bodies. Ultimately, I want to use the body as a lever on space – to have it act as a catalyst by being in a room or on the pavement on different terms to the body of the viewer.

JACKY KLEIN You talk about bodies as 'carriers of potency', and it seems to me that this potency cannot be detached from their physical specificity. Since your own body is the starting point for so many of the works, the specific index of that body invariably becomes a central element with which audiences must engage. It seems a challenge then to make universal assumptions or to evoke a 'collective condition' as you call it, through a body of very specific proportions, sex and ethnicity.

AG This is a really old chestnut! The work tests the premise of universality and a lot of other assumptions central to the mind/body problem, like the fact that we can never ever

fully know either the contents of another's mind or share her true feelings. This is what makes life worth living and art worth making!

I see the work as entirely propositional and experimental: how does making this particular body form, captured at this moment of its lifetime, at this time of the year, in this emotional state, in this part of the Northern Hemisphere, out of this mix of tiny stainless-steel needles, evoke a feeling – in me or in you? How does this piece of rusty iron in a human form act as a lodestone to emotion? What is its relationship to its time of origin and to its time of apprehension? In answer to these questions there is only subjective truth and naively I believe I am celebrating it! The longer I work and the more multifarious the ways in which this body is evoked and traced, the less important the question becomes of whose it actually is – whether it's mine, yours, anyone's or everyone's.

JK I wouldn't say that the use of your body necessarily puts up a barrier, but rather that it acts as one filter through which the work is experienced, particularly perhaps by those who are not male or Western but somehow physically 'other' from the work.

AG I would like to think that I have disappeared in the work. The work involves using my own existence as tool, material, subject; this is an anthropological field study that started with one subject and has now evolved and involves plenty of others. *Allotment II* (1996) is an example in this show where I asked 300 other people to be involved by creating objects that relate to their bodily measurements. So I feel that this issue of a male, Western register is not really pertinent any more.

RR Though often cast from your body, your sculptures are hardly portraits: they are void of telling personal detail. Are you inviting viewers to fill in that blankness with their own projections?

AG One of the liberating opportunities of the

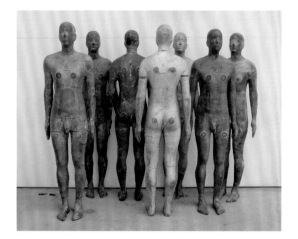

ANTONY GORMLEY, RALPH RUGOFF AND JACKY KLEIN

notion of art as a field activity is that it is not about reading, it's about experiencing, and the experience is mutually engendered. How an object is interpreted or experienced by the viewer is none of my business at all. My feeling is that if I get the crystallisation of the mineral part of it right, the emotional and intellectual engagement of the viewer will be the other half of the equation. So the projection of the viewer is critical.

But the bodies I make are not simply blanks – the human equivalent of a tabula rasa. In this show, my work moves from quite brutal evocations of the gestalt of a body held in a lead body-case [*Still Feeling (Corner)* (1993)] to suspended solid iron bodies cast from the outside of a mould [*Critical Mass II* (1995)]. And in *Drawn* (2000/07) the bodies are very close to life – you can see the traces of all the processes that have gone into the moulding and casting, including every wrinkle of the cling film in which my body was wrapped. To me these works are all possible places, possible sites of being, feeling and thinking.

JK Although you make use of these different materials and surfaces, it is interesting that you don't think of your works as having any intrinsic aesthetic interest or value in and of themselves.

AG I suppose that is my way of sidestepping the issue of beauty, and the whole idea of the unique, rare and therefore valuable thing. I just see all of the works as fall-out from a process of investigating the human condition. They only make sense once they are lived with and seen in context. Maybe 'seen' is even too specific – once they are propped up against life. I think of the work as a catalyst or resonator whose value or significance is not intrinsic but is generated in relation to the viewer and to its context.

RR In this exhibition your outdoor work *Event Horizon* (2007) is indeed 'propped up against life'. You have placed around 30 life-sized figures on the rooftops of

Antony Gormley, patterns for *Event Horizon*, 2006

buildings, with some as far away as 1.5 kilometres and others sited around the Southbank Centre and on Waterloo Bridge, with all of them placed so as to be visible from The Hayward's three sculpture terraces.

One of the first things that strikes me about this work is that you are offering viewers two very different experiences: on one hand, an intimate encounter where you can walk around and closely examine a three-dimensional figure, and, on the other, a distant sighting where the physical object appears to us as a tiny form, essentially a graphic image. What was your thinking in combining these two very different experiences?

AG It has to do with the relationship between the real and the image, the palpable versus the perceptual, that I have been interested in for a long time. The title comes from cosmological physics and refers to the boundary of the observable universe. Because it is expanding, there are parts of the universe that will never be visible because their light will never reach us. I also think that one of the implications of *Event Horizon* is that people will have to entertain an uncertainty about the work's dimensions: I mean the spread and number of bodies. Beyond the figures that you can actually see, how many more are there that you can't see?

From The Hayward's eastern sculpture court, people will be able to see the sculptures on Waterloo Bridge, and to watch how the flow of daily commuters deal with these static bodies in their midst. I am very interested in that kind of process: life encountering a register of itself in an unexpected place. It unhinges our certainty about our own particular journey, and about where we fit into the world.

JK All of the figures in *Event Horizon* were cast from your own body, but in subtly modified attitudes. I am interested to know why you chose to use six slightly different moulds.

AG *Event Horizon* is similar in this respect

to *Another Place* (1997), in that it was very important to me to create a sense of diversity in unity among the 100 cast-iron figures on Crosby Beach. The six states introduce something biological, in a way that's barely perceptible but important. It's the same body but at different moments – the various moulds were actually made over a ten-year period.

For me, repeating variations of a figure is also a means of abstraction. Presenting large numbers of similar figures is a way of acknowledging that these bodies are made in the age of mechanical production. There is also a sense in which the figure gets emptied through repetition: the more you reproduce it, the less aura, the less inherent content it has. It detaches the work from statuary, and links it more to mass-production.

RR This is the lesson of Warhol to some extent, but at the same time it seems to me that repetition can invest an object or image with a different kind of power, a sort of incantatory power. And then added to that is the uncanny sensation of seeing the same figure watching you from all these various vantage points.

AG We are always looking for the authentic, the original, and yet here you don't know which it is. In fact it isn't any of them really and it might even be you – rather like the 70s film *Invasion of the Body Snatchers*.

My hope is that *Event Horizon* should allow somebody visiting the gallery exhibition to look back out on the world and to see it differently. I guess that's the wager of the work: to infect this collective, built environment of London with these foreign objects that sit on the skyline, the interrupted horizon that city-dwellers on the whole don't bother paying much attention to. I hope that by animating this lost horizon with foreign bodies it will in some way make this inherited, collective, built environment seem like a model, make it into a representation of itself, and allow us perhaps to think about this entirely constructed environment as a picture in which we are implicated.

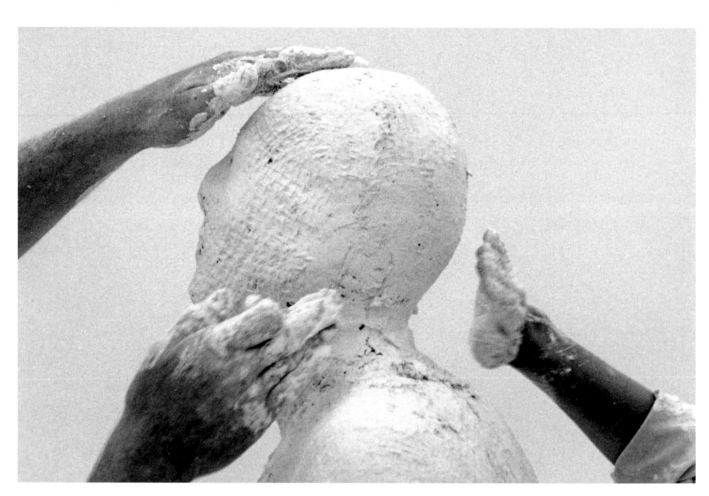

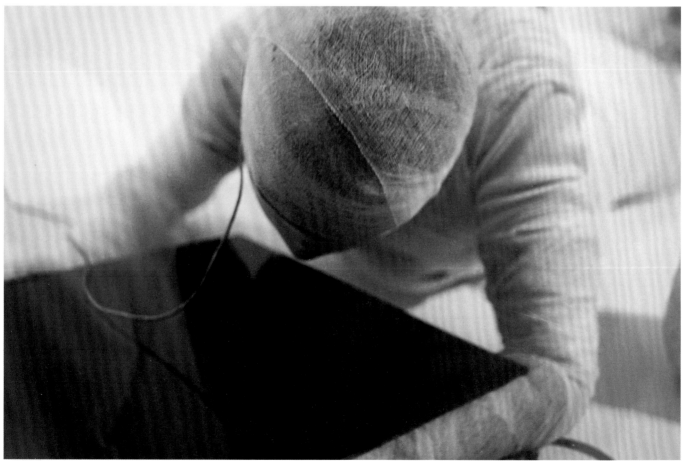

JK So in a sense the 'event' of the work's title is partly also about making an event of our everyday environment, of the things that normally go unnoticed in the world around us. How much of your intention with this work was to re-invent – or 're-event', if you like – our perception of the city?

AG I think this is a very subliminal work: as a presence in our visual field, it's hardly there. But I think that that's a model of art that I like: not inventing spectacles, but providing a catalyst or a kind of tuning device that allows you to see something differently. We are to some extent always victims of the last time we looked at something, the last mental snapshot we took that made us think 'London', or 'home'. What I am interested in is how that immersed existence with its shorthand mental references can be renewed by looking at the world as a picture, a living picture that we are in, but having been given this instrument of distance, we are also removed from.

I'm interested in the forms of the city as an aggregate, as a kind of crystalline layering that has been laid down over time. It is a model of built time as opposed to geological time – this is the first time that a species' habitat has taken over from host systems in such an indelible way.

JK With *Another Place* the figures were positioned so they were looking out to sea, as if inviting us to survey the landscape from the same orientation and to almost become one with the work. In contrast, the figures in *Event Horizon* are all staring back towards The Hayward, so that the viewer looking out at them from the sculpture terraces seemingly becomes the object of the work's attention. Did you intend this new work to act as more of a confrontation?

AG You could say that. It was about being watched, about being put on the spot, really. But this reversal of the normal relationship between viewer and art object is a preoccupation that has run through my work for a long time – the idea that the individual

becomes slowly aware that he or she is the focus of this witnessing field.

JK In this case there is also a witnessing field of CCTV cameras. *Event Horizon* occupies an area of London that must be one of the most heavily surveilled urban spaces in the world.

AG These forms are liberated caryatids for the time of the CCTV camera. We are all witnessed impersonally these days. The world looks at itself now with disembodied eyes.

RR Your exploration of perceptual issues, and of the relationship between bodies and built spaces, continues with the works in the gallery exhibition. Rather than discrete objects that can be framed within a single field of vision, many of these works can only be experienced by moving through or around them, and invite us to explore more complex spatial relations.

AG The whole show in a sense is about perception and about using your body as an instrument. I am trying to fold architectural space into the body or the body into architecture, and this dialectic between space that is articulated by architecture and space as experienced by the body has always been part of my work. *Room* (1980) is the first example of my folding personal space as carried by the body into collective space as carried by architecture. Then there is a work like *Home* (1984) [see p.115], a lying lead figure with its head in a house, which is very explicit in addressing this subject. But I would reject that now as a work.

RR Why would you reject it?

AG Because it is illustrative. It evokes claustrophobia and the relationship between mental and physical space, but it does so in an imagistic way. It gives you a picture rather than putting you in it. That's a bigger challenge. That's why *Man Asleep* (1985) is not as good as *Field for the British Isles* (1993) [see p.82].

Antony Gormley's head in plaster, 1995
Rudolf Schwarzkogler, 6.Aktion, 1966

Man Asleep is an illustration of an idea about history, and about our being asleep and not taking responsibility for our own and others' futures. *Field* wakes you up and puts you on the spot: you are no longer a passive viewer looking at a stand-in, but instead are the creator of the world, the living membrane between unborn and ancestor. For better or worse there is a sense in which the work is saying to people: you have made this world, now what are you going to do about it? That kind of imperative knocks on our skulls with greater insistence.

JK Part of the success of works like *Field,* as well as a work in this exhibition like *Allotment II,* seems to me to be related to scale and architectural space. As installations, *Allotment* and *Field* are that much more powerful because of their immersive quality, because they absolutely take over a given space. The same is true in a way with *Drawn,* where eight life-sized cast-iron figures redefine each of the corners of a room. The figures have a strong physical presence that forces you to reorientate yourself within that space. Sculpturally and spatially, they do something very different from an object sitting on the floor.

AG This relates to my seeing Walter De Maria's *Lightning Field* (1977) in 1979 as well as *The Earth Room* (1977) and *Vertical Earth Kilometer* (1977). They were all quintessential turning points in terms of my understanding of what was possible, of how the pursuit of sculpture had embraced multiplication and context, and turned away from a concern with the singular object. *The Earth Room* takes over an interior space and goes beyond the visible to change the way you feel; *Lightning Field* has all the characteristics of a specific object turned into a proliferation which then embraces landscape. Like *Event Horizon,* in it the viewer becomes implicated in something that is no longer simply about the concentration of thought or feeling into an object, but about the expansion of feeling that can never be contained.

Walter De Maria, *Vertical Earth Kilometer,* 1977, Kassel, Germany
Antony Gormley, *Full Bowl,* 1977–78

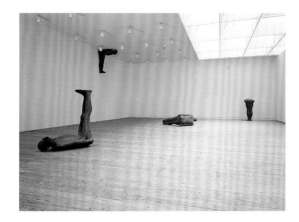

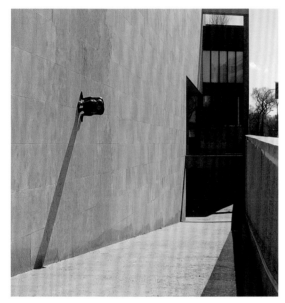

JK It seems that expansion and contraction have been key motifs in your work for many years.

AG Going beyond the self-contained object has been in the work from the beginning. *Full Bowl* (1977–78), for example, suggests a radiating form that could go on ad infinitum. In this show, *Seeds III/V* (1989/1993) is a collection of units that likewise could multiply forever. With a work like *Testing a World View* (1993), I wanted to show how you could allow an object repeated five times and installed in different orientations to question not just its own formal syntax and psychology, but also that of the room. The five identical, jack-knifed, right-angled body forms in *Testing a World View* take their form from the architecture, and then use it to test the architecture.

RR So do you see that piece as a direct precursor to *Drawn*?

AG Yes absolutely, but *Drawn* is a lot fresher; it is one of the most exposed body-form works. *Testing a World View*, although solid and massive, is made from the outside of the mould; *Drawn* is a very precise cast with much greater detail.

RR And yet the body form is almost geometric. It's a right-angle split, so obviously they're not cast from life.

AG Oh, but they are.

RR But recomposed from individual body parts?

AG No, I was in that position.

RR It looks almost anatomically impossible.

AG It wasn't very comfortable. We did make the legs one at a time, but essentially what you see is how it was made.

JK Does the position of the bodies have any significance beyond delineating the corner?

Antony Gormley, *Testing a World View* (detail), 1993,
Malmö Konsthall, Sweden
Antony Gormley, *Pore*, 1988, Winnipeg, Canada

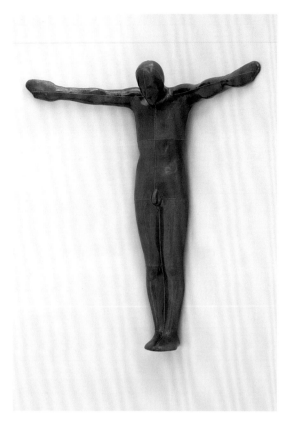

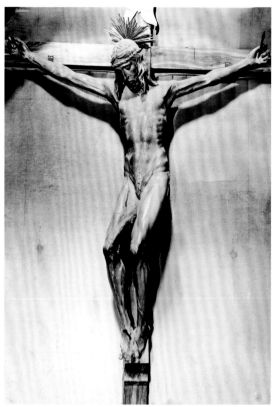

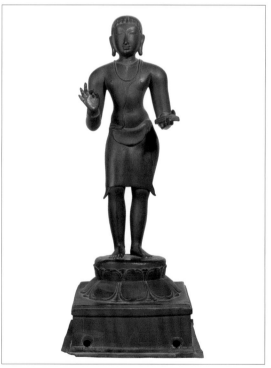

Clockwise:

Antony Gormley, *A Corner for Kasimir*, 1992

Filippo Brunelleschi, Crucifix, 15th century, Italy

Saint Manikkavachakar, c.1100, Chola, India

Buddha, early or mid 5th century, Mathura, India

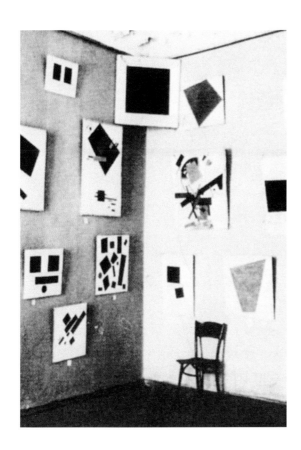

It seems very physically demanding, and calls to mind the postures of yoga, for example.

AG I think it has much more to do with crucifixion, pushing the body to conform to a given structure. *Drawn* is a dialogue with Kasimir Malevich. Previously I had made *A Corner for Kasimir* (1992), which makes a reference to the Suprematist black square and the fact that Malevich put it up in the corner where the icon of Christ would normally go.

JK The Constructivists took on a heavily loaded iconography and through abstraction tried to make it as aesthetically neutral as possible. Is that urge to remove the content or symbolism of the icon something that you had in mind with *Drawn*?

AG The natural attitudes of the body, whether sitting, standing or lying, are symmetrical – any body when it accepts stasis consciously becomes hieratic and is in dialogue with sacred sculpture, whether Hindu, Christian, Buddhist or Oceanic. My work is totally a-religious, but that idea of the contemplative icon, an object that makes you stop for a moment in the bustle of everyday life, is central to me.
 I feel very sympathetic to Malevich's Suprematist ideal that you could create objects that would transform the context of everyday life into a crucible for remaking the human project.

RR With *Drawn*, it seems that you are also playing with the idea of gravity by drastically skewing the conventional relationship between the body and architecture.

AG Not being sure which way is up hopefully puts the viewer into freefall and loosens the boundaries of certainty. The gravity adds to the lever effect, hopefully making the viewer more uncertain about his or her position in space and gravitational value. Mass, weight and light are as important as scale for me.

Kasimir Malevich, *Last Futurist Exhibition 0,10* (detail), 1915, St Petersburg, Russia

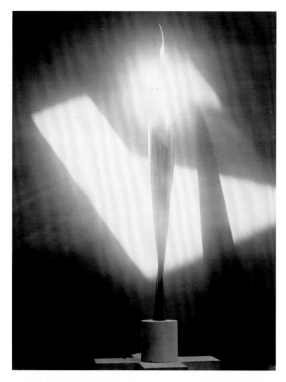

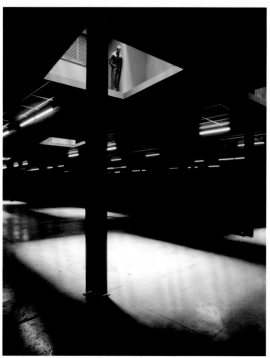

RR If Minimalism took sculpture off the plinth and put it on the floor, a number of your recent works move sculpture off the floor and put it elsewhere.

AG Put it on the ceiling, put it on the skyline.

RR I'm thinking of the bubble matrices and expansion pieces, and wondering why suspending these bodies is important for you? Why are they not resting on the floor?

AG The matrices and expansions are the closest I get to Brancusi's notion that you can turn an object into light. He did it by polishing sculptures, whereas I have tried to do it by abandoning weight and mass and dissolving surface. These bundles of nothing are the most dematerialised works I have ever made. The bodies are free, lost in space, weightless, and with no internal determination. They appear as emergent zones: you cannot be sure whether the bubble matrix is produced by the body zone or the zone by the matrix.

JK In some of the other new works created for this exhibition, such as *Hatch* (2007) or *Blind Light* (2007), the bodily form has entirely dematerialised and is simply not there. Arguably the only figure present is that of the viewer.

AG What I am trying to do in these works is to put the viewer where the body was in earlier sculptures like *Home* or *Man Asleep*. This allows other viewers an experience of seeing real bodies interacting with a conceptual space that is also physical, and seeing how they deal with it. In works like *Blind Light*, *Allotment* and *Domain Field* (2003), part of the experience is watching how other people navigate their way through or around the work, get lost or bump into each other or into the objects themselves.

I was very struck by how Juan Muñoz's installation *Double Bind* (2001) at Tate Modern's Turbine Hall incorporated the presence of spectators: you saw people

Constantin Brancusi, *Bird in Space* (*L'Oiseau dans l'espace*), 1932–40, photographed by Brancusi in 1933 at his studio, Paris
Juan Muñoz, *Double Bind*, Tate Modern Turbine Hall commission, 2001

completely stilled, looking up through three-metre-square apertures that allowed natural top-light to come down. As you walked down the ramp of the Turbine Hall you were faced with these two contradictory experiences – the very light grey floor with holes in it on top and, below, a dark space, a cavernous nether-world where the viewers were still, looking upwards in square pools of light. It was powerful the way that the viewers took on the role of sculpture. Muñoz had made a trap where the viewers became fixed, an implicated part of the sculpture.

I'm hoping this might happen in several instances in the installation at The Hayward. For example, with *Space Station* (2007) the overall mass of the sculpture will have a relation to viewers as they lean forwards and look through the holes in its surfaces. I am hoping that something similar will happen with *Blind Light* – a very brightly lit glass box filled with a dense cloud, where people will vanish as they enter the chamber but might emerge as shadows for the viewers on the outside of the box.

And perhaps *Event Horizon*, which is designed to be seen from The Hayward's sculpture terraces, will create another version of this phenomenon. As you walk out on to the sculpture courts you might encounter individuals or groups of people pointing at the horizon in the manner of a classical group of sculptures. This is exciting to me: reflexivity becoming a shared activity. The conceit in all of this is that in observing the works dispersed over the city these viewers will discover that they are the centre of a concentrated field of silent witnesses – they will realise that they are surrounded by art that is looking at them!

RR *Hatch* is another new work in the exhibition that places the viewer in the centre of a surrounding field – all those converging metal tubes – that seemingly focuses on you.

AG Well not quite; there's basically a cruciform

in *Hatch*, which is the open field where you can see your way forwards. There is a safer, more open spot in the centre of the room, but there are also many places where you become the focus of external gazes, as other visitors can observe you through the metal tubes that penetrate the walls of the room. By looking down the tubes you also experience a kaleidoscopic effect: the single view is multiplied, refracting the subject into pixilated cubes.

JK How do you see *Hatch* relating to *Drawn* in this double installation?

AG *Hatch* forces you to occupy the centre – the place where the bodies in *Drawn* couldn't be.

JK *Hatch* could also be read as a three-dimensional drawing in space, with lines projecting out from the 'ground' of the room. The projecting aluminium rods even seem to relate to traditional drawing techniques like cross-hatching. Was it your intention, as in other recent works like *Breathing Room I* (2006), to invite the viewer to effectively step into a picture plane?

AG Yes. But I also wanted to make an instrument that would detach perspective and deconstruct the coordinates of a room or a box so as to make its geometry physical.

JK Brancusi once said that 'architecture is inhabited sculpture'. This sculpture, in the reverse, seems to inhabit, if not take over, its architectural case.

RR And like both *Blind Light* and *Breathing Room*, *Hatch* is explicitly responsive to the environment. Some of your earlier outside works, like *Another Place*, play off elements of change in their surroundings, such as the tide coming in and out, but the works themselves don't change. These new works, on the other hand, dramatically respond to changing light conditions and the presence of spectators.

AG With *Blind Light* you could say that light is the environment, but actually people are

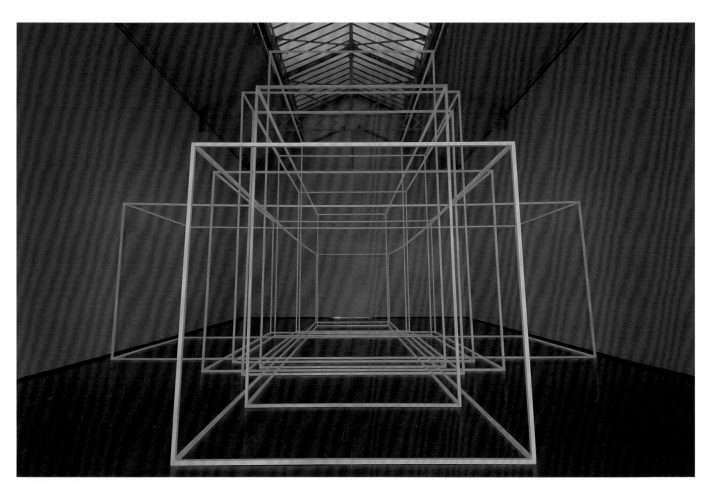

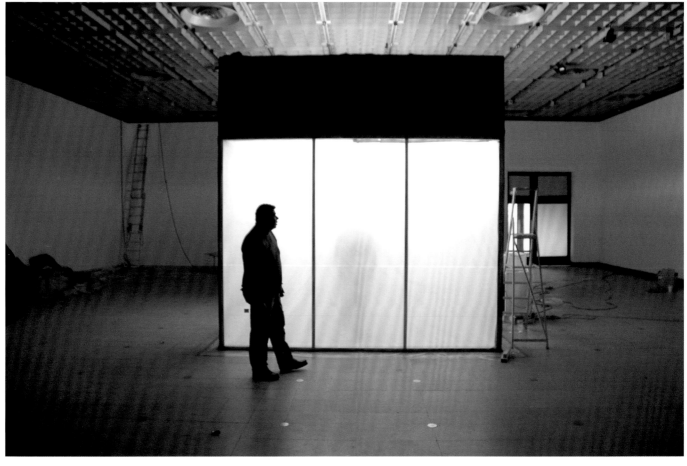

the environment. It's about these very close encounters with the other, encounters that are well inside people's normal interrelational comfort space yet here create a new kind of social space.

RR More than any other installation in this show, *Blind Light* radically departs, in appearance at least, from your earlier work. It is like a Bauhaus structure with this cloud of unknowing within it. Yet at the same time it picks up on concerns that you have pursued in very different ways in the past. In a particularly immersive and experiential manner it engages viewers in a play of appearance and disappearance. This motif also appears in many other works, whether in the tenuous legibility of the figure in *Space Station* that is only readable from afar, or the figures in *Event Horizon* that disappear into the density of the urban landscape.

AG I think that the most important thing about *Blind Light* is suggested by the title: the idea that light itself can be the opposite of illuminating. Viewers will enter into a very bright space where the visibility may be as little as two feet. The blinding light will be part of an experience of disorientation.

Of course, this work also presents the paradox of something clean, square, well-designed, safe and dry that is completely inverted by being used to contain all those elemental things that Modernism was supposed to have protected us against.

RR Could you say more about what you mean by that?

AG Architecture is supposed to be the location of security and certainty about where you are. It is supposed to protect you from the weather, from darkness, from uncertainty. And *Blind Light* undermines all of that. You enter this interior space that is the equivalent of being on top of a mountain or at the bottom of the sea. In spite of all we have said about potential encounters, it is very important for me that *Blind Light* is a room that has been

Antony Gormley, *Breathing Room I*, 2006
Prototype for *Blind Light* installed at The Hayward, January 2007
Antony Gormley, *Hatch* (detail), 2007

dissociated from its room-ness so that inside it you find the outside.

JK In contrast to the spaces of Modernist architecture, *Blind Light* engenders a profound disorientation, an unnerving feeling of almost losing *yourself*, of not being able to map out the contours of your own body, or being precisely aware where your body ends and someone else's suddenly begins.

AG There is a part of me that feels that a lot of human nature is about trying to reinforce the illusion of our certainties. Art can undermine that. Losing the bonds of certainty about where or who we are seems to me to be very important.

RR While *Blind Light* disrupts or sabotages the transparent space of the glass box, *Space Station* plays with scale in a disarming way by scaling up an abstracted body form so that it resembles a giant model for a Minimalist housing complex.

AG *Space Station* has a double conceit to it: it's a small thing that has been made into a very large thing, but that large thing is itself a model for something much larger. In a way, the figure's foetal pose suggests both the birth position or the kind of amniotic context at the most compressed beginning of human life, but also the collective city environment in its most dense form. It's formally just like the Shell office building [which sits behind The Hayward on Belvedere Road], which has the same repeated fenestration.

Space Station conjures a dark, labyrinthine, internalised, prison-like space but it also has the feeling of a sieve, of something perceptually open.

RR With the dark veneer of its steel surface as well as its forward tilt and sheer mass, this work seems to evince a sinister or threatening presence.

AG There is a bit of Richard Serra in the big cantilevers of the head and feet but it's more

cereal-packet model than Ur of the Chaldees. But what I am interested to see is whether people will look through the peepholes into the interior spaces of the boxes, into these strange places that are disorientating yet familiar. With *Space Station* the key question for me is how to unhinge people's comfort with the existing dimensions of their habitat. In doing this, a certain space is created that hopefully triggers feelings of exposure, nausea, perhaps fear, yet also excitement.

RR *Space Station* seems to have a direct relationship with *Allotment II*. It is almost as if you have piled up the block-like forms of *Allotment* to create a vertical edifice. One crucial difference, though, is that the apertures perforating the forms in *Allotment* emphasise interiority, whereas in *Space Station* they create a sense of porousness.

AG I think Space Station is more positive in that respect. It is the model for Stephen Hawking's recently declared vision for the future of human life, a habitat in space, with each window seen as a view on to the cosmos. *Allotment* is quite severe in its articulation of the human desire to live in higher and higher densities but to have less and less to do with each other. I did a little bit of a survey on the demographics of this trend, and the number of single bedroom apartments that are being built in Western cities. It does seem that people want to be very close but at the same time to have nothing to do with each other. That is a very trite way of interpreting *Allotment*, but there is a sense in which that hidden interior is acknowledged and celebrated by the absolutism of the concrete overcoat. It is hermetic in every way.

I am very interested in how you can translate the physical presence of somebody through measuring them very precisely, as in *Allotment*, or through registration by moulding, as in *Domain Field*. Even when transforming their physical presence into the language of architecture I still believe that

Antony Gormley, *Allotment II* (detail), 1996
Antony Gormley, *Space Station* (interior detail), 2007

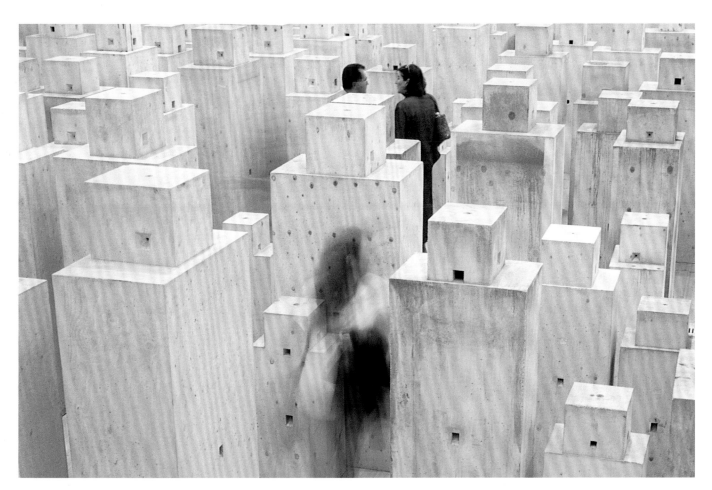

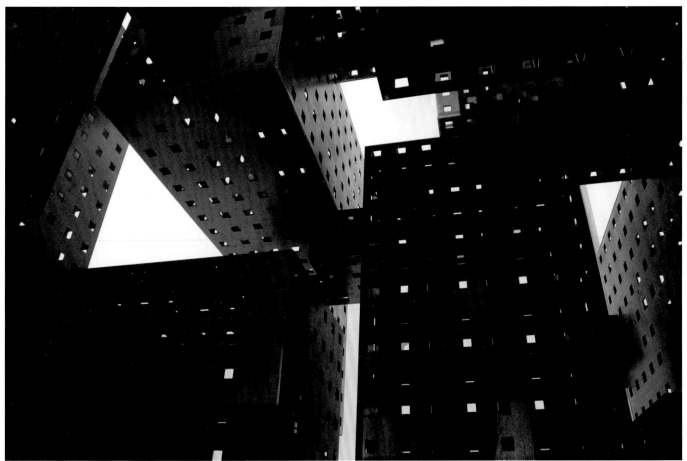

an empathic viewer can derive some feeling about the original subject, even at that degree of alienation. This may be wishful thinking on my part, but certainly in the way that I am distributing the elements in *Allotment* it is not very difficult for people to tune into the associations, the family romances or the relationships between children, between child and mother, mother and father, father and lover. In every block of *Allotment* there is a family romance.

RR *Allotment II* presents a field or maze of these block-like forms that the viewer has to navigate over time, and which, like a city, acts as a framing device for how we see the space around us and perceive the bodies of other viewers.

AG Yes, the journey you make through this landscape is itself the subject of the work. It is a labyrinth, an internalised ghost town.

JK *Allotment* could also, to some extent, be seen as a cemetery, as rows of headstones.

AG Yes, the structures are like vertical graves.

RR Partly because your figures are constructed as encasings — whether as a mould of your body or someone else's — they evince a sense of absent life that implies a connection between representation and death, recalling the argument that the corpse was the first sculpture, the first object to which a trace of life clung.

AG I think that to me the power of art is the fact that it is not life, but exists in a different time. And by accepting its inertia, its silence and its mineral nature, it can in some way give us a context in which our own vitality is amplified. I am more interested in meditation in a graveyard because it returns you to life with a greater awareness than, say, looking in a mirror.

The proliferation of the visual in advertising, video, cinema and television focuses us on the

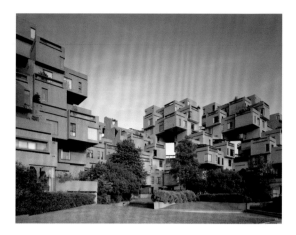

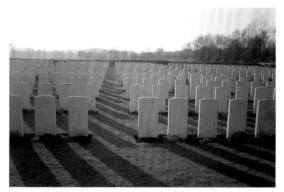

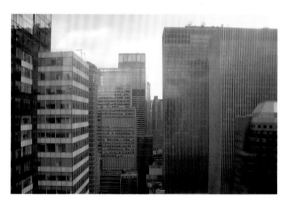

Moshe Safdie, *Habitat*, Montreal Expo building, 1967, Quebec, Canada
First World War cemetery, Ypres, Belgium
Manhattan, 2005

spectacle of life and its superfluity of energetic self-projections. Commercial imagery reinforces the notion that there will always be more, or that if you bank at this place or buy that car, you are going to be fine. The job that art continuously has to do, on the other hand, is to undermine those complacencies. I see my work as trying to counter that in some way and trying to undermine the engendering of desire for possession, for action, for experience.

So part of this voiding in the work – the voiding of subject, of gesture, of drama – is about trying to provide a context for just being, for reinforcing the being of the viewer. The work is, I believe, always trying to be a kind of flat surface, like a plinth or a platform, for the viewer's experience.

RR By removing the figure in your more 'environmental' sculptures, you succeed in foregrounding the experiential nature of your work, and the way that it speaks to experiences of uncertainty. I wonder how much that current goes through your work – what kind of uncertainty you're interested in and what the boundaries are for uncertainty?

AG I think this whole question relates to some very early experiences in my life. I can remember as a child going to school on misty, dark mornings and looking out of the windows on the train on to that condition of early morning dawn light, watching the illuminated windows of the houses and thinking: that could be my bedroom, that could be me waking up.

That was a very powerful experience of the total arbitrariness of why this particular human life should have landed in this particular human body (with all its dependencies) at this time. That's still the fundamental mystery: why are we the way we are? Why do we have the names we do, live the lives we do, or have the affection for apples that we have? It seems arbitrary and extraordinary. Yet we cling on to this notion of particular identity in the same

way that we cling on to this notion of location in architecture.

I think another fundamental experience for me as a child was being sent to bed far too early, of being in a body that was completely conscious but being told that I wasn't supposed to move. Going into this zone of sleep that wasn't sleep, lying there awake with my eyes closed in a space that at first was terrifyingly claustrophobic and small. Being forced to stay in this matchbox-like space behind my eyes, and then finding the space slowly expanding, becoming colder, becoming edgeless. And in the end just floating in this indeterminate cold, dark but limitless space that was somehow where I lived – the space of my life. This repeated phenomenon amplified my sense of the arbitrariness with which human life and consciousness is sewn into the material world.

RR So then, very generally, would you say that the purpose of art is not to reflect the world but to tell the truth of our situation within it?

AG I think that we are extremely incidental and our position is extremely vulnerable. It is a very dangerous illusion to think that art can have a moral purpose. I don't know how it can impinge on our notions of personal choice and freedom, but if we were allowed to feel more vulnerable and less certain about the fact that the sun is going to rise tomorrow and that there will be enough air to breathe and that we will have fresh water, we might behave more responsibly.

This conversation took place at Antony Gormley's studio on 10 January 2007.

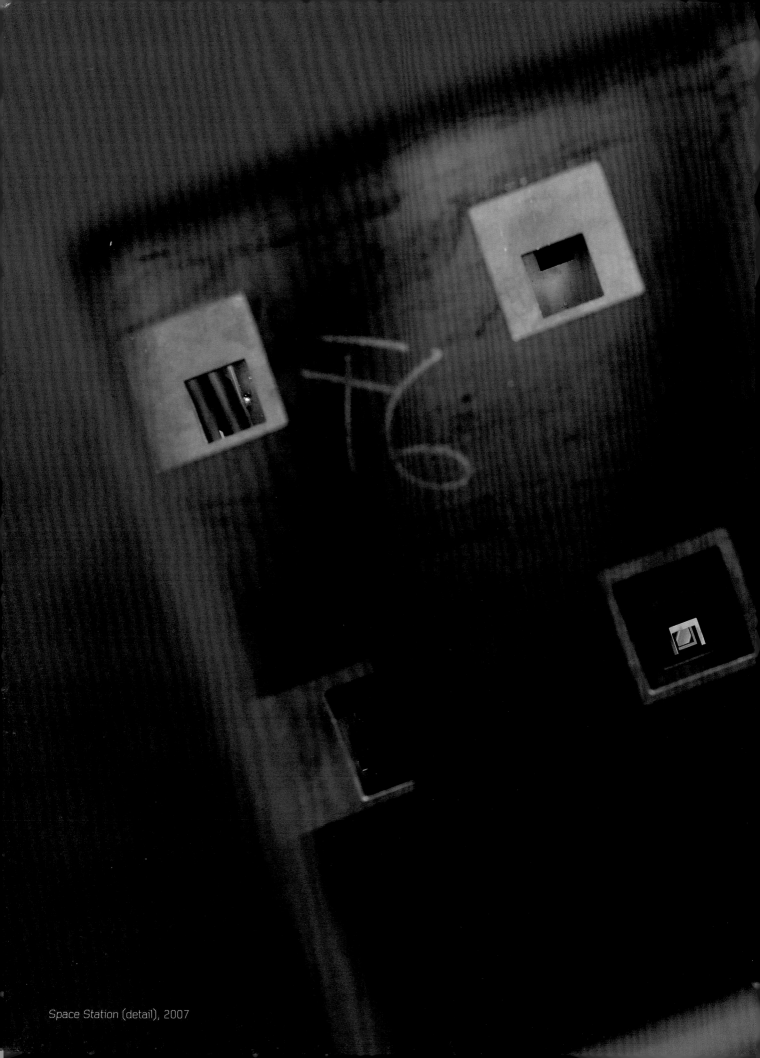

Space Station (detail), 2007

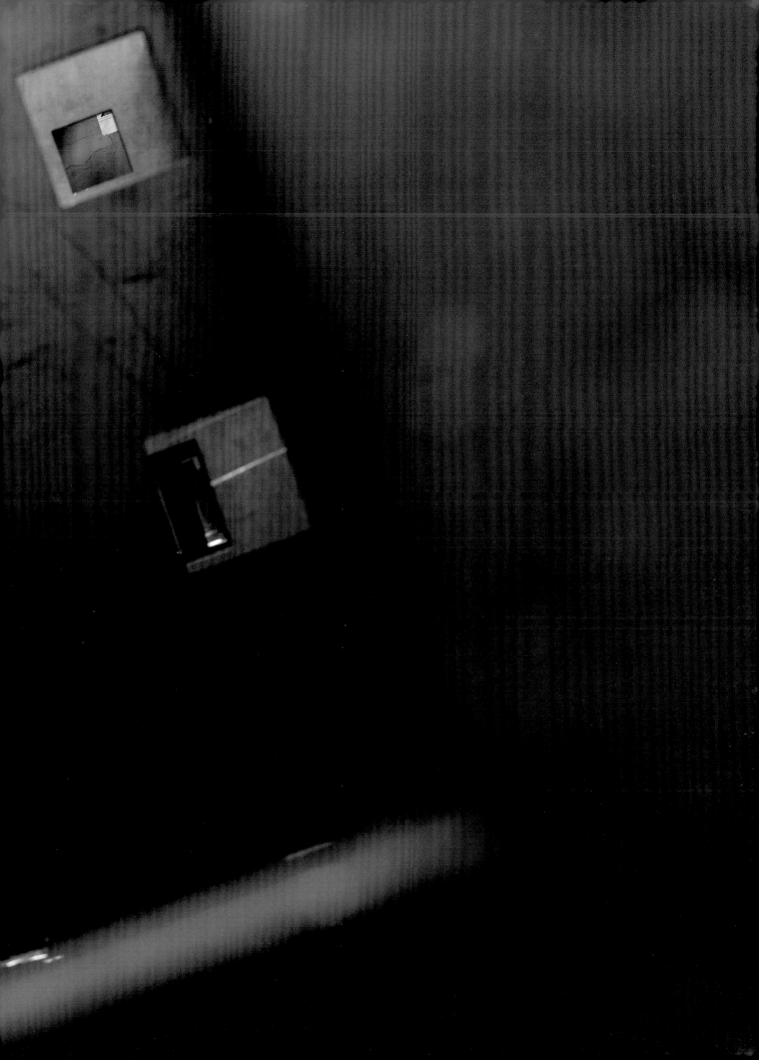

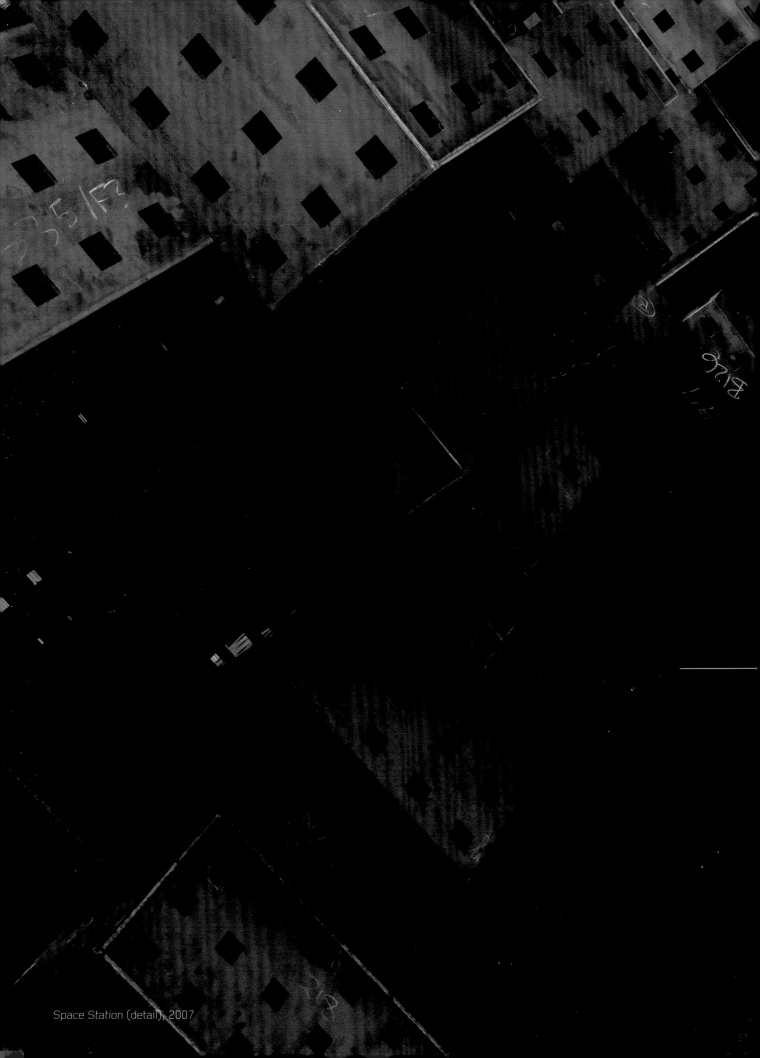

Space Station (detail), 2007

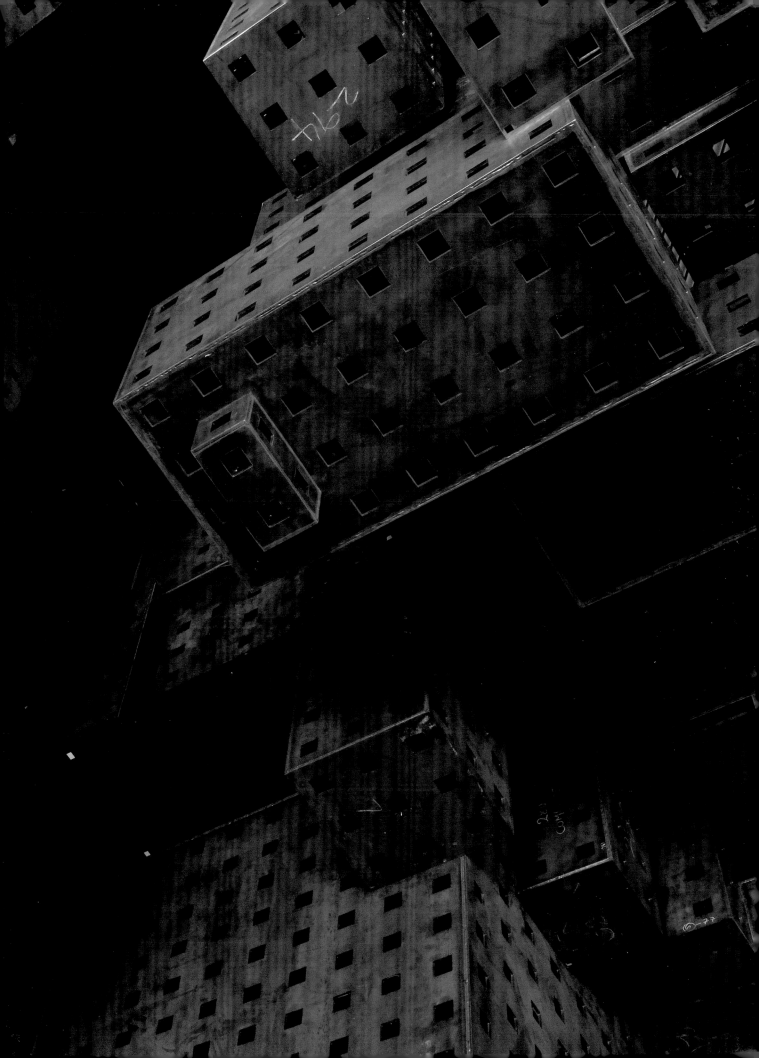

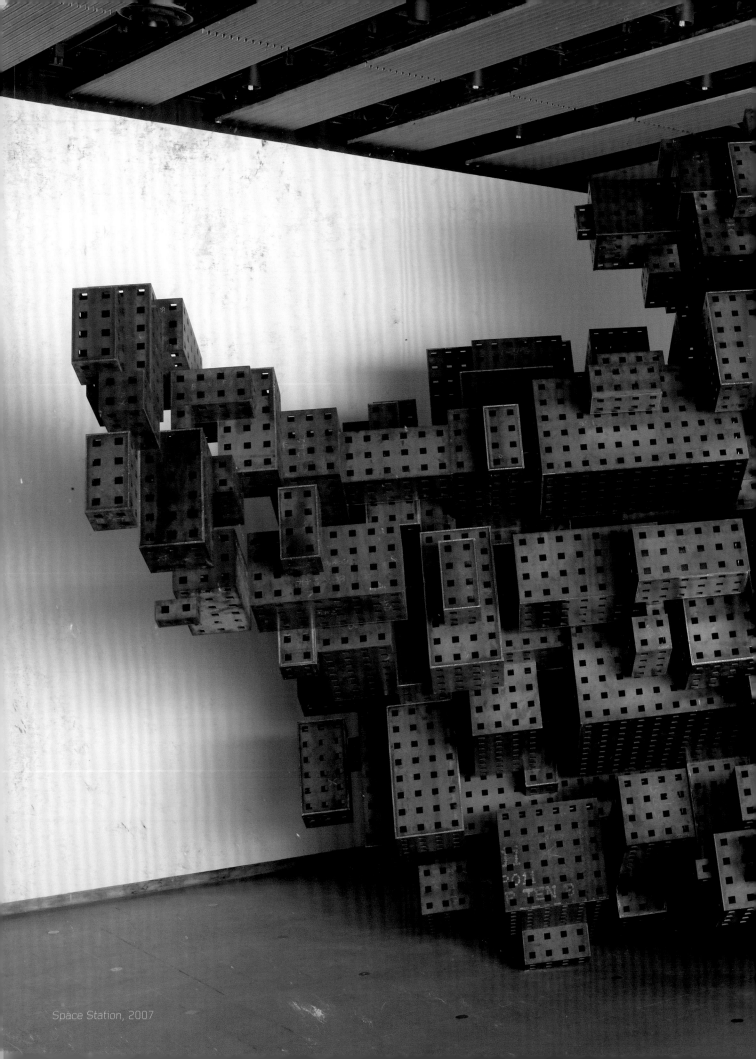

Space Station, 2007

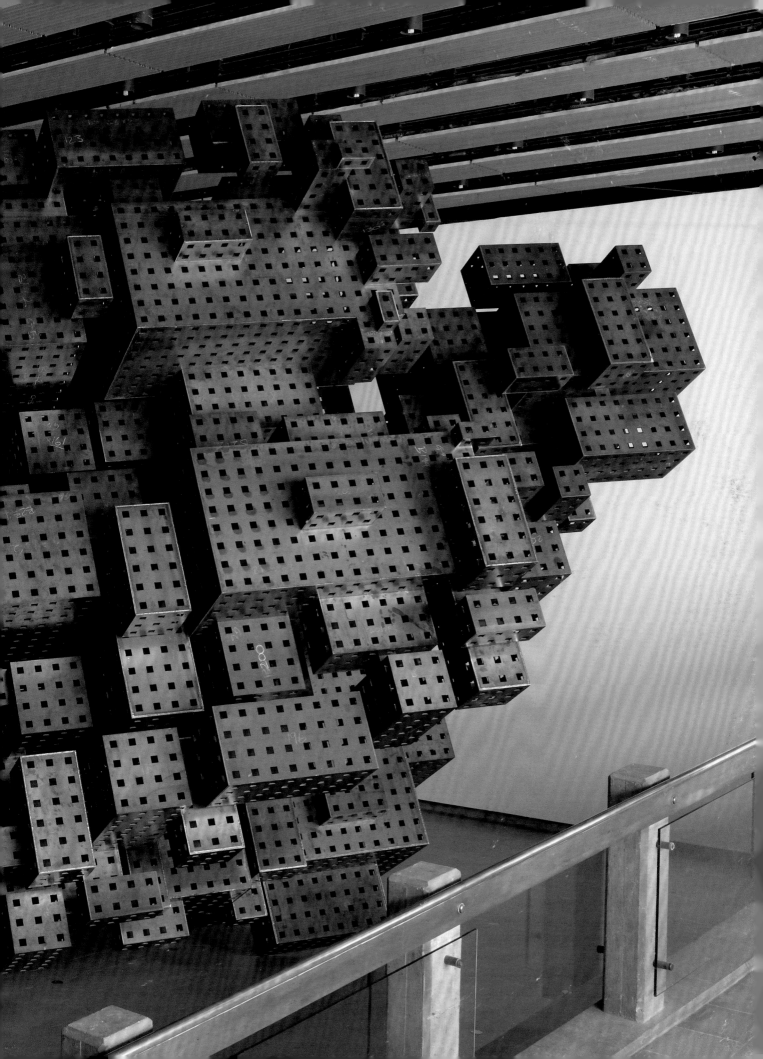

Habitat, 2005

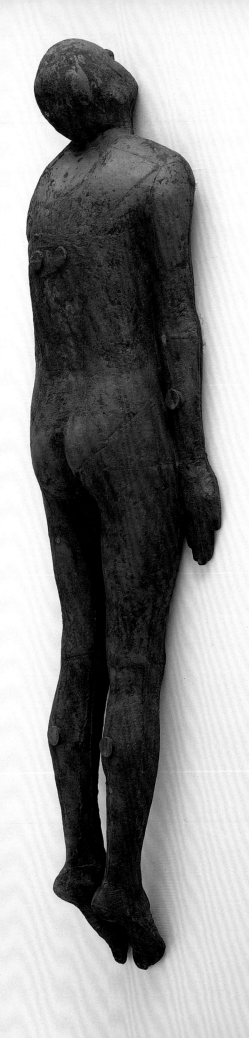

Shift II, 2000

Shift III, 2006

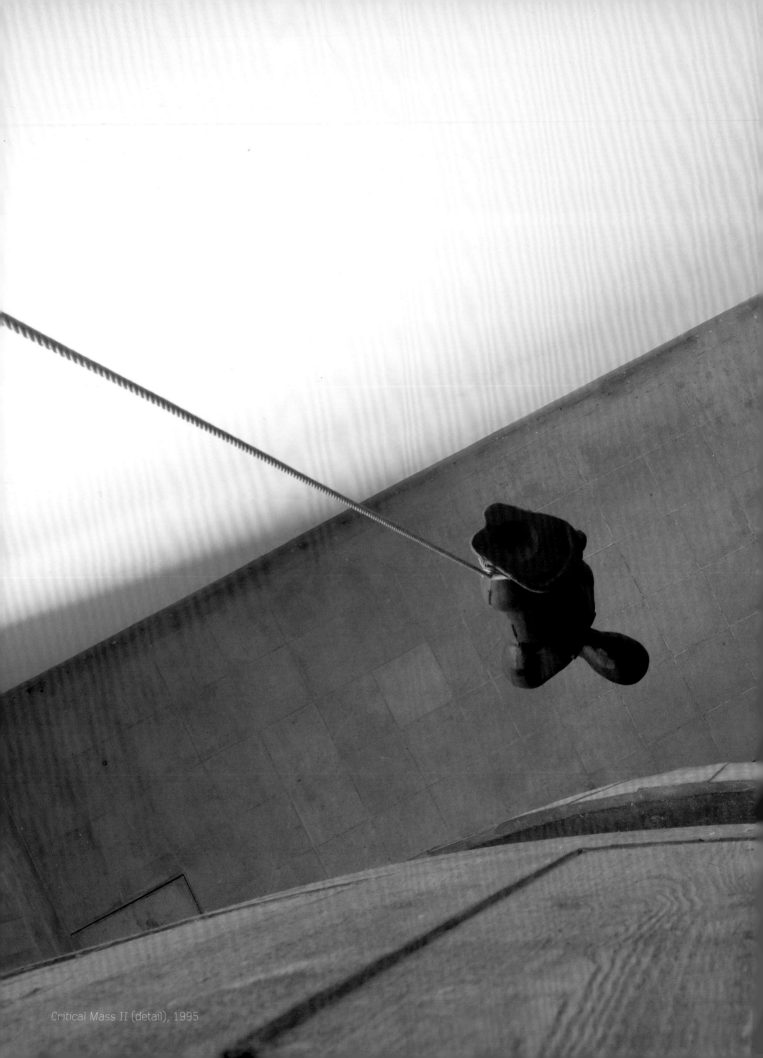

Critical Mass II (detail), 1995

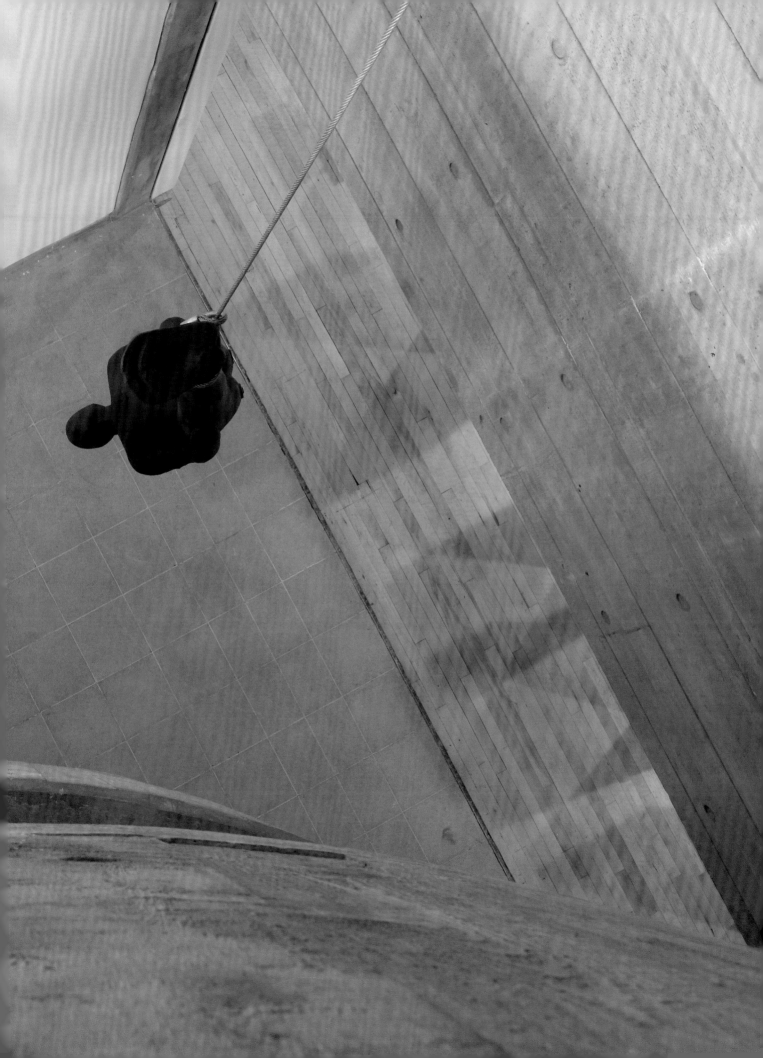

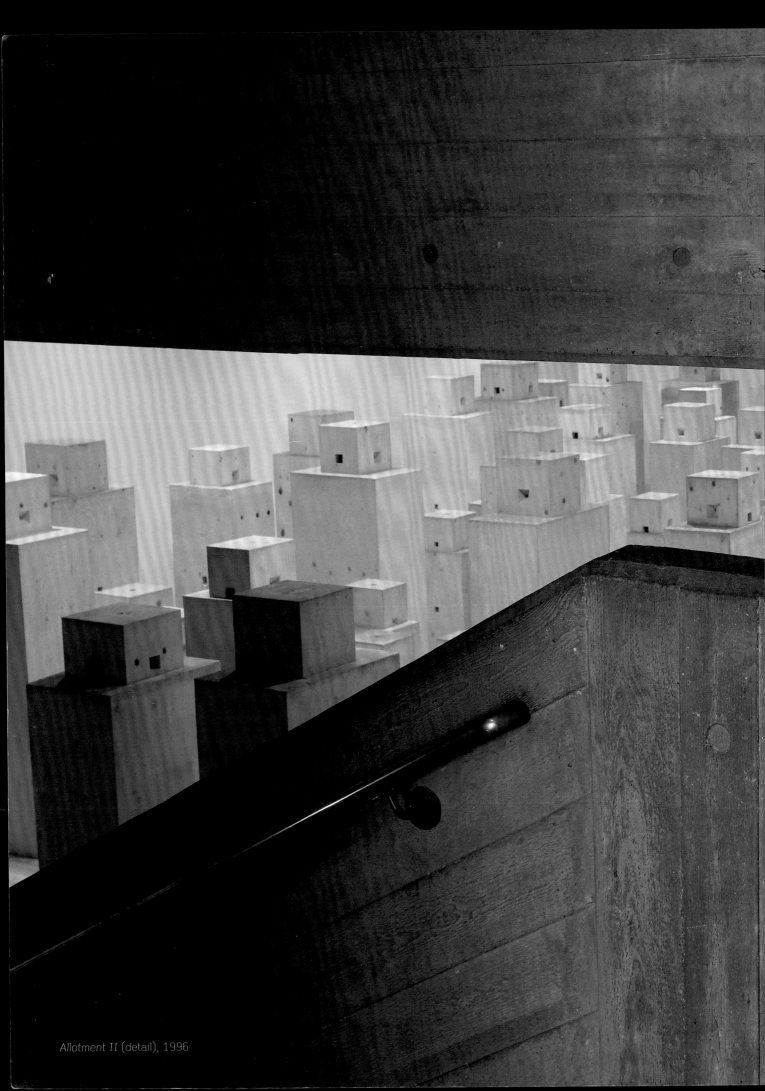

Allotment II (detail), 1996

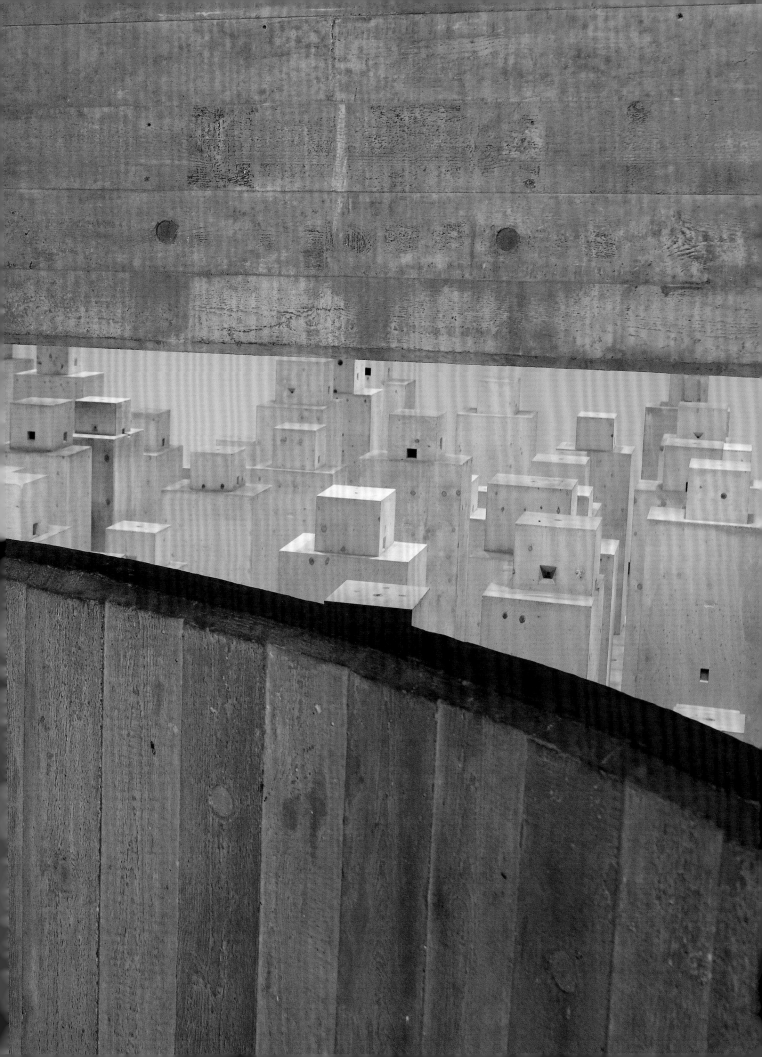

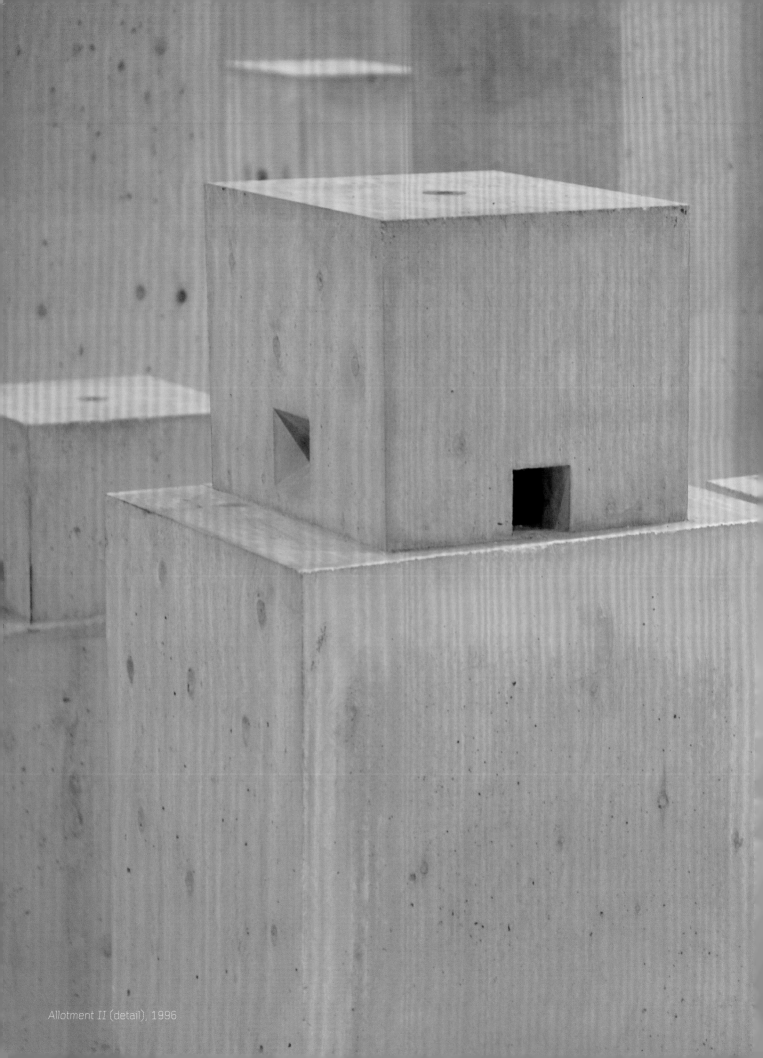

Allotment II (detail), 1996

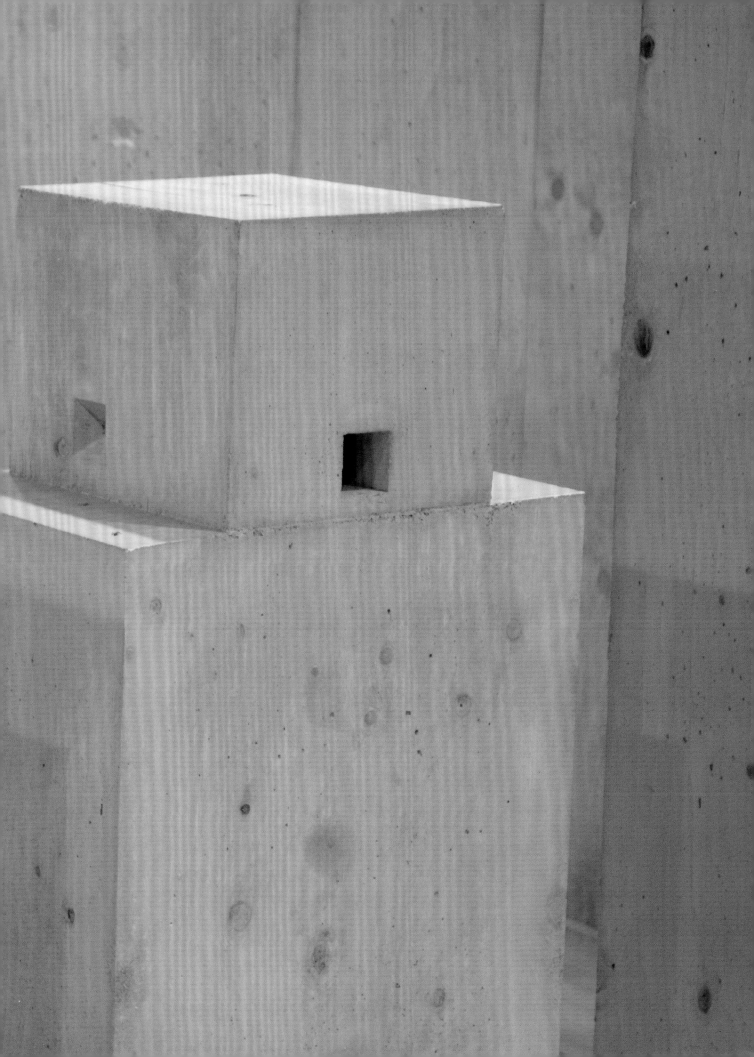

UNCANNY SCULPTURE
ANTHONY VIDLER

The figuration of the human body in sculpture has always held within it something of the uncanny. From ancient Greece to the present, the sculptural figure, whether considered as magical talisman to ward off danger or propitiate the gods, or more recently as the disturbing double or imago, has been seen either as a defence against, or an uninvited guest of, unseen forces. Romantic philosophers identified the presence of the uncanny in early Greek sculpture: Schelling writing of the sculptures from the Temple of Aphiai at Aegina, saw in their attempt to configure a representation of the gods in human form, 'something extra-human or non-human – something strange,' that he qualified as a 'certain uncanny character.'[1]

It was Freud, however, who unearthed this ancient feeling of anxiety for the modern, secularised world. Writing during the terrifying years of the First World War, he was concerned to identify this feeling of slight unease, as against stronger feelings of terror, in Western literature and art; what had been a simple enough evocation of nervousness in the stories of E. T. A. Hoffmann became, in Freud's hands, a developed theory of anxiety and a grounding of the general aesthetics of the 'sublime' as espoused throughout the nineteenth century. Freud associated the uncanny with fear of castration, the death-drive or the desire to return to the womb, and found it in the terror of the evil eye, the fear of loss of sight and, above all,

the double. The definition he employed was that of Schelling – the uncanny as 'something that had been repressed but which suddenly returned.' The shock of 'return' was especially associated with the double, or the doppelgänger: the sudden apparition of the ghost of the self.

Over the last two decades, the sculpture of Antony Gormley, fabricated out of casts, actual or abstracted, of the human figure, has explored many of these aspects of anxiety, placing his (or by extension, our) doubles in spatial juxtapositions and extraordinary positions that stimulate that sudden shock of realisation associated with the uncanny. From figures in space to figures making their own space, his work has gradually developed to encounter, then embrace, and finally to construct what we would call the 'architectural' in its broadest connotations. This encounter of sculpture, of the cast figure with and in space, itself produces a new kind of space: one that, rather than waiting to be occupied by human presences, as in traditional architectural space, possesses all the attributes of occupied space from the outset. Thus occupied this space is, in the deformations that stem from Gormley's figural positions, a space of uncanny dimensions: a 'double' space that disturbs precisely because it proposes an occupation before our own subject-inhabitation, and an occupation that further responds not so much to any possible occupation we might imagine, but one of ourselves distorted, positioned and transported into a world that would be, in everyday life, unimaginable.

In this exhibition Gormley activates a range of bodily–spatial intersections, some drawn from his

1 Schelling, F. W. J. von., *Philosophie der Mythologie* (1842), Wissenschaftliche Buchgesellschaft, Darmstadt, 1996, vol. 2, p. 654.

earlier work, some entirely new, in order to pose a set of inserted spaces within the constraints of a pre-existing architectural matrix to evoke the potentiality of alternative modes of spatial and bodily occupation. Against the strict and regulated interiors of late Brutalist architecture, with its enclosed sequence of dark and artificially lit concrete-walled volumes, Gormley has constructed an 'other' architecture formed of space-filling and space-articulating sculptures, each moment in the sequence both resisting and extending traditional architectural codes.

Figural Space: *Drawn* (2000/07)

The figures, for surely they are figures with their splayed legs and outstretched arms, are pressed into the corners of the room, for surely it is a room, with its four white walls, top-lit ceiling and painted white floor. Four of the figures lie awkwardly on the floor, their arms and legs following the right angles of the corner; four others defy gravity and press themselves into the corners of the ceiling. All eight are geometrically distorted to align with the right angles of the corners. Closer inspection reveals that they are all the same figure, deployed in different ways as if to emphasise the geometrical coordinates of the room. The room is white, the figures black, and taken as a whole composition, the figures construct a space within the space of the room, pointing towards each other from their corners, sometimes with their legs, sometimes with their arms, as if intimating an organic interior to an otherwise abstract exterior.

The apparently effortless appearance of these contorted figures in the space, their clear geometries and their seeming obedience to the laws of its geometry, however, belies the radically contradictory nature of their presence. For in a number of fundamental ways, some concerned with architecture and others with sculpture, these figures contest the commonplaces of both disciplines.

Firstly, the traditional role of architectural space is to house the human body; its dimensions, its scale, its relationship to the vertical and horizontal, its enclosing surfaces, are all calculated to enclose, shelter and comfortably accommodate the figure,

whether upright and still or in movement. The grid of top lighting in the space under consideration affirms this role, attesting to the difference between surfaces used as floors, walls and ceilings. When architects design spaces, they trace their outlines in three dimensions with these distinctions firmly in mind; they attribute roles to their surfaces according to imagined bodies, upright, standing, walking or running, circulating through and utilising their spaces, in a virtual enactment of future occupation. Architectural space is, in this sense, constituted, stabilised and given authority by reference to such bodies.

Here, however, the bodies are suddenly displaced from their proper spatial role, into a space that no architect (unless designing according to gravity-free rules) could imagine. The position of the eight figures indeed challenges all regular coordinates of verticality and horizontality, constituting an alternative space within the regular architectural space, one that turns incessantly in every dimension, thus placing our own observing and participating bodies (subject to the normal rules of architectural space) in precarious suspension.

Secondly, these figures are placed in conscious opposition to the normal rules of architectural perception. These rules guarantee that surfaces are recognised as walls, floors and ceilings in relation to their vertical and horizontal intersections – the lines, so to speak, that are delineated by planes coming together at right angles. But these figures accentuate a little-observed aspect of spatial geometry – the interior corners. They act as markers of the points from which this geometry is projected, the origins of the lines articulating the intersection of surfaces. As such, they are markers of normally unseen and unnoticed spatial origins – much as if they were the residue of the architect's drawing techniques, the little crosses that allowed for the setting-up of the projection in the first place. And while outside corners – like the much discussed corners of Mies van der Rohe's IIT buildings, with their careful representation of intersecting steel members – are often inspected in architecture as evidence of the architect's mastery of formal and technical demands, inside corners

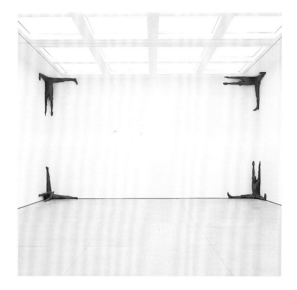

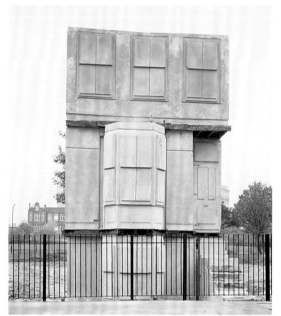

are generally overlooked, more the difficult repositories of dust and the uninhabitable realms of the space than any contribution to its architectonic value. And it is this very uninhabitability of the inside corner that the inserted figures challenge, as if they had quite comfortably taken up residence in a space normally forbidden to the body.

Thirdly, these figures are to all intents and purposes bodies, or rather those surrogates for bodies generally called sculptures. Here it is that a second set of conventions is defied. For the classical Western figure sculpture, like the classical Western body, is upright, and defines a space for itself much like the body it represents, an all-round space implying possible movement and calling for the rotating movement of the spectator. It was Adolf Hildebrand in the late nineteenth century who first considered the demands that sculpture places on space and, hence, on the observer. Distinguishing between the spatial implications of bas-reliefs (frontal vision) and freestanding sculptures (all-round vision) he set out the grounds for a modern spatial psychology, one that would take hold in all the arts after 1900. These figures, however, are pressed into service to the space: they conform to its geometrical demands rather than posing their own, and they certainly cannot be seen in the round. They, then, are certainly not sculptures in the classical sense, despite their apparent realism. In this context our figures demand an impossible space both from the viewer and for themselves as sculptures: fully in the round yet pressed into the wall as bas-reliefs, they allow of no circular motion around them, constrained as they are to the geometrical limits of the space they both articulate and are bonded to.

But of course, we know that these figures are in fact not sculptures, modelled or carved in the traditional sense, but figures resulting from casts of actual bodies, in this instance of the sculptor himself, and thus positive replicas of the negative hollow space left by a body that once occupied a plaster cocoon. And where casting might be a recognised sculptural technique, it is generally a process that reproduces a solid model, and not a living, breathing body the absence of

ANTHONY VIDLER

Antony Gormley, *Drawn*, 2000, White Cube², London
Rachel Whiteread, *House*, 1993, London

which creates a void filled by the molten metal.

Here a solid reproduces a void, much in the same way that, say, Rachel Whiteread's *House* (1993) cast the negative imprint of a space in solid impermeable form. Perhaps these figures are, so to speak, the expelled inhabitants of such a house, inhabitants of a world in reverse. Architects in the modern period have often imagined 'space' as a positive entity to be sculpted and moulded as if in clay or plaster – Pier Luigi Moretti even cast models of classic buildings demonstrating the properties of space in a three-dimensional figure–ground reversal. Gormley's figures are somewhat of the same genre, with the exception that they are deployed in real space, articulating in this way a strange dialectic between inside-out and outside-in.

The great puzzle for the German art historian J. J. Winckelmann was how to get inside a sculpture. Obsessively he would circle the body, calibrating its convexities and concavities, sometimes heightening the effect of the shadows by using candlelight, always asking the mute stone for an answer to the interior meaning, the 'ideal' of human figuration exemplified by the outer surface. How else, he reasoned, could the Greek sculptor have achieved such perfection in the imitation of the figure, if he had not held in his mind some ideal model, which, imprisoned within the block, might be revealed by his work? Later critics drew the comparison between the sculpture and the equally mysterious mummies being disinterred in Egypt. One might imagine that the ideal inner body was hidden within layers of cloth and wax, as if one could peel the sculpture like an onion to reveal its hidden perfection. Gormley, by casting his own body, has in a way duplicated and articulated this analytic perception, but now again in reverse mode; the ideal starting-point of the sculpture is real, and its cast intimates an ideal that is ever embedded in the living model.

Infinite Space: *Another Place* (1997) / *Event Horizon* (2007)

The figures, their backs turned to us, are spaced in irregular lines across the field of view, their feet in the water, their multiplied dark forms stretching towards the horizon. Neither bathers nor a holiday crowd by the beach, they seem more like observers, keeping watch for the appearance of something that we might miss through inattention or lack of time. They are timeless and will evidently watch for us through eternity, their shadows seamed on the folded surface of the water by the setting and rising sun. We have the impression that even if nothing should appear, they would still be standing, like primitive dolmens, those standing stones that Hegel saw as the origin of architecture, the first columns, symbolic of the figure later to be sculpted in the classical age.

The self-conscious placement of figures in the landscape – whether as actors playing the part of a 'hermit' or 'monk' or as pictorial conventions in painting – was a favourite pastime in the late eighteenth century. As the critic John Barrell has reminded us, such figures, placed for aesthetic or historical effect, were in some way stand-ins for the figures that actually populated the working landscape – beggars, peasants, labourers – that would spoil the real view from the great house. Even as ha-has were invented to allow the expanded view of the landowners' territory, uninterrupted by inconvenient hedges and fences, so the figures in the landscape needed aesthetic control, scotomisation and re-engineering. There were some figures, however, that were less the fashion accessories of aristocratic picnics and more the projections of the individual's imagined self. Thus the mysterious observers depicted in Caspar David Friedrich's paintings of landscape vertigo with their backs turned to the viewer, in shadow, as if inviting the viewer to enter into their bodies and share the objects of their gaze.

In *Another Place*, the deployment of Gormley's figures across the horizon of the viewer's gaze, however, also produces the effect of a panorama, one that reminds us of the early nineteenth-century panoramas with their intimations of 360-degree

vision. In particular, we might see the image of Friedrich's painterly panorama of the solitary figure on the beach, his *Monk by the Sea* (*Mönch am Meer*, 1809). This figure is also turned with his back to us, almost a black shadow against the horizon of grey sea and turbulent clouds, inviting us, as with many of Friedrich's figures, to step into the picture and substitute ourselves for the shadowy presences that looked out at their infinite landscapes. In Gormley's picture, however, the isolated figure of the meditative Romantic subject is replicated in many figures; the individual replaced by the multitude, but a multitude composed of single individuals, each one with its own position in the picture, and a ready substitute for our own modern subject-hood.

Heinrich von Kleist observed of Friedrich's painting that one looked at its intimidating vastness as if one's eyelids had been stripped bare, marking the sublime terror of nature's infinity by the equally terrifying isolation of the individual subject. Now, with the sublime divested somewhat of its originating awe, we have company as we contemplate the universe; but yet a company still returning to its monadic origins, self-enclosed in the endless replication of single selves.

For this Hayward exhibition, Gormley has reversed the vision of his watchers. In *Event Horizon* the standing figures, mounted on the tops of surrounding buildings, look towards the gallery to form a perimeter of viewers, viewing the site of the exhibition. As a panorama, enclosing a broad urban circle around The Hayward, these figures at once silently guard and monitor the collective community of figures assembled within the gallery. Whereas in *Another Place*, we are, so to speak, outside the circle of the panorama, looking in and uncertain of the object of the figures' vision, now we are at the centre, the very object of the watchers' attention.

It was common in Roman building, and in its revival in the Renaissance, to stand figures of the gods and heroes on the balustrades of public buildings and private palaces. Looking out to the city or the countryside, these statues not only variegated the profile of the building, linking it

to the urban or rural landscape, but also in a sense protected the owner from harm, acting as sentinels and stand-ins in the same way as their modern equivalent, the surveillance camera, provides an artificial eye in the absence of the inhabitant. In *Event Horizon* Gormley has established the inverse of this outward looking presence, substituting a multiplicity of guardians overlooking and verifying the contents of the gallery. By implication this establishes the exhibition in a double circle, the first within the walls of The Hayward, the second deeply embedded in the city itself. If this were a Greek foundation, The Hayward would be the treasury and the ring of watchers the guardians of the 'polis'. In the modern condition, however, the appearance of these sombre figures, silhouetted against the sky, taking charge of rooftop after rooftop like so many alien bodies precipitated from outer space, gives pause to any sense of security. If the watchers are tied to their compatriots in the gallery, they are also occupying the city and controlling the space of the viewer – if not abrogating that space to themselves. Where are we in this equation, if not subjected to a gaze we cannot reciprocate, and that refuses to see us? In Lacan's words, 'The picture, certainly, is in my eye. But I am not in the picture.'[2]

Solid Space: *Field for the British Isles* (1993) / *Allotment II* (1996) / *Space Station* (2007)

In *Field*, the seemingly innumerable multitude of figures are pressed together in a mass – no one the same, yet all similar. Crude clay versions of the human with roughly moulded bodies, vestigial heads, and no limbs; but their eyes, deeply pierced, look mutely ahead towards us, seemingly inquisitive, perhaps appealing, calling for something from us, or even demanding, if not threatening. Their mass is certainly threatening, as it pours like some terrifying and endlessly enlarging blob through the spaces of the gallery. Indeed, the river of figures fills the space completely,

2 Lacan, J., *The Four Fundamental Concepts of Psychoanalysis*, Miller, J. A. (ed.), translated by Sheridan, A., W. W. Norton, New York, 1978, p. 96.

Antony Gormley, *Another Place*, 1997, Cuxhaven, Germany
Caspar David Friedrich, *Monk by the Sea* (*Mönch am Meer*), 1809

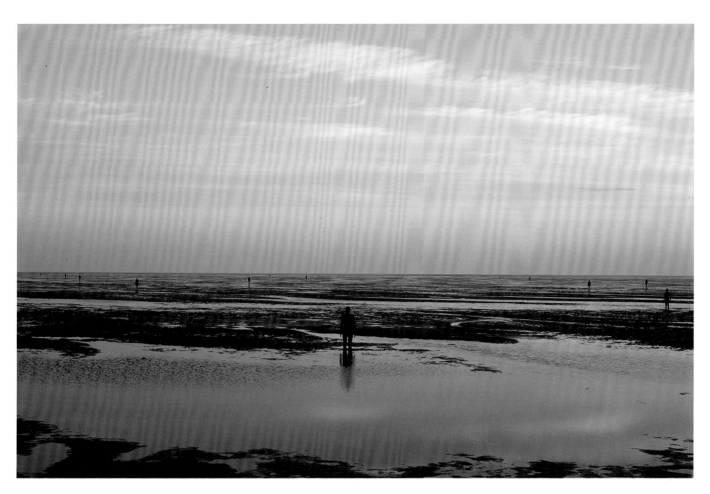

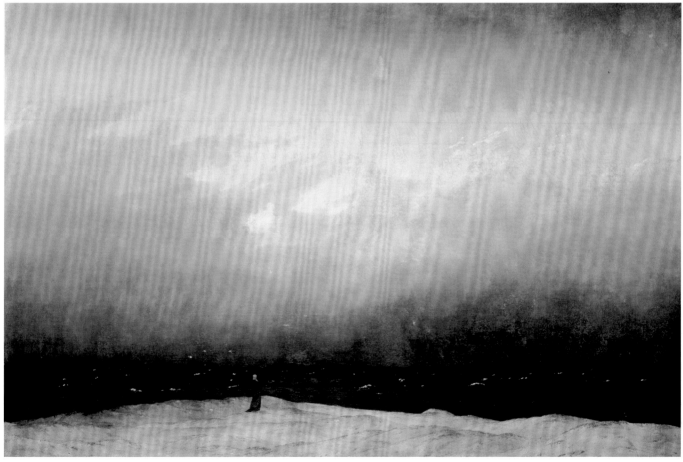

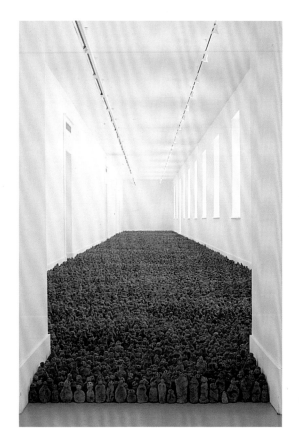

ANTHONY VIDLER

pushing against walls that can hardly contain it. Fired in clay, this mass has the air of a burial pit, the figures created to accompany some ancient ruler to the nether world. Yet the animation of the figures, some with head cocked to one side, others sunk in thought, still others looking steadfastly ahead, all gestures apparently intimated with a simple pressure of the fingers in the clay, gives us the sense that the mass is still very much alive.

We know the story of their making: a collective work, thousands made in a week by a whole village or community, the community replicating itself several times over and gathering itself together in miniature. This is then a collectively fabricated mass, a multitude with an origin. Assembled *en masse* in the gallery, this collective has the force to create its own space; if the traditional gallery is a void for the display of single works, then this is a gallery transformed into the negative space of a solid mass. Le Corbusier spoke of the fundamental elements of architecture as 'Volume, Mass, and Surface', and invented an abstract language where volumes became masses on the outside, articulated by their surfaces inside and out. Here the mass, constituting itself as an architectural force, has invaded the volume and, pressing up against its surfaces, challenges its solidity. Figures, the stand-ins for individuals, arrayed as a collective, have become architecture in and for themselves.

There are other figures of architecture in Gormley's work. In *Allotment II* these are figures literally constructed out of the dimensions of individual subjects, proportionally and geometrically formed as standing monoliths with cubes for heads and holes for ears, mouths and sexual organs. With no eyes to see but only orifices to hear, taste and feel, these figures inhabit their rooms, silently communing in space. Lacan spoke of the painful origins of architecture in the figure of Daphne transformed into a tree; here the body is rendered sightless and mute by its reduction, or rather return, to geometry. Like the monument erected in his Weimar garden by Goethe, that cube surmounted by a sphere said to be characterised by J. G. Herder as 'stone with a head on it,' they at once figure the origins of architecture and sculpture.

Antony Gormley, *Field for the British Isles*, 1993, IMMA / Irish Museum of Modern Art, Dublin, Ireland

In The Hayward, Gormley inserts two versions of these space-filling mechanisms, *Space Station* (2007) and *Hatch* (2007). *Space Station*, with the double implication of the name indicating its origins from space as well as its operation as a station-point in space, seems to grow from a single unit, as if a three-dimensional pixel had accumulated in order to fill a prescribed volume, with the sense that even this volume would be soon uncontainable within the restraining walls of the gallery. Like some uncontrollable phantom from an early horror film, now articulated as a precise structure of DNA elements, *Space Station* hovers in the first gallery of the exhibition, a warning that the space of Gormley's installation, however articulated by figures of a more or less humanoid form, and despite our knowledge that they are for the most part cast from Gormley himself, will not be entirely for our own occupation and enjoyment. *Hatch*, by contrast, takes up the regular coordinates of a spatial grid – the virtual grid that inhabits every geometrically defined volume – and makes them tangible in a forest of material lines. Whether or not the resulting space is actually inhabitable by a viewer, the struts and beams of this grid are clear indications that, to paraphrase Lacan, 'The space, certainly, is in my eye. But I am not in the space.'

Original Space

In each of these cases, the figures in the corners of interior space and the figures standing in exterior space, space itself has been reinvented by the self-conscious transformation of the body as a surrogate for the figure that, in the first place, constituted space itself. Here we might hazard the proposition that Gormley has, so to speak, retraced the origins of architectural space and in the process reinvented it for a present that has not yet fully appropriated, much less exhausted, the potentialities of that idea of abstract space we have called 'modern' since the end of the nineteenth century.

For the idea of architectural space was an essentially modern idea that emerged with force at the turn of the twentieth century, invested with all the power of a new psychology of the subject's relation to the object. Where the space of a Descartes or a Kant was stable, universal and mathematical in its certainty of position and placement, the space of the late nineteenth century was an uncertain realm of projection and introjection, relative at every moment to the psychic life of the subject; it was a space created by and for the subject, whether moving in dance or poised in momentary stillness. The *Spielraum* or space of play envisaged by Heinrich Wölfflin, was even given a history, as Alois Riegl traced the effects in art of the emergence of Roman distant vision from the haptic, close-up vision of the Egyptians and the middle-vision of the Greeks, each stage of development forcing a new viewpoint of the observer and thus a new form of appearance for the object.

In the context of our discussion, it is not incidental that this new idea of space was a direct product of the sculptural imagination. From Winckelmann's careful tracing of the contours and surfaces of classical sculpture in the mid-eighteenth century, to Adolf Hildebrand's analysis of the relation between vision, space and sculptural object at the end of the nineteenth, an idea of the space formed by and for sculpture developed that was to dominate spatial theory for the first half of the twentieth century. The sculpture, so to speak, stood in for the viewing subject as a surrogate, demonstrating the principles of spatial experience – Étienne Bonnot de Condillac's sculpture of sensations now animated by psychological forces.

From this new sense of space emerged a new history of architecture that authorised the attempt to constitute a new architecture. Out of the anthropomorphic tradition established by Vitruvius and confirmed by the Renaissance, a tradition given historicist dimensions by Hegel, was developed an idea of transcendent abstraction, one that overcame the particularism and nostalgia of the historical styles, in order to posit a universal language of form in itself. Critics have accused this vision of having abandoned the human, together with the figural symbolism that once gave architecture meaning. Yet whether Expressionist in its literal depiction of subjective movement or

Purist in its abstract intimations of psychic states, this architecture relied on the fundamental premise of a new subject. What has been interpreted as vulgar functionalism was in reality the sculpting of space around the hypothetical subject, but now with all its bodily attributes supplemented by recognition of its mental states.

With uncanny precision Gormley's figures re-enact these absent bodies, but in a way that goes beyond the simple re-introduction of the anthropomorphic into modern abstraction. Figures that are bodies, bodies that are casts of bodies, bodies that reformulate the spatial dimensions of inside and outside, are figures that make architecture in and by themselves, throwing our own subjective visions of interiors and landscapes into doubt, but also projecting them into new potentialities. Inhabiting Gormley's figures as subjects, we are, one by one and together, constructed as architects of our own spaces and thus invested with the analytical and constructive power both to think as well as to create space. That this space resists and is critical of the world as it is while proposing a possible world that is inclusive of, and reciprocally responsible to society and nature is perhaps the most we can hope for from sculpture today.

Blur Space: *Blind Light* (2007)

Each time the word *unheimlich* appears in Freud's text – and not only in the essay of this title, *Das Unheimlich* – one can localise an uncontrollable undecidability in the axiomatics, the epistemology, the logic, the order of the discourse and of the thetic or theoretic statements.[3]

Gormley goes one step further to contest the very limits of spatial definition in such a way as to dissolve the uncanny effects of sculptural installation and to transfer those effects to the nature of space itself. In *Blind Light*, he constructs space as a sculpture, making its form, normally virtual and only sensed through the forms of its

enclosure and occupation, tangible and tactile through the operation of light on moisture that is both space and space-filling. Here he reprises, with significant modifications, experiments in ambiguous space by architects over the last decade, first in the play of translucencies and opacities initiated by Rem Koolhaas in his competition project for the Bibliothèque Nationale in Paris of 1989 and, more recently, extended by the architects Diller Scofidio + Renfro in their installation for Expo 2002 in Switzerland.

In the summer of 2002 in the lake at Yverdon-les-Bains, Switzerland, the architects Diller Scofidio + Renfro installed a building constructed out of a steel frame equipped with thousands of small nozzles that projected droplets of purified water into the air. The result was, in the architects' words, a 'blur', or 'cloud' that hovered above the surface of the lake. Its form was ovoid in still weather, and elongated and distributed across water and land in windy weather. It was approached by narrow steel bridges across which visitors passed, dressed in plastic raincoats. Entering the 'cloud', visitors gradually lost all sense of open space, and were absorbed into the atmosphere of a palpable but opaque, translucent space. Bodies disappeared and reappeared; lights shone momentarily, then were blotted out; the stairs to the upper level were seen, now obscured. In this moist cloud, all confidence in the clarity of an architectural space was lost together with that of the visiting subject's body. All was absorbed into light and mist.

The building fundamentally destabilised the common version of architectural space as an open *spielraum*, a humanist playroom, or a functional layout, and rendered space as a positive rather than a negative force. The body, commonly reinforced by architectural space, was progressively lost and itself became a blur. 'Lost in space' became a reality, and the sense of disorientation accompanying a visit to the Blur Building was, for most visitors, a (slightly) terrifying experience. The emergence and disappearance of others in the mist, like the double glimpsed and then lost in a mirror, was disturbing, if not uncanny.

3 Derrida, J., *Archive Fever: A Freudian Impression*, translated by Prenowitz, E., University of Chicago Press, Chicago, 1996, p. 46.

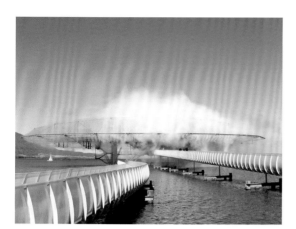

Five years later, Antony Gormley has taken this experience inside, enclosing it in a translucent cubic volume in The Hayward. But where the Diller Scofidio + Renfro installation was in the open air, subject to all the vicissitudes of wind, temperature and atmospheric pressure, now the experiment is controlled – with temperature and density held at a precise level and the resulting viscosity of the space-filling moisture – the captured cloud – constant. Bodies enter the enclosure, and are progressively lost to view, even as each body loses its sense of sight; the haptic sense replaces the optic sense, as if reversing centuries of visual evolution, and body and mind lose their way in a deliberately disorientating, coolly refrigerated and mistily obscure space. The coolness, the loss of vision and the impossibility of orientation all reinforce the artificial nature of the experiment. But unlike the Skinner Boxes of the 1950s, those black boxes for psychological experimentation, Gormley's installation plays with psychological themes without instrumental programme; rather the sensation of losing spatial coordination is experienced as a positive and enriching state – one that liberates the body from its normal conditions of responding to verticality, horizontality and clear boundaries. Sculpture and architecture here absorb each other with reciprocal cannibalism, to produce a space that is, in itself and for itself, truly autonomous; an autonomy that allows the body to assume an alternative state, half concrete, half virtual, and suspended between the two. Such a suspension, somewhere between the traditional 'utopia' of no place and the Modernist 'utopia' of 'good place', might conceivably provide the conditions for a re-thinking of both: an experience of 'neither/nor' in a way that, through its very ambiguity, opens a space for an uncanny that is no longer an anxiety, but a form of individual and social projection beyond the confines of the real. Here, the elusive figures in the cloud join with the watchers on the horizon as a virtual model of a possible urban contract: between those we know we are, and those we know we are not; between others and ourselves.

Diller Scofidio + Renfro, Blur Building, 2002,
Yverdon-les-Bains, Switzerland

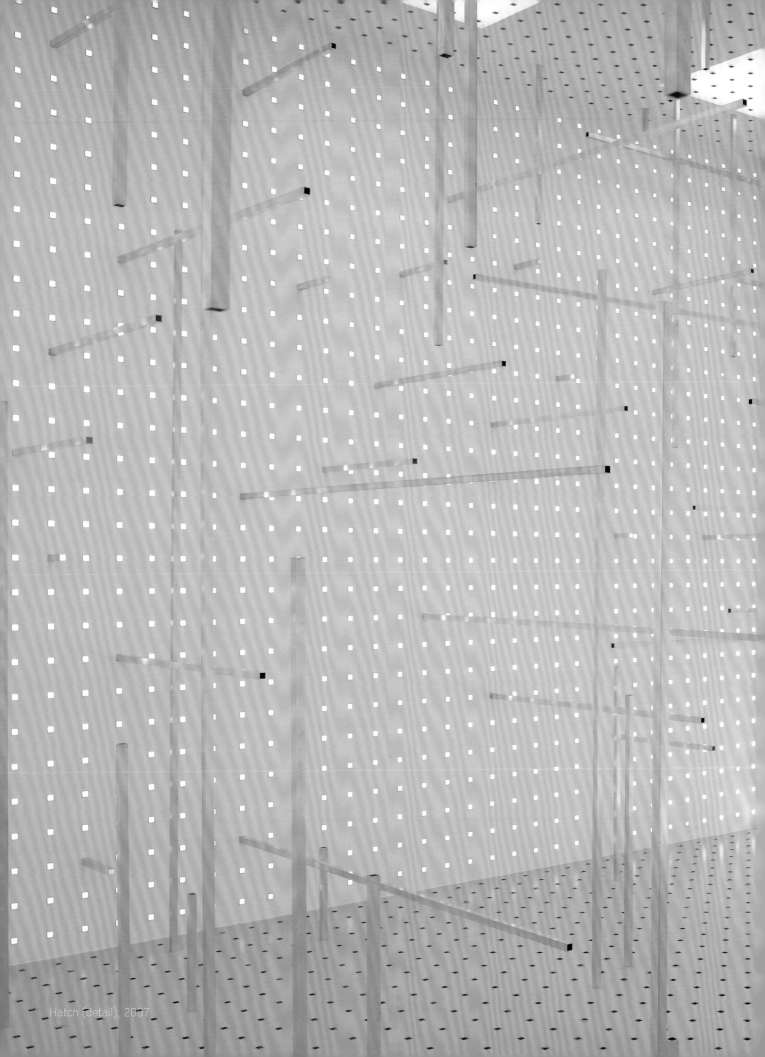

Hatch (detail), 2007

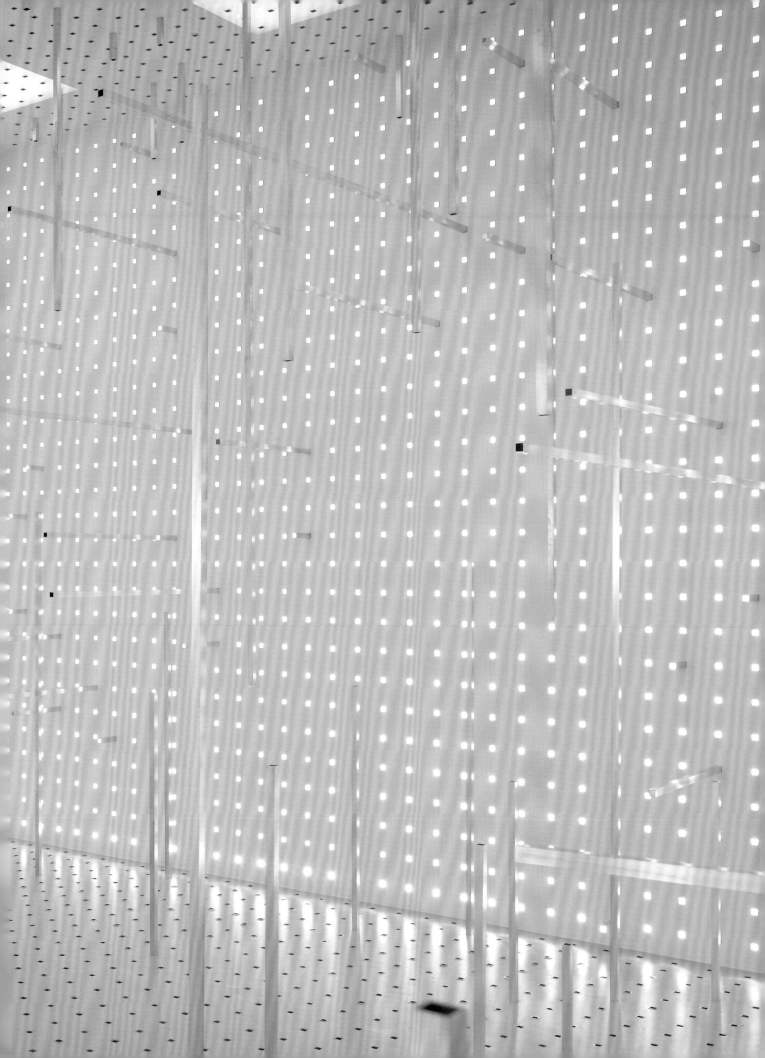

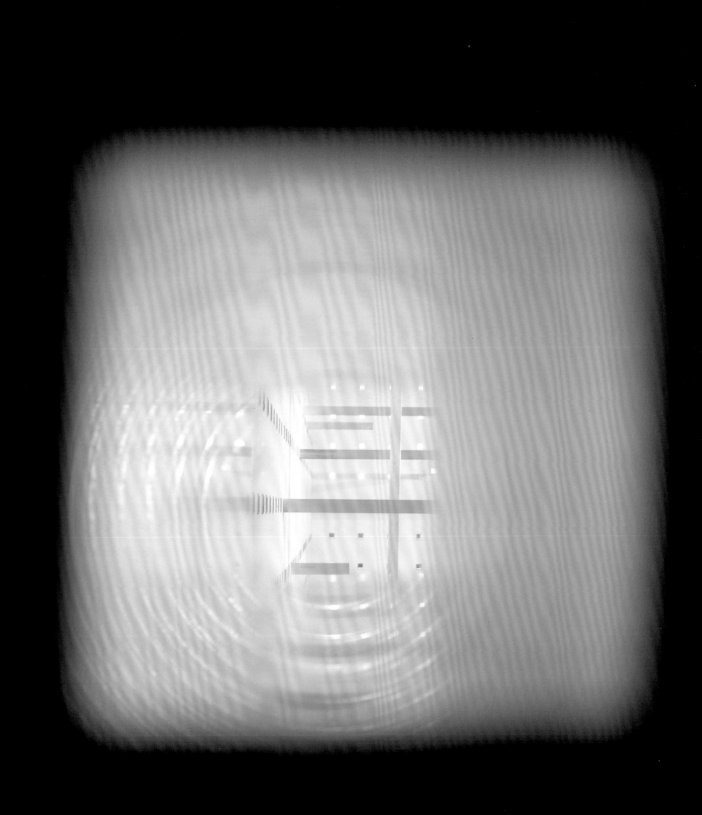

Hatch (details), 2007

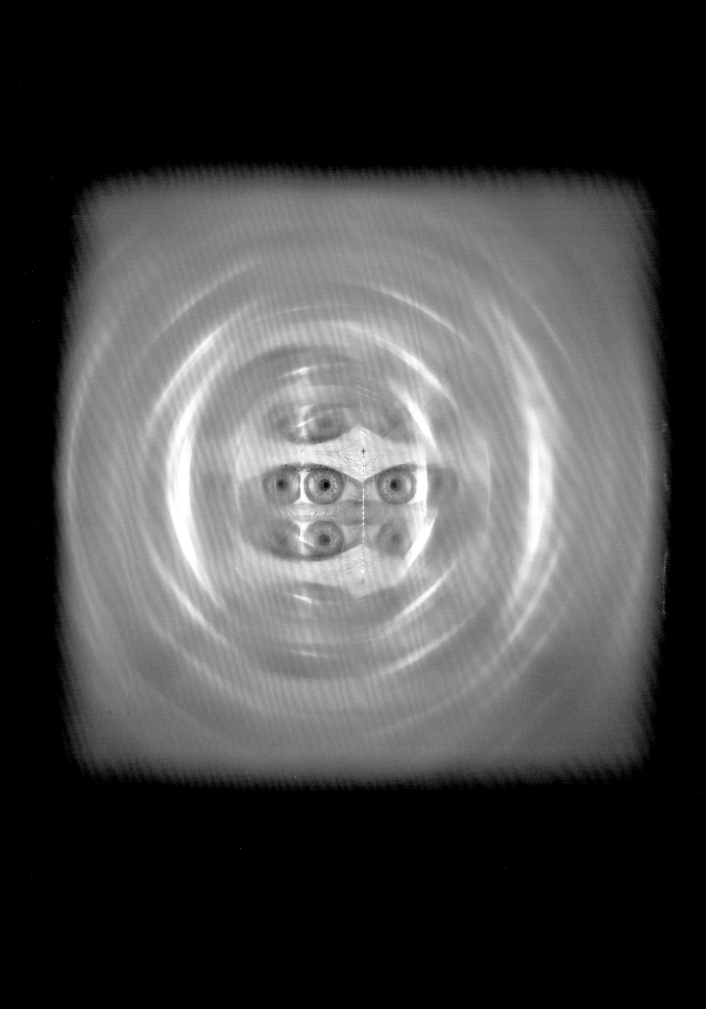

Floor, 1981

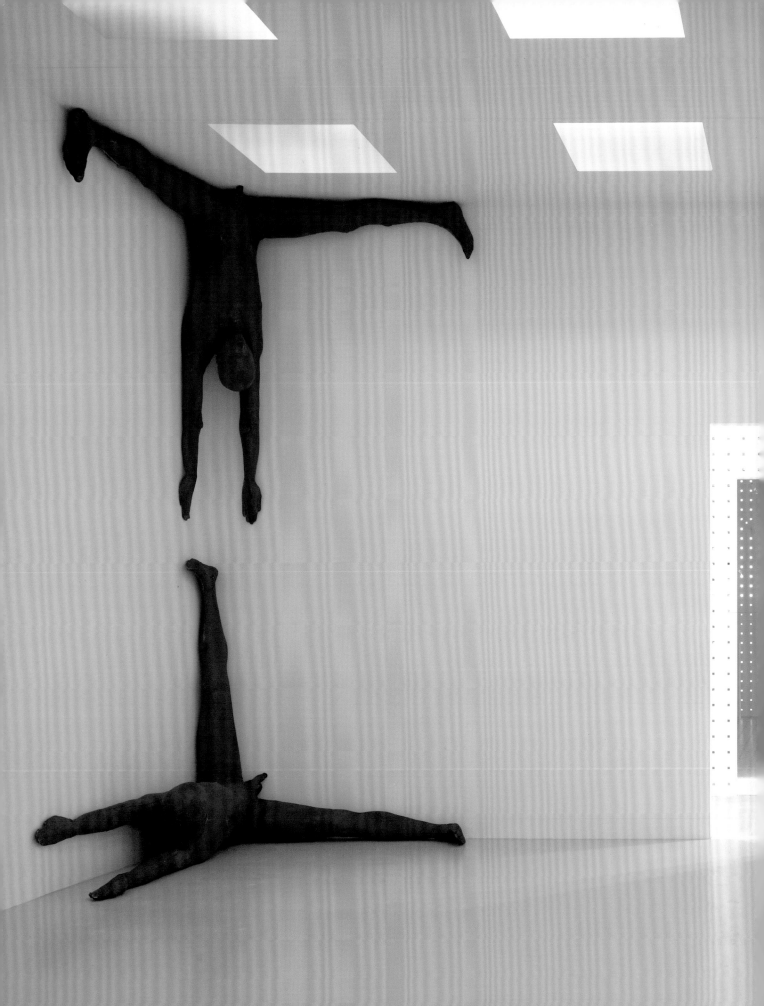

Drawn (detail), 2000/2007

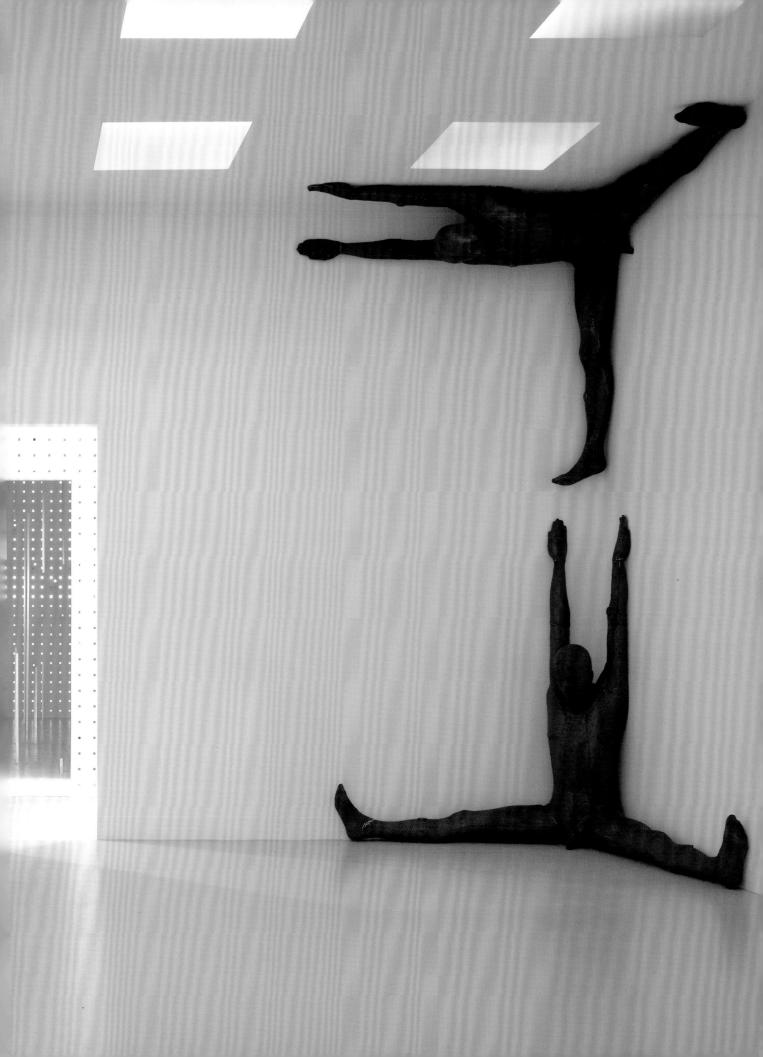

THE SCULPTOR AS FIRST FINDER
SUSAN STEWART

I
Undis, ignibus, aere
Pictum, gemmeum, & aureum
O sum, (scilicet, O nihil.)
Richard Crashaw (1612/13–49), 'Bulla' [1]

Abstraction is an inevitable aspect of perception –
not only in peripheral and nocturnal vision, for
example, but also to the extent that it is an outcome
of any view of a certain proximity or distance.
Yet abstraction is not a consequence of perception
alone; to the contrary, our capacity for abstraction
is what makes it possible to remove (*ab-strare*)
ourselves from sense-bound context and locate
ourselves in relation to the supersensible. In
painting, the advent of Modernist abstraction
freed artists from the necessity of representing
two-dimensional space as three-dimensional, as
it also made possible the actual transformation of
two-dimensional space into three dimensions:
painting became both colour field and relief
sculpture in the age of abstraction and that age
necessarily carried with it a discourse on sublimity.

But sculpture in the age of abstraction never
lost its phenomenal foundation and, to the extent
that abstract painting became sculpture, sculptural
values continued to pull all abstract art forms back,
or forwards, into the realm of the senses and the
density of matter. Sculpture inevitably suggests
concepts of appearance, presence and beholding.
Regardless of the changes Modernism brought
to the practice of sculpture, interiority, surface,
domain and, most profoundly perhaps, death and
animation remain crucial features of sculpture's
three-dimensional legacy.

As sculpture continues to mediate the
relationship between our physical being, the built
environment that shelters us, and the environment
of nature, it necessarily has worked between the
scale of the hand and the monument. Human
form remains the measure of all things, but issues
of abstraction bearing on the human figure become
particularly problematic since our terms for
abstracted persons – the collective, the community,
the crowd – all depend upon various individual
identifications. At its most positive pole, the
'human abstract', as William Blake called it,
is a matter of consent and collective, reciprocal,
recognitions;[2] at its most negative, it is a matter
of complicity and herd-like blind motion.

I begin this essay on the work of Antony
Gormley with these comments regarding
abstraction and identification because Gormley's
artistic practice is a concerted study of these
fundamental problems in sculpture, as it is also
a path-breaking exploration of the relationships

1 'Water, fire and air / Painted, bejeweled, and golden / O I am
(that is, O nothing)', Crashaw, R., 'Bulla' [Bubble], translated
by Reid, D., in *The John Donne Journal*, North Carolina State
University, 2005, vol. 24, pp. 297–302.

2 Blake, W., 'The Human Abstract' (1794) from *Songs of
Experience* in Erdman, D. V. (ed.), *The Poetry and Prose of William
Blake*, Doubleday, New York, 1965, p. 27. Of particular relevance
is Blake's notion of how 'the Catterpiller and Fly, / Feed on the
Mystery' and the last stanza: 'The Gods of the earth and sea,
Sought thro' Nature to find this Tree, But their search was all
in vain: There grows one in the Human Brain.'

between makers and made things. In this regard, Gormley's contribution to the subject–object problem in art is analogous to the contribution the phenomenologists have made to that problem in philosophy more generally – Gormley begins from deep within the experience of life and moves outwards to encompass more and more of the given world; there is no alienation between perceiver and object or, more accurately, artist and nature. Even on the scale of his perhaps most famous works – the monumentally singular *Angel of the North* (1998) and the monumentally multiple and handmade *Field for the British Isles* (1993) [see p.82] – there is no need for a discourse on sublimity, since the sense-bound world of matter remains the object of the sculptor's literal *métier*, his loom.

The mythical sculptor Daedalus is described in later Greek and Roman literature as a *protos heuretes* or 'first finder', for, as Diodorus of Sicily (1st century BC) writes in his *Library of History*, Daedalus was the first to show the living, open-eyed, quality of human beings in motion and extension. In Plato's Socratic dialogue *Meno* (c.402 BC), too, the living statues of Daedalus are described as being so remarkably lifelike that they are said to 'play truant and run away' if they are not tied down. Yet Daedalus also made the wax wings that were the ruin of his own son, Icarus.[3] Gormley is another *protos heuretes* as he sets out where Daedalus' myth of transcendence goes wrong. Gormley's work continually reminds us of our necessary submission to fundamental forces of gravity and magnetism, and of our elemental relations with sunlight, the tide and those molecular forms that we share with the most primitive versions of life and matter, such as yeast and crystals. His sculptures are earth-bound and heavy; their closed eyes sense the immediacy of the onslaught of sensory phenomena, the too-blinding

3 Herder, G., *Plastik* [*Sculpture*], Gaiger, J.,(ed. and trans.), University of Chicago Press, Chicago, 2002 (first published 1778). The epigraph to part II of this essay comes from p. 76. For a discussion of Daedalus as 'first finder', see Gaiger's editorial note on pp. 123–24, n. 13. For the skittishness of Daedalus' statues, see *Meno* in *The Works of Plato*, Jowett, B., (ed. and trans.), 4 vols, Tudor, New York, n.d., III, pp. 51–52.

Antony Gormley, *Angel of the North*, 1998, Gateshead, England
The Mausoleum of Qin Shi Huangdi, 3rd century BC,
Xian, China

light of that idealism the sun proposes. They are not representations of life, but rather part of life, drawn from within matter and emergent. To behold them is not to think of a person as a thing or a thing as a person; we, the observers, become the moving open-eyed forms who mediate between these figures cast from inward-looking bodies. We are able to follow a human intention carried out to particular ends and to view the continuity between artistic process and life processes. Casting, moulding, firing, framing, lowering and rising – the tasks of sculpture are linked to the thickening of hides and shedding of skins, the fossilising and unfreezing of motion in time, processes of birth and incarnation marvellous by virtue of being perfectly ordinary.

II

We are made wonderfully great, our bones have been numbered and ordered with care, our nerves woven together, and our veins made into torrents of life. We are made from clay, poured out like milk and curdled like cheese; we are clothed with skin and the breath of God gives us life.

Johann Gottfried Herder (1744–1803), *Plastik [Sculpture]* (based on Psalms 139:14, Job 10:9–11, Job 33:4–6 and Genesis 2:7)

Deep below the gallery spaces of The Hayward lies the 'plant room' where the institution's heating, air conditioning, plumbing and electrical systems are rooted. Each gallery is served by great aluminium ducts that continually extract, temper, filter and supply air. Like enormous Möbius strips, these channels seem to be all surface, yet they pulse and rumble with the motion of the air they contain. Meanwhile, the electrical system hums, the plumbing knocks and whooshes, and gridded fans squeak like a congregation of wrens.

A building – like a city or a universe – can have a heart and lungs, a centre and skin. And, as Gormley's 1996–97 work *Sieve* indicates, our own heart, lungs and other organs can be seen as living machines – sieving, pumping, hammering, funnelling, taking on the work that is necessary for life. Once we begin to imagine those processes that

move us and those processes we set in motion as continuous, the metaphysic of interiority and exteriority begins to dissolve, and creation is no longer a matter of animating what was lifeless. Expansion and contraction are the primordial motions of the universe and each Gormley sculpture or installation is a material meditation on the repetition of this breathing motion.[4]

At the same time, every Gormley work begins, and continues to find its centre within, the human body – frequently the habitat of his own body, for many of his works take their point of departure from plaster of Paris casts of himself that he creates, with help from others, through an exacting and physically demanding process. These casts are used as the core of works in lead, steel, aluminium and iron, with one hide replacing another. The word 'habitat' and its corollary 'habitation' come from the Latin verb for 'having and holding' and Gormley, like a caterpillar with a spinneret, is able to hold or encase himself or others at the premise of his work: each layer is held within another environment and awaits its expansion as internal phenomena are continually externalised. The lime used in the plaster that preserves these living forms is the same lime that breaks down organic matter. Our disappearing lanugo; our expanding, growing carapace; our confining sarcophagus: a womb, a bomb, a tomb – these frames are analogues in Gormley's sculptural thinking. In this art, energy is cyclically contained, released and recontained; birth and death are paired, just as motion is potential in stillness and rest in motion.

Whether architectural or figurative, made by various collectives or by the artist working with a few helpers, Gormley's works always begin in an act of inward-looking will and end in the standpoint of a viewer who is viewed while viewing. The moment of viewing as *punctum temporis* has been explored, of course – in texts from Leon Battista Alberti's *Della*

4 Gormley's experiences in the 1970s of studying the Buddhist meditative breathing technique *anapana* or 'mindfulness of breathing' with the Vipassana teacher S.N. Goenka, have been a key influence on the forms and effects of his art.

The Hayward's plant room, 2007

Pittura (1435) to Gotthold Ephraim Lessing's *Laocoön: An Essay on the Limits of Painting and Poetry* (1766) – and indeed has become something of a cliché in Modernist and contemporary art. Yet Gormley's sculptures, in their installed settings, emphasise that there must be a partial disassociation or distance between viewpoints or, in a kind of perceptual lock-down, there will be no means to witness any event or transformation. To hold a point of view is necessarily then to see the connection and diremption between that point and others. In this regard, Gormley's work returns us to a more basic perceptual issue explored in Aristotle's discussion of a point [*stigma*] in *De Anima* (c.350 BC).[5] Meditating on the irreducibility of the soul, Aristotle observes that a point, irreducible in itself, is nevertheless always a boundary; every singularity is also a dividing line. Similarly, while the *stigma* marks a site of terminus, it also is the centre of a set of radii. Is the stigmata of a saint, for example, the end of a motion or the beginning of one? The concentration of an array, or the initiation of radiance? A centre may seem to be singular, but each centre is also potentially infinite.[6]

A number of natural phenomena serve as models and guides for the geometry of Gormley's own points, sequences and surfaces. Among them, the living cell membrane, strengthened by its spherical shape and the fluid motion of its response to the watery bath that surrounds it; the spherical shapes of bubbles, which adjust to each other at points of attachment and undergo a

5 Aristotle, *De Anima* 3.2.427a9–14, in McKeon, R. (ed.), *The Basic Works of Aristotle*, Random House, New York, 1941, pp. 535–606; discussion of the point is on pp. 585–86.
6 My comments here are indebted to the extensive and insightful discussion of Aristotle's thinking in *De Anima* on the undivided and singular and its relation to the soul, as well as its legacy in the work of Alexander of Aphrodisias, in Daniel Heller-Roazen's *The Inner Touch: Archaeology of a Sensation*, Zone Books, New York, 2007, pp. 32–34. Aristotle draws forward the idea that every point, in that it is both itself and at the same time an end and a beginning, is both singular and double. But it is Alexander who develops the idea of not simply a limit point, but countless lines extending towards a circumference that resembles, in its fixity, its initiating centre.

The Ludovisi Throne or *Throne of Venus*, c.470–60 BC, Rome
Plaster reproduction of an inhabitant who died during the eruption of Vesuvius in AD 79, Museo Vesuviano, Pompeii, Italy
Laocoön, Hellenistic original, 1st century BC, Rome

process of cavitation or bursting, depending on the stress produced by those surfaces they encounter; and, finally, the patterns of rhizomes, whose terminal nodes are always a point of origin for another line. Cells and bubbles are evoked by the matrices welded on and out of the surfaces of the figures, rhizomes by trajectories of negative space. These are established as the viewer draws sight lines or haptic agendas around and through large-scale works such as *Allotment II* (1996), presented in this exhibition. Rhizomic structures are also evoked by the appearance and reappearance of the water-bound and water-borne figures of *Another Place* (1997) along the sea at Cuxhaven, Germany; Stavanger, Norway; De Panne, Belgium; and Crosby Beach near Liverpool. As these figures travel horizontally from place to place, they are submerged and revealed by the vertical action of the tides.

Our baptism begins with the fluid bath of the cell; we are made from water, though, at least in Britain, our weight is measured in 'stones'. The antinomy of stone and water, central to all sculptural making and erosion, is a recurring dynamic in these sculptures; like stones cast in water, they ring outwards to the next point or node. Analogously, Gormley's global work orbits out to include more and more far-flung communities, from Scandinavia to the Australian desert. At the same time, this work seems rooted in the industrial grids and transportation lines, the ring roads, and that most fundamental of rhizomes, the Underground, that characterise the metropolis of London – all the humming circuits of the capital city.

Certain of Gormley's sculptures confront us with concentrated forms of density and potential, as in his *Seeds III/V* (1989/1993), his *Capacitor* (2001), and the whirling concentric spheres of his *Feeling Material* pieces (2003–07). Others are expanded radii with absent, yet discernible, centres, as in his *Quantum Cloud* pieces of the late 1990s and in *Space Station* (2007). If Gormley often counters the urge to expansion with a retrospective, and conscientious, movement of concentration, *Space Station* exemplifies how an urge to expansion

counters the stasis of too much concentration. Here he and his team of assistants began with versions that involved filling the container of the figure with blocks until reaching a point of saturation. They then turned to opening up the space between such blocks. The final work is haunted by the position of the initial, foetus-like or fallen figure, bearing its 'cast' as we might bear the shadow of a feeling inside ourselves without necessarily manifesting it; indeed the shape is carried like a seed while the scale of the overall work has grown up to 100 times the initial human figure. The final accretion of this piece is the Cor-Ten rust that first erodes the work and then becomes a surface that protects it.

Gormley creates a cosmology that begins with the rhythm of his own pulse and hands, and moves to the edges of his body, to the edges of his clothing, to the edges of his encounters with others, to the edges of his dwelling places, to the edges of the built environment, to the edges of such geographical spaces as the shoreline and desert. Our perception of existence is founded upon such encounters with edges. Our bodies are bodies by virtue of the fact that they resist – they resist the will and the imagination and they resist the pressing matter of the world. They are impressed, as Gormley emphasises in *Sense* (1991). And, as he emphasises in *Floor* (1981), they leave impressions. In *Hatch* (2007) the perspective is detached from containment entirely. The edge is a place of potential penetration and gives the viewer a sense of what it is like to be inside a mould. To travel through the space horizontally the viewer pours himself into it; this is an active reversal of such passive experiences as, say, going down a slide. Gormley's *Blind Light* (2007) and *Breathing Room I* (2006) [see p. 54] present totalised light environments that create a sense of disorientation and vertigo in the viewer. Kant had written in his 1786 essay 'What is Orientation in Thinking?': 'To *orientate* oneself, in the proper sense of the word, means to use a given direction – and we divide the horizon into four of these – in order to find the others, and in particular that of *sunrise*.' Nevertheless, he goes on to explain that our capacity to orientate

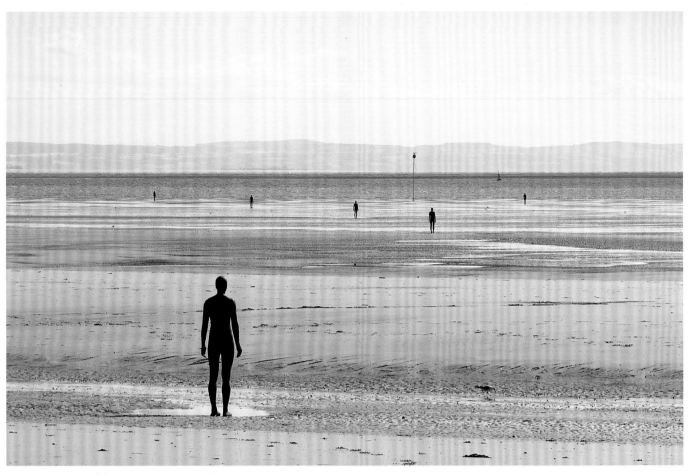

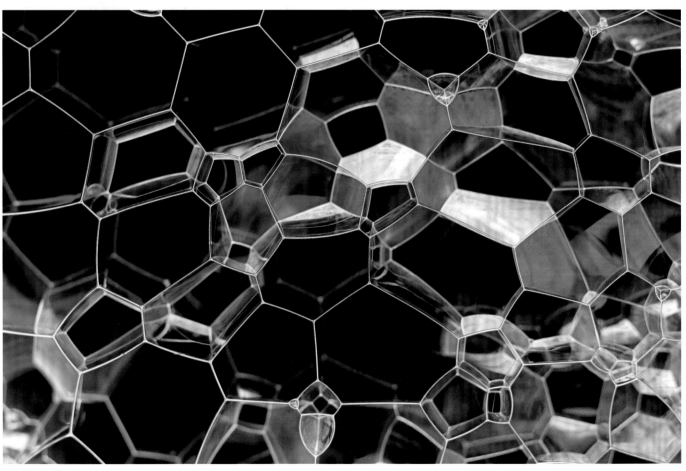

ourselves geographically proceeds by means of a completely subjective distinction, by a feeling of right and left. Such feeling finds its origin in an environmental correlate, but we forget that basis. As we negotiate movement by means of sound and haptic memory in *Blind Light* or are returned to solar coordinates in *Breathing Room I*, we experience a sense of loss of edge, yet are thrown back into the edge of our own proprioception.[7]

Are the figures of *Drawn* (2000/07) left at the corners of the gallery room by the expansion of an explosion, or have they been pulled out through the edges by threads that we can no longer see? Does an equivalent, cantilevering weight hold them in place? Are the figures dangling to the floor in *Critical Mass II* (1995) dropped like executed prisoners from a dock or are they rescued, held up and back, from some deeper abyss? Fast-thinking, good reflexes, careful approaches, well-meaning impulses – all are aspects of our physical being that save us, and these sculptures remind us of what such states of heightened alertness require. The array of Gormley's figures ambiguously suggests worshippers entering the sea, ancient figures fleeing fire and cast forever in its ashes, postures of banishment and welcome, self-containment, enclosure and embracing. Some figures swarm and spark; others seem the very embodiment of patience and stillness. We recognise the casts of Gormley's own body, yet we also come to know the precise dimensions of myriad other persons through the measured forms of *Allotment II* and *Domain Field* (2003). We see others metonymically through the ghostly fog of *Blind Light* and then encounter them again as presences in the open spaces of the exhibition.

We are vertical beings on the horizontal surface of the earth with a sense of haptic purpose. Though distance is necessary for any experience of seeing, distance is also something we tend to think of as in need of closure. Moving inside The Hayward spaces, we can see the sculptures only from certain points of view and it gradually becomes apparent that the exhibition is constructed as a series of concentric rings. The inner limit is the absent central gestalt of *Space Station*, or the feeling of lost coordinates within *Blind Light* – views from which we can begin to build inside a building. The outer limit is *Event Horizon* (2007). These vast figural nudes, around 30 casts placed along public walkways at eye level or high on the rooftops around the Southbank Centre, subtly draw the attention; they, too, suggest viewers being viewed, as they also suggest the horizon as a limit to intelligibility.

In his classic treatise *Truth and Method*, the phenomenologist Hans-Georg Gadamer described the horizon as 'something into which we move and which moves with us' – indicating that a horizon is a limit of perception, a kind of perceptual blind spot, and yet a place where views might be fused or put into communication.[8] Gormley's figures, there on the edge of our seeing, intensify our sense that cities are places where we are observed and observe others. Yet because of their remote and high situations, they also suggest at once the lonely anomie of suicides and the engaged solicitude of guardian spirits. They are like magnets in search of a field: they will make us stop in mid-step in order to animate them with narratives to which they may or may not conform. At the centre of Gormley's *Space Station* and by means of these antennae-like solitaries, the 'alien' turns out to be potentially familiar: these are figures who have re-entered our world and bear the scorch and wind marks to prove it.

Where is the frontier today? It is not, as Daedalus imagined, in transcendence, but rather in a recognition of the finitude of our lives on a finite earth. To a logic of scarcity and escape, Antony Gormley counterposes an ethic of concentration and expansion, one where freedom is a relation of dependency, and descent into matter, true *gravitas*, figures the progress of human form.

7 Kant, I., 'What is Orientation in Thinking?' in Reiss, H. (ed.), *Kant: Political Writings*, translated by Nisbet, H. B., Cambridge University Press, Cambridge, 2003, pp. 237–49 and pp. 238–39.

8 Gadamer, H-G., *Truth and Method*, translated by Weinsheimer, J. and Marshall, D. G., Continuum Books, London and New York, 2004 (first published 1960).

Antony Gormley, *Another Place*, 1997, Crosby Beach, England
Soap bubbles

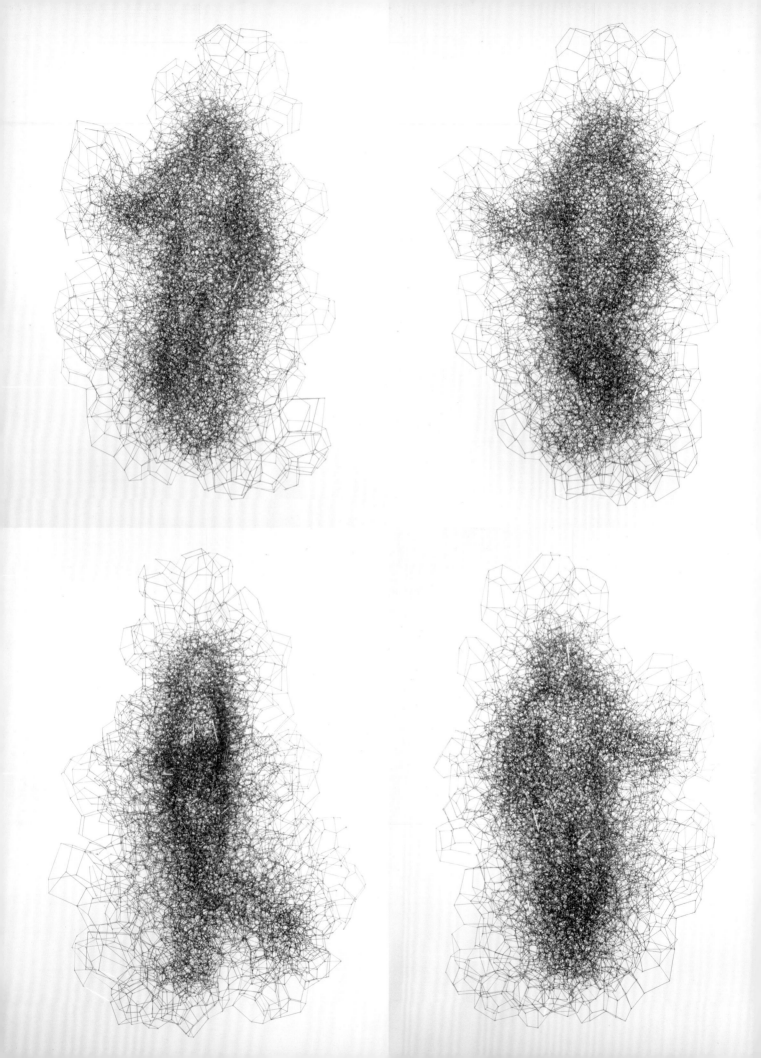

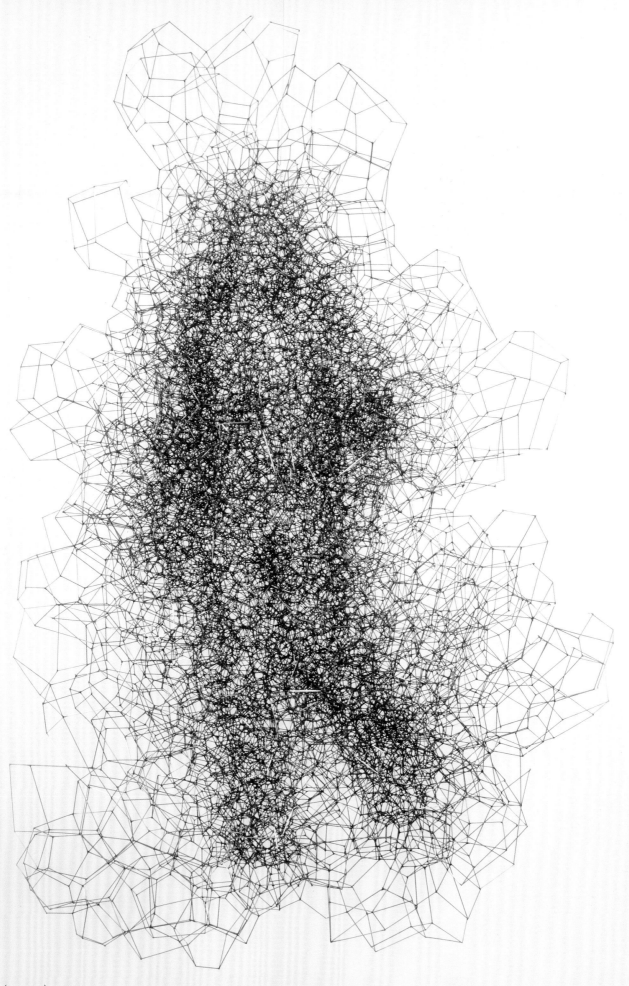

Ferment (rotated), 2007

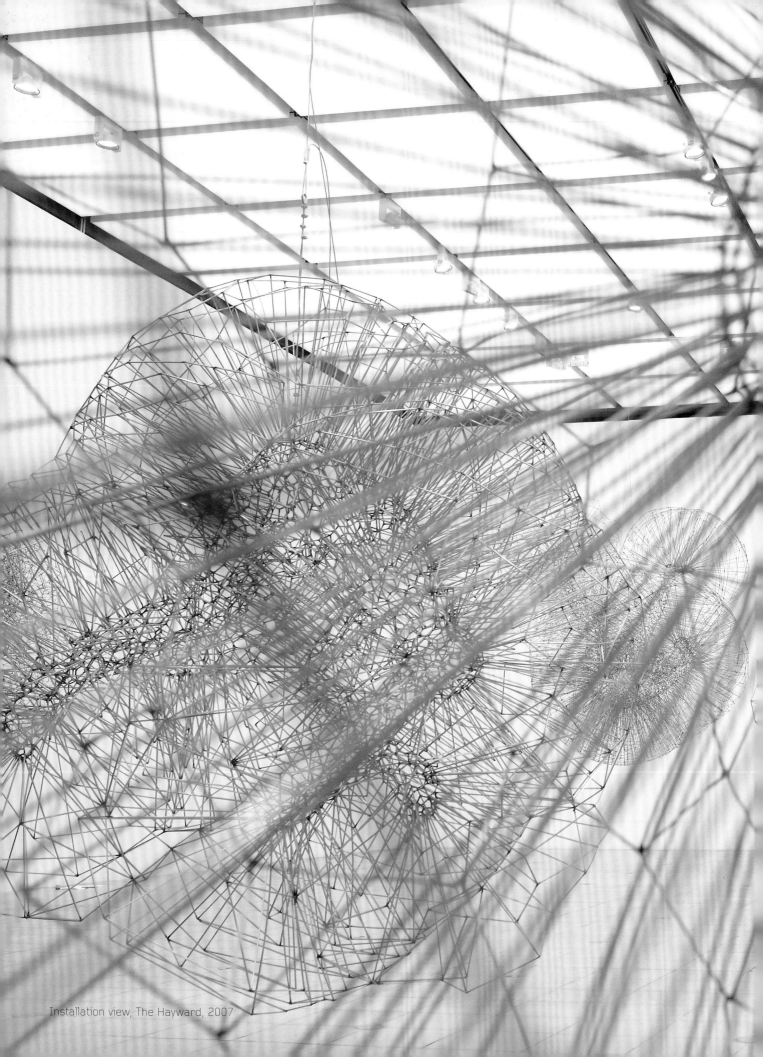

Installation view, The Hayward, 2007

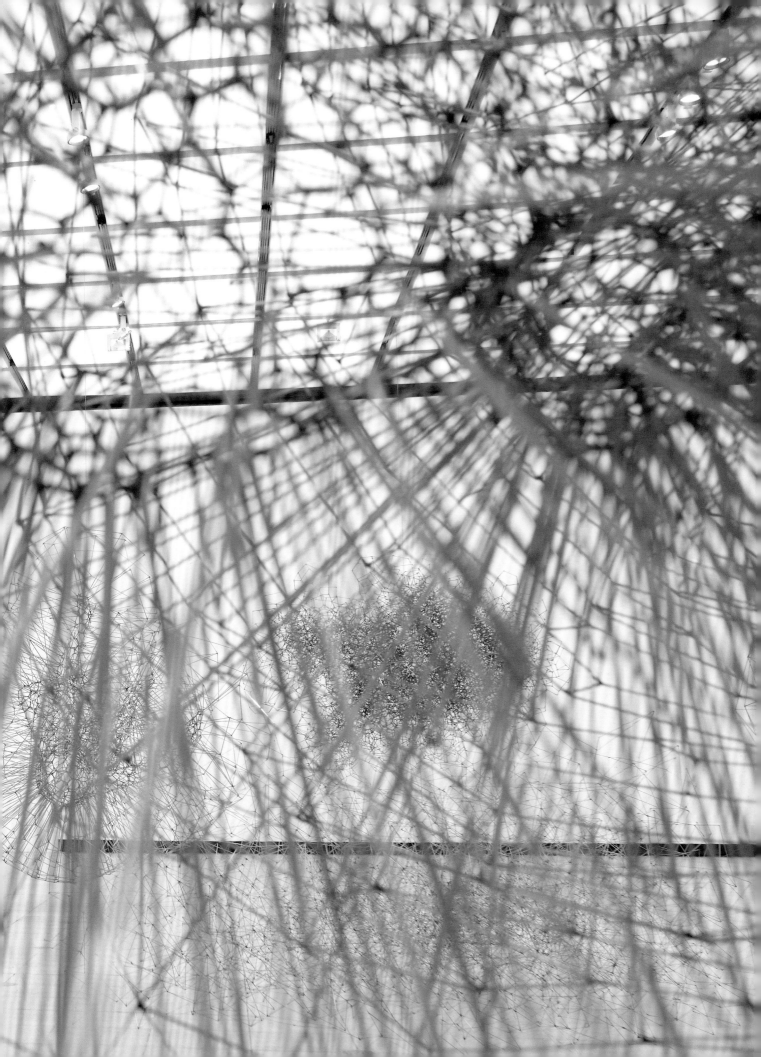

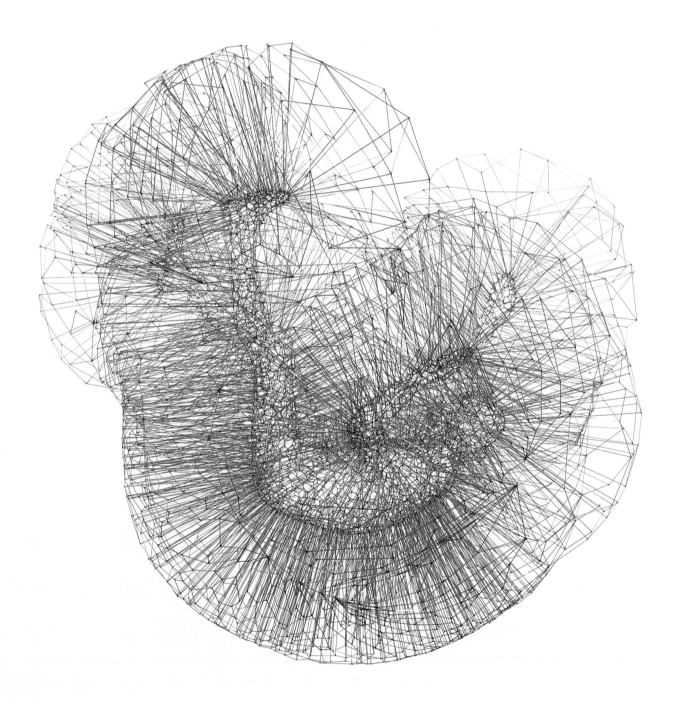

Flare, 2007

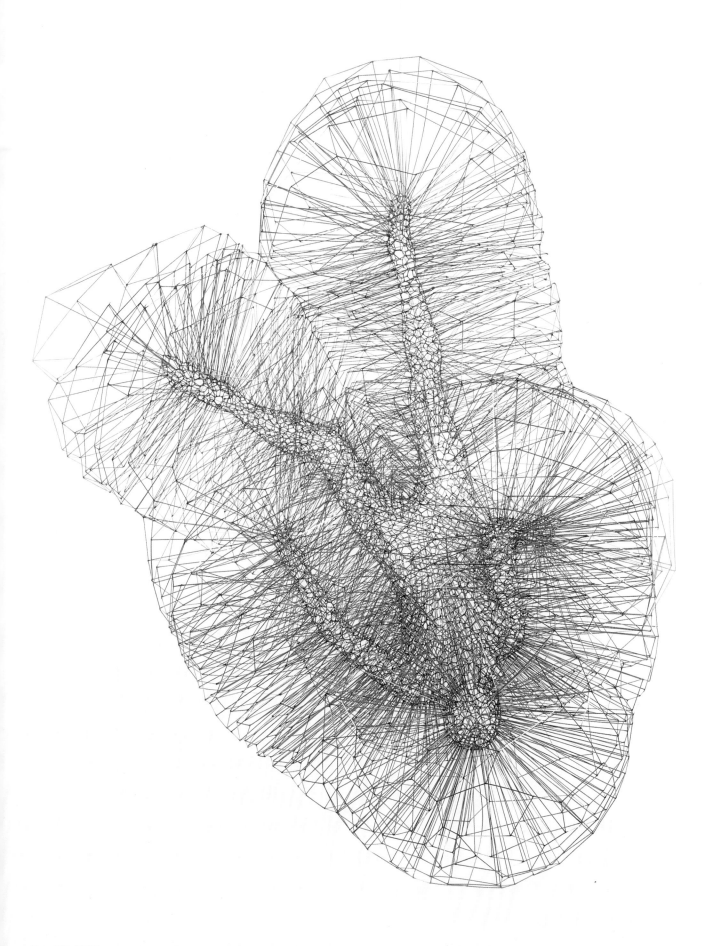

Freefall, 2007

Mass, 2006

Quantum Cloud XVII, 2000

Static, 2007

ARCHITECTURE AS SCULPTURE AS DRAWING:
ANTONY GORMLEY'S *PARAGONE*

W. J. T. MITCHELL

What is the relationship between architecture, sculpture and drawing, when considered as 'ways of world-making'?[1] William Blake provides a triptych showing three portraits of the artist as demiurge, creator of a world. First, the architect: Urizen with his compasses dividing the light from the darkness, outlining the spherical form of the cosmos, measuring out the abyss. Second, the sculptor: Los with his hammer, resting to behold his creation, a fiery globe that has been shaped on his forge. Third, the painter-draughtsman hovering over a globe of blood that has drained from his body, like a mother nurturing an embryo with a placenta of fibres, hair and veins. Three images of the artist engaged in what Henri Lefebvre calls the 'production of space':[2] conceived space, the space of the designer or architect; lived, practised, constructed space, the realm of the builder and shaper of materials, the sculptor; perceived or 'secreted' space, the immersive environment, reproduced blindly and instinctively, like automatic drawing or painting.

Of course a blink of the eye allows all three figures to change places: the architect is a draughtsman, drawing the outlines of the world in space, sketching a shape to be sculpted in matter; the sculptor is an architect and draughtsman, drawing his form in metal and shaping a world with his hammer; the painter-draughtsman gives birth to a world with fluids drawn from her own body, caught at the moment of parturition when the drawing

is still going on, the wound of the birth trauma is still bleeding, the embryonic world not yet separated from its creator. Virtual, actual and visceral worlds delineated in firm, wiry, bounding lines engraved in a copper plate, signed 'William Blake, sculpsit'.

I wish the English language had a word to denote the convergence of architecture and spatial design with the graphic and sculptural arts. Of course one may question whether – in the age of the post-medium condition, when all media are mixed, hybrid and remediated by digital technologies – there is really any such thing as distinct media. Has architecture, for instance, not gone virtual, existing as much in speculative, notional and graphic or modular form as it does in actual building? And do not the buildings reflect this virtualisation and liquidation, with the seemingly absolute malleability of materials, shapes, surfaces and spaces? And does this not make for a convergence of architecture and sculpture, so that structures such as Frank Gehry's Guggenheim Museum in Bilbao or Daniel Libeskind's Jewish Museum in Berlin become a kind of expanded field of sculptural gestures, while Peter Eisenman's Holocaust Memorial goes all the way over to the sphere of public sculpture, but this time as plaza, a place of labyrinthine chasms and rolling contours, a landscape of monolithic gravestones, a social space of mourning and sunbathing, solemn contemplation and frivolous hide-and-seek?

As for drawing, with its connotations of manual production, primal 'first steps' towards the fabrication of three-dimensional, material objects,

1 I use the phrase coined by philosopher Nelson Goodman in his classic text, *Ways of Worldmaking*, Hackett Publishing, Indianapolis, 1978, who dedicated his book to K. L. G., 'who makes worlds with watercolors'.

2 Lefebvre, H., *The Production of Space*, Blackwell Publishing, London, 1991 (first published 1979).

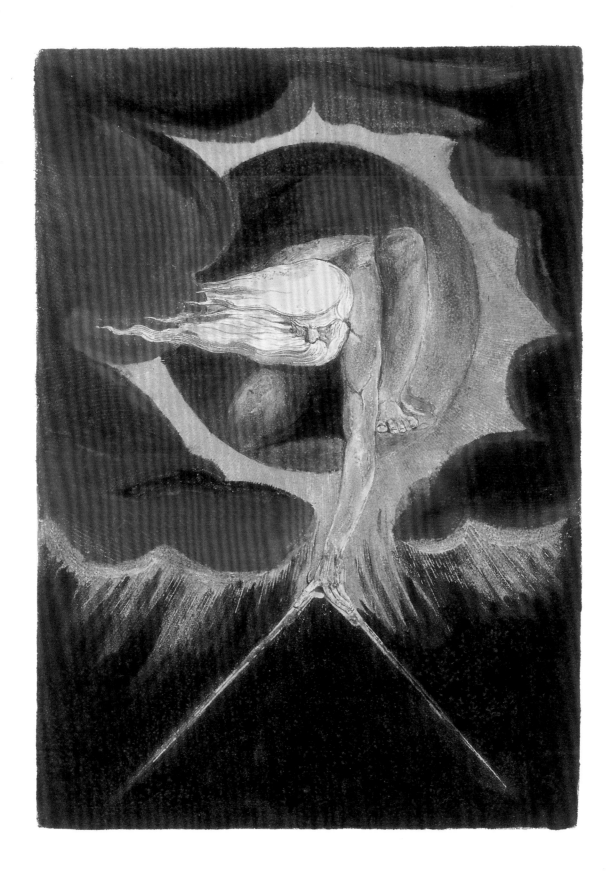

William Blake, *Europe a Prophecy*, frontispiece
(*The Ancient of Days*), 1794

or its secondary role as the trace, the image 'drawn after' objects made by nature or art: drawing remains closest to the centre of the vortex of image production, the 'fissure' in which Henri Focillon saw 'crowds of images aspiring to birth'.[3] Drawing is the crossroads of architecture and sculpture, emanating from and returning to the body. It remains linked directly to the hand/eye circuit, the scopic drive and the imaginary, even in the sphere of digital imaging. Think of Saul Steinberg's world-making draughtsmen, delineating their own environments. Or of Blake's divine, rational architect drawing the line between light and darkness as the fundamental structure of the visible universe. Think of the legendary origin of drawing and its relation to sculpture in Pliny's *Natural History* (written AD *c*.77): the Maid of Corinth traces the silhouette of her departing lover on the wall, thus inventing drawing, a medium grounded in desire, eros and fantasy.[4] But then her father, Butades the potter, goes on to invent sculpture by making a three-dimensional relief portrait out of the sketch as a gift to his daughter. Both the drawing and the sculpture, however, depend upon two prior conditions: 1) the presence of architecture in its minimal form: the silent, blank wall on which the two-dimensional image is cast, traced and then sculpted in three dimensions of 'relief' from flatness; 2) the human body, as both the centre and periphery of architecture, what envisions it from without, and inhabits it from within. The body is not only what draws, but also what is drawn, both to sculpture and to architecture. The body is itself both building and statue, a brick shit house or a monument. Whether body as building (as in the metaphor of the temple of the spirit) or the building as a body (complete with skeletal framework, interiority and orifices), whether it is clothed or naked, draped and ornamented, or exposed and transparent, the body is what brings sculpture and architecture together.

3 Focillon, H., *The Life of Forms in Art*, Zone Books, New York, 1992 (first published 1934).
4 See my essay, 'Drawing Desire', in *What Do Pictures Want?*, University of Chicago Press, Chicago, 2005, pp. 57–75.

William Blake, *The Song of Los*, plate 8, 1795
William Blake, *The First Book of Urizen*, plate 17, 1794

W. J. T. MITCHELL

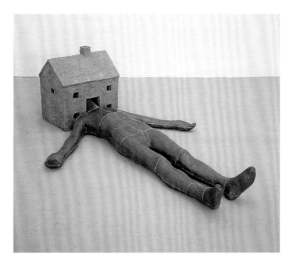

Antony Gormley's figures are almost never clothed, but they are certainly housed – or unhoused, cast out, wandering in the wilderness, on the beach. Sometimes they have a kind of comic, Gulliverian relation to dwelling, as in the aptly titled Home (1984), in which a prone body finds a place to rest its weary head – but nothing else. The most radical and disturbing housings of the body are the cast concrete-block overcoats of Allotment II (1996). This work, in its quiet, ambiguous way, is among the most terrifying inventions of modern sculpture. The work literalises the anthropomorphism that Michael Fried complained about in Minimalism: the feeling that (for instance) Robert Morris' slabs, columns and boxes were of a scale to suggest the human form or presence within. In Allotment we see the perfect sculptural answer to Brutalist architecture. The structure is essentially one of confinement and fortification, a reduction of openings to minimal orifices. Like the few isolated structures that withstood the nuclear firestorm of Hiroshima, the bunker-like architecture of Allotment could be an image of comfort or survival only in a post-Holocaust landscape. Gormley's pod-people on life support, and his armoured, cocooned figures are comparable here. The whole effort is to suggest a hidden internal space into which one can imaginatively project oneself – a hollowness that one can infer, but not see, waiting to be filled by the beholder's body.

But to imagine oneself immured in one of the blocks of Allotment– blind, but (just) able to breathe, speak and hear – is to imagine the condition of absolute terror and the structure is reminiscent of certain genres of torture – the 'Little Ease' which prevents all bodily movement, or the 'Iron Maiden' which surrounds the victim with spikes. Body (1990) and Gormley's new work Hatch (2007), specially conceived for this exhibition, correspond even more exactly to the Iron Maiden. Hatch inserts the beholder into a Piranesi-like room in which shafts of metal tubing disrupt the architectural perspective, and resemble what one imagines as the interior of a magician's box, penetrated from every angle by swords that miraculously leave the body intact. The assembled body casts of Allotment, then, form a kind of Modernist housing project, a tract of Brutalist council flats, one building per body, in which the inhabitants cannot see each other, but could conceivably hear each other.

How could one last for a minute in this confinement without panicking? Only if one imagines oneself in a deep,

Antony Gormley, *Home*, 1984
Iron Maiden of Nuremberg (Vierge de fer de Nuremberg, instrument de supplice), 19th century

meditative trance, reducing the activity of the body to a minimum. The phenomenological version of bare life. Inner peace as survival mechanism, the construction of an invisible space in which the beholder must imagine herself as 'being held'.

The more these distinct media – sculpture, architecture, drawing – seem to merge in these practices, the more indispensable becomes the invocation of their names, as though the ghosts of the traditional artistic media refused to be laid to rest.[5] Stephen Melville's wonderful essay, *As Painting*, an exploration of painting after its widely reported death, inspires my title here.[6] The work of Antony Gormley is generally classified 'as sculpture'. He is known for fabricating beaten lead body cases formed around moulds, generally, of his own body. The casings superficially resemble traditional statues, and in fact remind us of early, archaic Greek sculpture in their stasis and rigorous refusal of movement, expression or gesture. They are figures that simply stand, or lie, or crouch. They do not 'do' anything, reminding us of the deep link between statues and stasis. The seams of the body casings declare unequivocally that these are constructed bodies, in contrast to the cast body forms, which are solid iron objects, cast 'from the inside', as it were, of the body casings. Both kinds of figures come in series, as indistinguishable multiples, impassive, anonymous duplicates who appear in real places often as aliens, outsiders, uncanny apparitions that seem 'out of place'.

Despite their instant legibility as figures of the male human form, they do not 'stand for' anything: they are not warriors or heroic figures, and though their stature and stasis reminds us of the monumental guardian and witness figures that adorn palaces and plazas, their characteristic placement in relation to architecture and public

space is typically non-iconographic and non-site-specific. *Event Horizon* (2007), for instance, treats The Hayward's sculpture terraces not as a space for displaying sculpture, but as an observation platform from which the more or less distant figures of Gormley's figures may be glimpsed among the surrounding panorama of London rooftops. These figures tend to occupy places with a sense of sudden, uncanny arrival, temporariness, or disturbingly bizarre intrusion – just the opposite of their internal, corporeal stasis and stillness. They are certainly not sculptural portraits of anyone, including the artist whose body provides the model for their casting, because their impassive anonymity and multiplicity render any specific individual reference doubtful; at the same time it would be doubly accurate to call them 'Gormleys', in the sense that the work is 'branded' with the name of its author–artist, as well as modelled on the specific contours of his own body.[7] Their branding, however, is not that of the commercial icon or logo, but more like that of the graffiti 'tag' or signature, an effect reinforced (as I shall show) by their often disturbing relation to space and architecture.

One is tempted, then, to fuse the double visual-verbal identity of the generic 'Gormley' with a third figure, the 'golem' or artificial human made from inanimate material, and call these figures 'gormlems'. Gormlems are best seen as sculptural 'clones', identical copies of an absent original that may be indefinitely multiplied. If they signify anything, then, it is the generic (male) human form itself, the central icon of a humanism that today has evolved into a Minimalist post-human form, what Giorgio Agamben has called *homo sacer* or 'bare life',[8] the body as a centre of sentience, awareness, endurance, witnessing and perhaps suffering, and nothing more. Milton might have seen them as

5 I am treating drawing and painting here as if they were the same medium, but in a more leisurely exposition it would be necessary to acknowledge the tension between these two practices as well. Certain artists, notably Jeremy Gilbert-Rolfe, view their painting practices as an attempt to 'destroy drawing'.

6 Melville, S., 'As Painting' in *As Painting: Division and Displacement*, MIT Press, Cambridge, MA, 2001.

7 The anonymity of the 'Gormleys' may be seen in sharp relief if one compares them to the famous terracotta army of the 3rd century BC Emperor of China unearthed at Xian. Among the most notable features of this multitude of figures is the fact that each has a distinctive face and head, placed atop a generic body-type (archer, footsoldier, horseman).

8 Agamben, G., *Homo Sacer: Sovereign Power and Bare Life*, Stanford University Press, Stanford, CA, 1998.

Antony Gormley, *Sovereign State I*, 1993
Antony Gormley, *Float II*, 1991

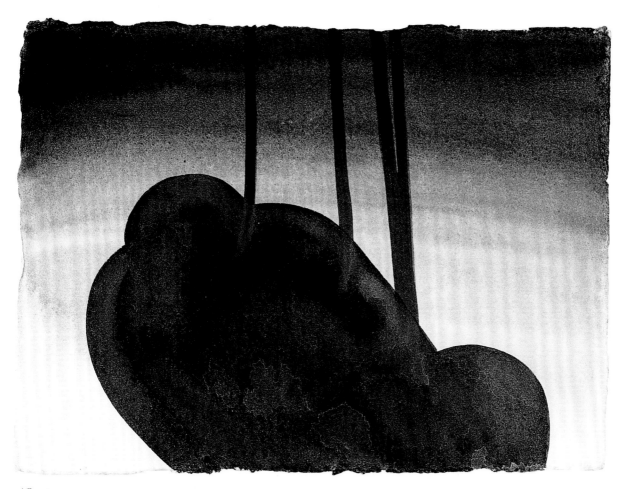

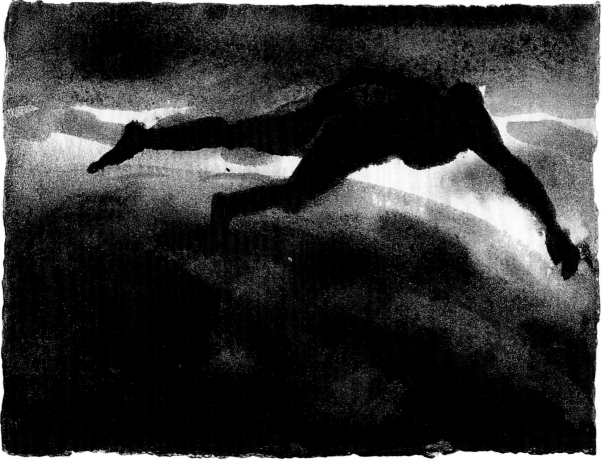

117

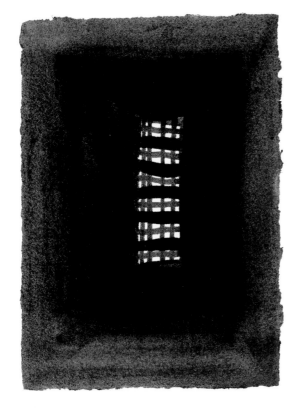

avatars of saintly patience and passivity: 'They also serve who only stand and wait.'

Consider three Gormley drawings: the first [see p. 117], the gormlem as a cocooned figure (cocoon is the literal meaning of 'golem' in Hebrew). Lying in a foetal position, hoses attached to the vital orifices of the encased body, this body is housed in a perfect, self-enclosed environment and placed (immersed) in a deep watery environment. It could be in a coma, awaiting its fate as an organ donor,[9] or in a cryogenic sleep, awaiting the awakening. The figure is an uncanny premonition of the pod-people of the classic sci-fi film The Matrix *(1999) who live in womb-like life support systems wired up to a virtual reality computer that gives them the illusion of a real life. The philosophical question 'are we just brains in vats?'[10] is here staged as a corporeal image, one that was realised, of course, in the sculpted object known as* Sovereign State *(1993). And this is, indeed, the perfect embodiment of the 'sovereign subject', the self-enclosed, autonomous, homeostatic human form, lying 'in state' as it were.*

The second drawing [left] is much simpler: we are inside a very dark space, a cell with a small barred window in the distance. The darkness intensifies as we move towards the light, and fades out to a grey wash as our visual field spreads out, moves to the periphery and tries to locate itself in the foreground. But there is no foreground, just the dark, rectangular tunnel leading to the barred window. This is conceivably the view from inside the figure of Sovereign State *– or from inside a dungeon, the prison-house as body or building – or both: the casket, pod, cocoon, womb, that confines and nourishes the body. Many of the gormlems, like Minimalist objects, are hollow, and announce their hollowness, asking us to imagine their dark, empty insides, and even to imagine ourselves inside them. This drawing draws*

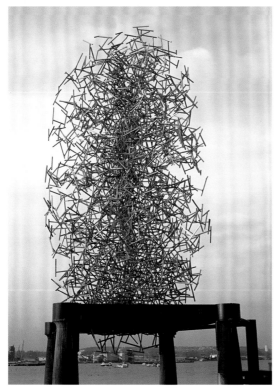

9 Organ donation is a common fate of clones in contemporary fiction. See Kazuo Ishiguro's novel *Never Let Me Go* (2005), or the film *The Island* (Michael Bay, 2005), both of which envision a future in which whole communities of clones would be created to donate their organs to the 'donors' of the DNA from which they were formed.

10 See the *Stanford Encyclopedia of Philosophy* for an excellent article on the famous 'body in a vat' problem, from Cartesian scepticism to Hilary Putnam's refutation of scepticism. http://plato.stanford.edu/entries/brain-vat/.

Antony Gormley, *Interior*, 1991
Antony Gormley, *Quantum Cloud*, 1999, Greenwich, London

us inside, looking out, just as Sovereign State *drew us outside, looking on.*

The third drawing [see p. 117], liberation from the other two: a cloud-like figure floating amid the clouds above the sphere of the earth. The body liberated – but from what? From the materiality of the earth-bound body, from gravity, from the dark cell of architecture or the casket of sculpture? Is this an Icarus about to fall? The architect who (in contrast to his father Daedalus) flew too high? Or an angel, or a spirit of the air, hovering above the globe? A demiurge fertilising the earth, measuring its expanse, dividing the light from darkness? This weightless body promises to find its sculptural realisation in the bubble matrices and expansions pieces [see p. 102–11] which are the 'virtual flotation tank' of this exhibition.

Consider these three drawings as Gormley's answer to Blake's three figures of the world-making artist in space: a triptych of body-spaces seen as womb, as cell, and as medium of flight, the body immersed in fluids, immured in solid walls, afloat in clouds. If Blake shows the artistic body as agent, designing, building and secreting new bodies in space, Gormley shows us the passive, non-artistic body, the patient, suffering body, secreting and drinking, gazing out from its cell, hovering in space. It is as if the globes and spheres of light, hammered metal and blood that Blake depicts as the object of artistic labour have become the corporeal, sculptural and architectural environments of Gormley's drawings. Gormley's treatment of the human body has, of course, often been compared to Blake's. He might be thought of as the post-human Blake, the artist of the Blakean body in the age of cloning. He remains faithful to the task he articulated in the 1980s: 'I am tired of art about art. I am now trying to deal with what it feels like to be a human being.' Was ever a stranger thing said? One could easily put it in the mouth of one of sci-fi novelist Octavia Butler's ooloi, the alien creatures who travel the universe interbreeding with the various species they encounter. It only makes sense as the utterance of someone who has called the human being itself into question, conducting an experimental inquiry into the conditions of embodied experience in relation to concrete objects in specific places and times.

Gormley's work has consistently engaged in what Leonardo da Vinci called a *paragone*, a dialogue or struggle with the values of architecture and both

designed and natural spaces.[11] The classical relationship between sculpture and architecture, or sculpture and designed spaces more generally, is one of 'site specificity' and the notion of the statue as a still figure ideally 'rooted' in a particular location. Gormley's sculptural figures defy the Heideggerean doctrine of locating sculpture in the 'right place' as a strategy of making a 'clearing' for Being to appear.[12] See, for instance, *Post* (1993), a cast-iron gormlem posted atop a topped and branchless tree, looking over Killerton Park in Exeter. Like Robert Morris' creosote-covered redwood stumps in his earthwork near the Seattle–Tacoma airport, Gormley's work flaunts the creative-destructive human agency in clearing and deforestation. But in contrast to Richard Serra's insistence on the site as an absolutely necessary condition for the identity of the work, Gormley renders the site a conditional, transitory element. If Serra was correct to say that the removal of his *Tilted Arc* (1981) from the Federal Plaza in New York amounted to the 'destruction' of the work,[13] Gormley's work might be said to stage the temporal conditions of arrival and removal, construction and destruction, as the very essence of its project. Even when a gormlem is located in a permanent site, as with *Quantum Cloud* (1999) or *Angel of the North* (1998) [see p.97], the figure appears ready to take flight, or seems caught in the moment of its explosive disappearance and dispersal.[14] The ocean-going or 'beached' gormlems

11 Leonardo's notion of the *paragone*, or debate of the arts and media, is principally staged between poetry and painting, but it includes other arts as well. For an excellent introduction, see Claire Farago, *Leonardo's Writings and Theory of Art*, Routledge, New York, 1999.

12 See my discussion of Gormley's spatial practices in 'What Sculpture Wants: Placing Antony Gormley' in *What Do Pictures Want?*, University of Chicago Press, Chicago, 2005, pp. 245–71.

13 See Serra's own statement, 'Art and Censorship' in *Art and the Public Sphere*, Mitchell, W. J. T., (ed.), University of Chicago Press, Chicago, 1992, pp. 226–33. On site-specificity, see Miwon Kwon, *One Place After Another*, MIT Press, Cambridge, MA, 2002; Deutsche, R., *Evictions: Art and Spatial Politics*, MIT Press, Cambridge, MA, 1996.

14 There are notable exceptions to this rule. The marvellous

of *Another Place* (1997) [see p. 100] slowly sink out of sight as the tide advances, and re-emerge as it recedes. This is why photographic documentation is so crucial to Gormley's practice, and why his drawings do not necessarily precede the sculptural works they reference, but are drawn from the pre-existing, pre-fabricated three-dimensional objects.

These objects can seem, then, like sculptural 'graffiti', inserted into places in which they do not belong and will not remain. But unlike graffiti – what Susan Stewart has called 'crimes of writing' – they do not attack the space or disfigure it. An instructive contrast would be the work of the graffiti artist Banksy, whose generic, spray-painted stereotypes and wall labels address video surveillance cameras, and warn visitors to Tate Britain to 'Mind the Crap'. Gormley's figures aim at a quieter, subtler address to institutional spaces. For Gormley, there is no space for art, no matter how remote, wild or 'natural', that is devoid of human, social significance; no abstract, purified environment inside or outside the 'white cube' of Modernism. His work reflects a prolonged engagement with the site, but one which tends to treat it as a temporary 'event horizon' rather than the place for an eternal monument.

It is a commonplace of contemporary art history that Modernism was obsessed with the problems of the distinctive media, and aimed to purify the media of contaminating forms of hybridity. As Clement Greenberg famously put it, 'purity in art consists in the acceptance ... of the limitations of the medium of the specific art ... It is by virtue of its medium that each art is unique and strictly itself.'[15] Painting and drawing are defined by their flatness, sculpture by its three-dimensional and transparently designed objecthood. As for architecture, Greenberg felt that it had been led out

of its 'eclectic historicism', its failure to achieve an 'independent contemporary style', by painting.[16] Cubist painting in particular was able 'to reveal the new style in architecture to itself'[17] and emancipate it (along with sculpture) from its heavy materiality into a dynamic space of thrusts and energetic displacements. The international style of secular, rationalised spatial design unites all the artistic media by treating 'all *matter*, as distinguished from *space*, as two-dimensional'.[18] All the arts are united, in other words, by becoming abstract and weightless. But each must become abstract in its own way. Greenberg also notes that despite the dominance of painting in his narrative, it is threatened by 'the architectural and social location for which [the painter] destines his product'.[19] There is a 'contradiction between the architectural destination of abstract art and the very, very private atmosphere in which it is produced' that 'will kill ambitious painting in the end'.[20] Painting either has to become larger or smaller: the two by two framed easel painting is in crisis, leaving only two destinations: 'the wall and the page' – or the mural and the drawing. 'The best work of Picasso et al. in the last 20 years ... has been in black and white and in reduced format, the etchings and pen-and-ink drawings ... and lithographs.'[21] Strange to say: Modernist architecture is the offspring of Modernist painting. But then the child kills the parent, or compels it to shrink down to its minimal form, and play a merely ornamental role.

A similar fate is often forecast for sculpture, which (in its public form) ornaments the plaza or lobby entrance of modern corporate or state office buildings like the parsley garnish next to the pot roast. Ad Reinhardt's famous comment, 'sculpture is what you back into when looking at a painting', reflects not only the Modernist notion of painting

siting of *Sound II* (1986) in the seasonally flooded crypt of Winchester Cathedral seems to have found a permanent home, although even it plays a dynamic – if entirely passive – role in relation to the rising and falling water.

15 Greenberg, C., 'Towards a Newer Laocoön', *Clement Greenberg: The Collected Essays and Criticism*, O'Brian, J., (ed.), 4 vols, University of Chicago Press, Chicago, 1986 (first published in *Partisan Review*, 1940); vol. 1, p. 32.

16 'Our Period Style', *Collected Essays*, II, (*Partisan Review*, November, 1949), p. 322.

17 *Collected Essays*, II, p. 323.

18 Ibid.

19 'The Situation at the Moment', *Collected Essays*, II, (*Partisan Review*, January, 1948), p. 195.

20 Ibid.

21 Ibid.

as the dominant medium, but the proper location of sculpture in the 'empty space' at the centre of the gallery or white cube. But another commonplace of art history is that in the era of Postmodernism sculpture began to displace painting in the hierarchy of media, challenging architecture at the same time that the architects seemed to want to behave like sculptors, while the art of drawing went underground. Sculpture accomplishes this in several ways: 1) by moving out into the open where (unlike painting) it can survive the weather, and make or find its own place, in a sculpture park, or in remote locations (Robert Smithson's *Spiral Jetty* (1970) on Utah's Great Salt Lake or Michael Heizer's utopian city in the Nevada desert (*City;* work in progress)); 2) by filling up architectural space, taking over entire rooms and buildings. Rachel Whiteread's plaster-cast interiors produce a three-dimensional image of the negative space of a room, while, in some installations, nearly filling the room at the same time. Richard Serra's interior pieces typically dominate the architectural spaces they inhabit, while the relation of his *Tilted Arc* to the urban design of New York's Federal Plaza was an aggressive attempt to rescue an undistinguished urban space from its own mediocrity by directly challenging its structure; 3) most simply, by attacking or attaching itself to the *wall*, in one stroke taking over the 'proper' location of painting and challenging the boundaries of built space: think here of Robert Morris' scatter pieces, Donald Judd's wall cases,[22] Joseph Beuys' fat corners, Robert Gober's body projections, Walter De Maria's *Earth Room* (1977), Edward Kienholz's *The Art Show* (1963–77) and a hundred other works. Minimalism did not bring an end to sculpture. It put it on a new basis, quite literally, in the form of the slab or plinth, the (normally) overlooked support made into a sculptural object.

If Robert Morris had argued that the medium of sculpture had concerns 'not only distinct but hostile to those of painting',[23] one might say something similar with regard to Gormley's sculpture and the framework of architecture – although I would not want to describe it as 'hostile'. Gormley's insight into architecture is more like that of Marshall McLuhan in *Understanding Media* (1964). As a medium, architecture is an 'extension of man', specifically (like clothing) an extension of the *skin*. The sculpture/architecture relation, then, is like that of a secondary and tertiary skin. *Allotment II* 'shrinks' architecture 'to the skin', bringing it as close to the body as possible without crushing it. Womb, tomb, cocoon and room describe the centripetal arc from body to building to sculpture to architecture. And this arc continues down to the inner core of the body, stripped of its skin, muscles, and even its skeleton in the *Insiders* series, and extends out to the skyline or edge of the world in works such as *Another Place* and *Event Horizon*.

The paradox is that, despite the (im)passivity of the figures, the encounter with space and place is dynamic. As I have noted, Gormley's work consistently betrays a kind of active engagement with, sometimes even a playful aggressiveness towards, architecture. If he 'shrinks it to the skin' in *Allotment*,[24] he abases himself before it in *Close IV* (1994); transcends and pierces it in *Learning to Think* (1991) and *Hatch*; invades and overwhelms it in *Field for the British Isles* (1993); floods it with mud and water in *Host* (1991/1997); defies its gravitational laws in *Edge* (1985); re-appropriates and incorporates its material elements in *Brick Man* (1987); violates its spatial design in *Critical Mass* (1995) and *Total Strangers* (1996); shatters it in *Quantum Cloud*. When Gormley notes that he thinks of his work as 'a kind of intimate architecture that is inviting an empathetic inhabitation of the imagination of the viewer',[25] there is nothing to guarantee that the 'inhabitation' will be comforting

22 It is notable that the curators of *As Painting* [Wexner Center for the Arts, Ohio, 2001] decided to include some of Donald Judd's hanging wall boxes (fabricated with conspicuously *unpainted* plywood, with red paint on the interior panel) and one of Robert Smithson's tilted mirror and gravel pieces.

23 Morris, R., 'Notes on Sculpture', *Artforum*, October, 1966.
24 Antony Gormley in an interview with Hans Anderson in Gombrich, E. H., Hutchinson, J., Njatin, L. B. and Mitchell, W. J. T., *Antony Gormley*, Phaidon, London, 1995, p. 148.
25 Antony Gormley in an interview with E. H. Gombrich in *Antony Gormley*, Phaidon, London, 1995, p. 17.

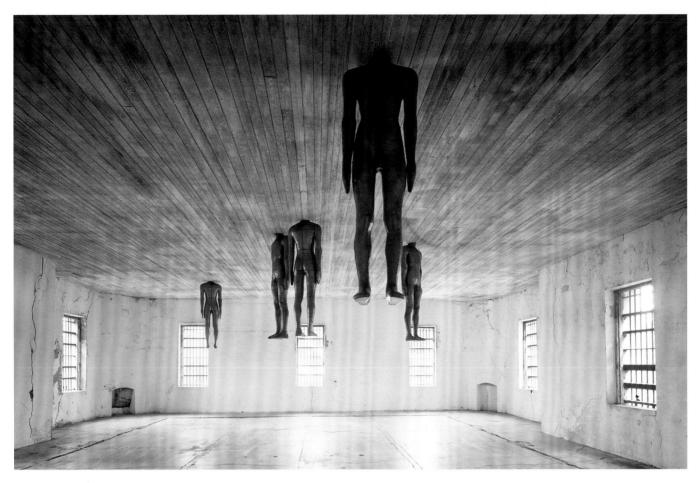

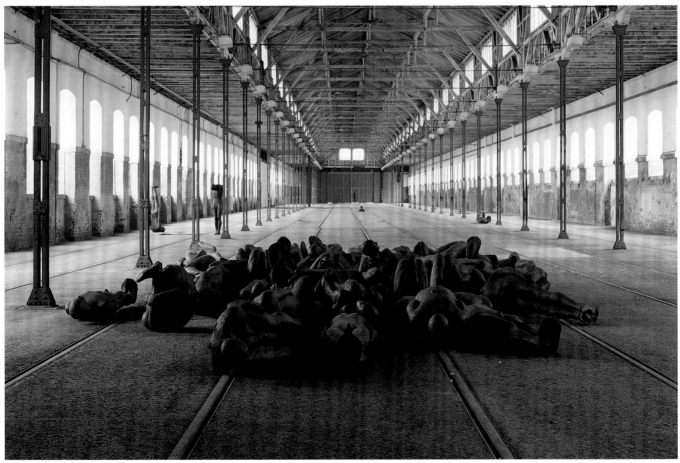

or pleasant, or that a sculpture as architecture will have a peaceful, accommodating relation to its architectural setting. The situation, as I've indicated, is more like a *paragone* (or struggle between the media) than a peaceful settlement.

This is why Gormley's installation/invasion of The Hayward is such an interesting event. The Hayward is among the most notorious examples of 1960s Brutalist architecture in London. Although grounded in Modernist architecture, Brutalism defies the Greenbergian principle of dynamism, weightlessness and transparency (while remaining faithful to other principles of abstraction in its design and structure). Opaque, heavy walls, massive, rough materials, and the institutional look of the fortress, prison or mausoleum marked Brutalism as a kind of fortified retrenchment of Modernism. (Unsurprisingly, it became a popular institutional style at American universities in the wake of student uprisings and building occupations in the 1960s.) In some quite obvious ways, then, Gormley's work is perfectly suited to this environment. If one had only *Allotment II* from which to generalise, one could call Gormley a neo-Brutalist sculptor.

The inclusion of *Allotment II* in this exhibition makes the link between sculptural and architectural Brutalism absolutely clear. But the major emphasis of The Hayward show is to draw the spectator inside the sculptural space, rather than allowing beholders to stand detached from the objects and contemplate them from a distance. This exhibition is not envisioned, in other words, as a retrospective or, indeed, any kind of '-spective' in the sense of disembodied visual distance. It does not survey the history of Gormley's work, but attempts to produce a new work inside – and outside – the architectural structure of The Hayward, one that calls into question the very notion of the insides and outsides of buildings, environments and sculptural objects.

In the interior of the gallery one encounters a series of designed spaces that render the architecture permeable and dynamic, as if one were to find oneself in rooms that enable a detachment of the beholder's perspective from the constraints and reassurances of architecture. The bubble matrices and expansion spaces draws the beholder into the

feeling of weightlessness, a 'virtual flotation tank'; while other rooms explore the forms of Piranesian labyrinths, tortuous panopticons in which the bodies of spectators are glimpsed coming in and out of view, and the relation of the seer and seen is put into question. *Blind Light* (2007) accomplishes this effect with water vapour; while *Space Station* (2007) opens portholes into Borgesian spaces; and *Hatch* extrapolates the logic of the spike-lined casket of the Iron Maiden to an entire room.

We have always been drawn in by Gormley's work. As with any sculpted object, we seem necessarily to approach it from the outside, drawn to it by the magnetism of the alien and alienated body, the uncanny 'thing' that stands over or against us. But this exhibition reverses this process, or literalises it. It draws our bodies inside, physically into environments that invite us to experience the sculptor's work from inside, as if we were pulled into sculpted, drawn and constructed spaces that we have previously viewed only from the outside as an act of projective fantasy. And then it reverses this process by taking us outside, to the rooftop sculpture courts, notably empty of sculpture, providing the only real prospect (in contrast to the intro-spections of the interior): the roof commanding a view of the London cityscape, subtly punctuated by *Event Horizon*'s distant figures of gormlems on various institutional rooftops facing The Hayward like alien invaders announcing their occupation of the entire city.

Despite (or perhaps because of) what might seem like a systematic struggle with architecture, then, I suspect that Gormley's works may be the perfect touchstone (*paragone*) for experiencing The Hayward in all its glory. His aim is not to use the building as a container for his work, but to transform it into a work. The values of site specificity, installation art and architectural/sculptural permanence/ephemerality promise to converge in this show. Gormley has always regarded his own work as a kind of 'intimate architecture', an intimacy that is as likely to be menacing as reassuring. If he can produce a *Breathing Room*, why not a 'breathing building', a work that will inhale the aura of The Hayward and breathe renewed energy into it at the same time?

Antony Gormley, *Learning to Think*, 1991, Charleston City Jail, South Carolina
Antony Gormley, *Critical Mass*, 1995, StadtRaum Remise, Vienna

Chair, 1987–88

Seeds III/V, 1989/1993

Mother's Pride, 1982/2007

Capacitor, 2001

LIST OF WORKS

All works are courtesy of the artist unless stated otherwise.
All dimensions given are in cm, height x width x depth.

Allotment II, 1996
Reinforced concrete. 300 life-size units derived from the dimensions of local inhabitants of Malmö aged 1.5–80 years
098 Gustav Adelcreuz, 097 Oscar Adelcreuz; 105 Anders Ahlin; 225 Taira Airaksinen; 100 Siri Albin, 154 Stephanie Alback, 296 Adam Jamal Aldinshmeis, 063 Bjorn Anderberg, 136 Camilla Andersson, 072 Gunnar Andersson, 214 Goran Andersson; 086 Hjordis Andersson, 243 Maria Andersson, 242 Marianne Andersson, 238 Torbjorn Andersson, 204 Daniel Addreasson, 107 Tina Apelgren, 182 Thomas Areskoug, 028 Alma Aronsson, 029 Christina Aronsson, 090 David Asker, 039 Ake Axelsson, 286 Lotti Becker, 287 Ulrika Becker, 223 Julianne Bengtsson, 224 Silvia Bengtsson, 236 Torbjorn Bengtsson, 060 Ewa Berg, 026 Sonja Berg, 091 Ida Bergqvist, 109 Dag Berntsson, 106 Liv Berntsson, 025 Mikael Billred, 009 Asa Bladh; 036 Theodor Blidberg-Czepan, 195 Olof Borgeke, 042 Andreas Brandt, 044 Jane Brandt; 170 Marie, Brandtmark, 083 Bard Breivik, 263 Susanna Bremberg, 064 Mats O Bunner; 045 Lennart Bylund, 162 Kerstin Bafving, 276 Julia Campbell, 261 Clara Cederholm; 260 Hannes Cederholm, 075 Ivan Cederlund, 123 Angela Cesarec ; 056 Francoise Chiclet , 272 Simon Christoffersson , 004 Ingvar Claesson ; 134 Anneli Claesson ; 133 Johannes Claesson , 185 Richard Claesson, 280 Nils Crone, 037 Jimmy Czepan; 140 Julia Dahl, 141 Linus Dahl, 043 Denise Djurfeldt, 176 Joel Dolkow, 177 Snild Dolkow, 191 Patrik Edman, 294; Tilde Edqvist, 265 Johannes Edvinsson, 148 Oscar Ek, 071 Susanne Ek, 068 Cornelia Ek-Uvelius, 069 William Ek-Uvelius, 187 Jens Ekander, 295 Joel Ekblad, 021 Anders Ekdahl, 022 Karin Ekdahl, 024 Lars Ekdahl, 023 Per Ekdahl, 020 Per Engstrom, 076 Gunnar Erici, 080 Gunnel Erici, 186 Ingrid Fahlgren, 079 Anette Falzon, 274 Erica Fantzon, 183 Jimmi Femo, 117 Fabian Frankenius, 116 Oline Frankenius, 145 Laila Fryksater, 099 Emil Garaybostos, 152 Kerstin Germundsson; 200 Gertrud Gillgren, 254 Antony Gormley, 096 Olof Gottfridsson, 202 Lars Grundstrom, 259 Gosta Gronvall, 084 Ineke Gudmundsson, 085 Sigurdur Gudmundsson, 258 Emma Guiomar, 257 Marcus Guiomar, 292 Niklas Gunnarsson; 128 Anna Goransson, 034 Arne Goransson, 151 Emmy Goransson, 038 Gunilla Goransson; 264 Ola Goransson; 113 Per Goransson; 174 Andreas Hansen; 175 Christian Hansen, 135 Linda Hansen, 173 Filip Hansson; 207 Ulf Hansson; 158 Ulla Hansson, 040 Arne Hartvell, 284 Kajsa Helleskog, 285 Olle Helleskog, 299 Alma Hellstrom; 298 Eugen Hellstrom, 167 Karin Hjertstedt, 031 Axel Holmbom-Larsen; 032 Teo Holmbom-Larsen, 058 Anna Holmgren, 215 Louise Holmstrom, 111 Nina Homann, 030 Henning Hove, 156 Birgit Hultgren, 221 Victoria Hakansson, 112 Anita Harstedt, 244 Emil Harstedt, 251 Hanna Harstedt, 252 Ida Harstedt, 205 Martin Harstedt, 150 Linda Hogberg, 231 Christer Igelstrom, 104 Suvi Jackman, 211 Andre Jacobaeus, 210 Hermine Jacobaeus, 273 Lovisa Jacobsson, 125 Bent Jenson; 001 Sonny Jenson, 278 Arvid Johansson, 124 Folke Johansson, 153 Sabina Johansson, 197 Elisabeth Johnsson, 139 Elsie Johnsson, 196 Gunilla Johnsson, 121 Pierre Johnsson; 159 Sonja Jungmark, 138 John Jonsson, 137 Simon Jonsson, 065 Bertil Kaa Hedberg; 059 Erik Kaa Hedberg, 051 Josefine Karlsson, 077 Margit Karlsson, 078 Sven Karlsson, 155 Ulf Karlsson, 275 Emmalinn Knutsson, 297 Karl-Arvid Kock, 222 Ase Krantz, 235 Henrik Krohn, 047 Jorma Kylli, 055 Lars Korner, 050 Hans Lanhed, 049 Tore Larsson, 054 Christiina Leander, 015 Sofia Leander, 066 Lena Leeb-Lundberg, 203 Remi Leskela, 216 Paulina Lilja, 114 Peter Lind, 115 Desire Lind-Apelgren; 208 Cecilia Lindberg, 219 Bo Lindblad; 248 Hanna Linde, 247 John Linde, 227 Julias Lindeberg, 290 Lina Linden, 289 Moa Linden, 089 Solvig Lindqvist, 122 Jeanette Linstedt, 213 Agnota Lindstrom, 160 Bjorn Ljungholm, 053 Jon Lundberg, 226 Matilda Lundbergh, 193 Egon Lundblad, 171 Lotta Lundgren, 108 Karin Lundquist, 228 Gustav Lofstedt; 262 Loke Lonnblad-Ohlin, 181 Linus Malmborg, 157 Fredrik Malmgren, 052 Jaana Markkanen, 014 Marjatta Markkanen; 126 Anne Mattsson, 240 Bertil Mattsson, 048 Karl-Gustav Mattsson, 271 Helena McCollum; 269 Ellen Moreau, 293 Rasmus Mozelius, 092 Pasqualina Mura, 229 Jenny Mansson, 230 Lennart Mansson, 119 Erik Martensson, 081 Kurt Nelson, 250 Astrid Nilsson, 249 Caroline Nilsson, 041 Cathrine Nilsson, 267 Fredrik Nilsson, 300 Hanna Nilsson, 074 Harald Nilsson, 087 Inez Nilsson, 232 Per Nilsson, 149 Rose-Marie Nilsson, 143 Susanna Nilsson; 073 Ulla Nilsson, 144 Ulrika Nilsson, 283 Jonna Niskakari, 282 Tove Niskakari, 209 Katinka Nordgaard, 062 Marianne Nordgren, 067 Sune Nordgren, 016 Rasmus Nordqvist, 218 Helen Norrval, 118 Gosta Nydre, 220 Gustav Ode, 002 Tommy Ohlsson, 160 Ethel Olsson, 212 Martin Olsson, 142 My Olsson, 161 Tore Olsson, 253 Nadia Omerson, 288 Nike Ossler, 132 Lars-Goran Ottosson, 217 Eva-Maria Ovin, 094 Gabriel Perez-Hjelm, 129 Christer Persson, 019 Gertrud Persson, 035 Lena Persson, 178 Marita Persson, 199 Ruth Persson, 033 Stig Persson, 146 Tony Petersson, 241 Lillemor Petersson, 234 Peter Pohlman, 172 Helen Preutz, 164 Elias Palsson, 165 Jonathan Palsson, 179 Judith Palsson, 180 Sara Palsson, 184 Linda Ransalu, 192 Astrid Reimer, 291 David Reimer, 057 Torsten Ridell, 281 Christoffer Rix, 007 Jonas Rosqvist, 006 Tim Rosqvist, 256 David Ross-Lindholm, 120 Ewa Runquist, 233 Hans Runquist, 082 Espen Ryvarden, 168 Ann-Marie Sandwall, 088 Ingrid Selander, 005 Stina Siljing, 046 Matz Sjoberg, 103 Sofia Sjolin, 245 Anders Skans, 246 Minna Skans, 189 Michel Srinc, 102 Max Stankovic, 008 Mikaela Stjerndorff, 027 Catarina Stomberg, 268 Nin Sukrom, 270 Nan Sukrom, 061 Jan Sundqvist, 103 Greger Svensson, 093 Matilda Svensson; 095 Anton Sverkstrom, 188 Anna Swanberg, 277 Amanda Ternblad, 279 Noah Ternblad, 147 Joanna Thede, 198 Barbara Tucci, 013 Clea Turic, 110 Ann-MarieTuveson, 190 Kristian Tarnhed, 266 Viktor Torling, 163 Lena Uller, 070 Jan Uvelius, 239 Karin van der Werf, 194 Mattias Varen, 127 Julianna Varnai, 237 Cary Vessnow, 012 Peter Wallstrom, 070 Adrian Weiss, 011 Gerd Weiss, 017 Henrik Weiss, 018 Ulf Weiss, 255 Jessica Wendel, 206 Gunlog Wilhelmsson, 166 Stefan Wulff, 207 Celia Zone, 101 Natasha Akesson-Petrovic, 131 Malena Asard, 003 Linda Astrom

Blanket Drawing I, 1983
Brown clay and linseed oil on white blanket. 170 x 226

Blind Light, 2007
Fluorescent light, toughened low iron glass, ultrasonic humidifiers, aluminium, water. 320 x 978.5 x 856.5
Jay Jopling/White Cube, London

Capacitor, 2001
Mild steel tubes and rod. 271 x 242 x 229
Collezione Longo Cassino, Italy

Chair, 1987–88
Lead and alabaster. 92 x 40 x 40

Critical Mass II, 1995
Variable, 60 life-size elements
5 cast iron suspensions from the installation
Jay Jopling/White Cube, London

Drawn, 2000/07
Cast iron. 8 elements, each 154 x 133 x 187
5 cast iron suspensions from the installation.
Jay Jopling/White Cube, London

Drift I, 2007
2mm square section stainless steel bar. 235 x 150 x 125

Drift II, 2007
3mm square section stainless steel bar. 190 x 270 x 170

Exergy I, 2007
3mm square section stainless steel bar. 230 x 210 x 210

Exergy II, 2007
3mm square section stainless steel bar. 210 x 150 x 240

Feeling Material XXIX, 2007
4.75mm square section stainless steel bar. 250 x 160 x 195

Ferment, 2007
3mm square section stainless steel bar. 267 x 215 x 116

Flare, 2007
2mm square section stainless steel bar. 230 x 210 x 210

Floor 1981
Rubber. 122 x 91 x 0.6

Freefall, 2007
2mm square section stainless steel bar. 290 x 185 x 180

Hatch, 2007
19.1mm aluminium square tube, plywood, plexiglass.
322.5 x 605.7 x 605.7
Jay Jopling/White Cube, London

Habitat, 2005
Bright mild steel blocks. 35.6 x 205.7 x 48.3
Unit sizes: 12.5 x 12.5 x 25mm, 25 x 25 x 50mm
50 x 50 x 100mm, 100 x 100 x 200mm
Galerie Xavier Hufkens, Brussels

Mass, 2006
1.6mm stainless steel rod. 102 x 191 x 290

Mother's Pride III, 1982/2007
Bread and wax. 285.5 x 230 x 6.
Jay Jopling/White Cube, London

Quantum Cloud XVII, 2000
4.76mm square section stainless steel bar.
166 x 145 x 147

Quantum Cloud XXXIX, 2007
2mm square section stainless steel bar.
60 x 60 x 70

Rise, 1983–84
Lead, fibreglass, plaster, air. 30 x 58 x 190

Seeds III/V, 1989/1993
Lead. Unit size: 3.5 x 1.1 diameter.
Collection Würth, Künzelsau, Germany

Sense, 1991
Concrete. 74.5 x 62.5 x 60

Shift II, 2000
Cast iron. 204 x 54 x 25

Shift III, 2006
1.6mm stainless steel rod. 210 x 60 x 24
Private collection, Monaco

Space Station, 2007
Corten steel plate. Approx. 680 x 900 x 800.
Jay Jopling/White Cube, London

Static, 2007
3mm square section stainless steel bar. 360 x 360 x 190

Still Feeling (Corner), 1993
Lead, fibreglass, air. 197 x 53 x 36.
Galerie Thaddaeus Ropac, Paris

DRAWINGS, PRINTS AND PHOTOGRAPHS

Body & Light, 1991–96
Jay Jopling/White Cube, London

Bar One, 1992
Pigment on paper. 14 x 19.5
Brain Wave, 1992
Pigment on paper. 14.5 x 19.5
Cosy Place II, 1991
Pigment on paper. 14 x 19.5
Dome, 1991
Watercolour on paper. 12.5 x 17.5
Elect, 1992
Pigment on paper. 14 x 19
Hand Over Water, 1996
Black pigment and casein on paper. 14 x 19
Home of the Heart I, 1995
Watercolour on paper. 14.5 x 19
Host, 1991
Pigment on paper. 14 x 19.5
Hover, 1991
Pigment on paper. 14 x 19.5
Inlet, 1991
Pigment on paper. 12.5 x 17.5
Light Passage, 1991
Pigment on paper. 14 x 19
Link, 1991
Pigment on paper. 13 x 17
Open Window, 1991
Pigment on paper. 12.5 x 17.5
Structure / Road, 1996
Pigment on paper. 14 x 18.5
Vector, 1991
Pigment on paper. 13 x 17.5
Through, 1992
Black pigment and casein on paper. 14.5 x 19.5
To, 1991
Pigment on paper. 12.5 x 17
Up, 1994
Black pigment and casein on paper. 19 x 14

Body & Soul, 1990
9 etchings. Each 50 x 58.1
Jay Jopling/White Cube, London
Paragon Press

Quads, 1979–2007
14 sections.
Inkjet on paper. 28 x 43

Event Horizon, 2007
27 fibreglass and 4 cast iron figures.
Each 189 x 53 x 29

Sited at the following locations:
80 Strand
Arundel Great Court, block 1, Surrey Street
Arundel Great Court, block 5, Arundel Street
Brettenham House, 1 Lancaster Place
Freemasons' Hall
The Hayward
IBM Southbank, 76-78 Upper Ground
King's College London, Franklin Wilkins Building
King's College London, Franklin Wilkins Building
(Waterloo Bridge wing)
King's College London, James Clerk Maxwell Building
The London Television Centre
National Theatre, Lyttelton Flytower
National Theatre, Olivier Liftshaft
Queen Elizabeth Hall rooftop (3 sculptures)
Queen Elizabeth Hall sun deck
Royal Festival Hall (3 sculptures)
Shell Centre
Southbank Centre Square
South-West Bush House (2 sculptures)
Swissôtel The Howard, London
Thistle Hotel Charing Cross
Union Jack Club
Waterloo Bridge (2 sculptures)
Whitehouse Apartments (2 sculptures)

EVENT HORIZON ACKNOWLEDGEMENTS
The Hayward, along with Antony Gormley, wishes to thank all
of the organisations that agreed to participate in *Event Horizon*
by providing rooftop locations for the work:

IBM UK Limited
Derwent London plc
Draco Bettenham Ltd
Hartnell Taylor Cook
ITV plc
Ivybridge Investments Limited Partnership
King's College London
Land Securities
Mapeley
National Theatre
Pearson plc
Shell
Swissôtel The Howard, London
Thistle Hotels
Union Jack Club
The United Grand Lodge of England at Freemasons' Hall
Whitehouse Apartments Freehold Limited

We would also like to extend our sincere thanks to everyone who
assisted us at each of the sites for giving their time, knowledge
and expertise so generously in order to help realise the project.

2006	*Breathing Room*, Galerie Thaddaeus Ropac, Paris, France
	Time Horizon, Parco Archeologico di Scolacium, a Roccelletta di Borgia, Catanzaro, Italy
	Critical Mass, Museo Madre, Naples, Italy
2005	*Another Place*, Crosby Beach, Merseyside, England
	Field for the British Isles, Longside Gallery, Yorkshire Sculpture Park, Yorkshire, England
	Asian Field, Institute of Contemporary Arts Singapore, Singapore
2004	*Domain Field*, The Great Hall, Winchester, England
	Mass And Empathy, Fundação Calouste Gulbenkian, Lisbon, Portugal
	Clearing, White Cube, London, England
	Field for the British Isles, Cathedral, Gloucester, England
	Fai Spazio, Prendi Posto (part of Arte all' Arte 9), Poggibonsi, Italy
	Asian Field, Jonan High School, Tokyo, Japan
	Unform, Yale Center for British Art, Yale, USA
2003	*Asian Field*, Xinhuahuayuan Huajingxincheng, Guangzhou, China/National Museum of Modern Chinese History, Beijing, China/Warehouse of former Shanghai No. 10 Steelworks, Shanghai, China/ Modern Mall, Jiangbei District, Chongqing, China
	Antony Gormley, Baltic Centre for Contemporary Art, Gateshead, England
2002	*Antony Gormley: Sculpture*, Centro Galego de Arte Contemporánea, Santiago de Compostela, Spain
	Antony Gormley, Galleria Mimmo Scognamiglio, Naples, Italy
	Antony Gormley, Xavier Hufkens, Brussels, Belgium
	Tuscia Electa, San Casciano in Val di Pesa, Italy
	Antony Gormley Drawing, British Museum, London, England
	Field for the British Isles, British Museum, London, England
	Inside Australia (part of Perth International Arts Festival), Lake Ballard, Menzies, Western Australia
2001	*Dialogue: Antony Gormley Allotment*, Kockumshallen, Malmö, Sweden
	Field for the British Isles, Church of St Mary the Virgin, Shrewsbury, England/Tullie House, Carlisle, England
	States and Conditions, Orchard Gallery, Derry, Northern Ireland/Model Arts and Niland Gallery, Sligo, Ireland

2000 *Quantum Cloud* (part of *North Meadow Sculpture*
 Project), Millennium Dome, London, England
 Strange Insiders, fig-1, London, England
 Drawn, White Cube², London, England
1999 *American Field*, Stroom, The Hague, Holland
 Intimate Relations, MacClaren Art Centre, Barrie,
 Ontario, Canada
 European Field, Malmö Konsthall, Malmö, Sweden
1998 *Angel of the North*, The Gallery, Central Library,
 Gateshead, England
 Critical Mass, Royal Academy, London, England
 Another Place, Stavanger, Norway
 Force Fields, Rupertinum, Salzburg, Austria
1997 *Total Strangers*, Kölnischer Kunstverein, Cologne,
 Germany
 Our House, Kunsthalle zu Kiel, Kiel, Germany
 Another Place (part of *Follow Me: British Art on the
 Lower Elbe*), Cuxhaven, Germany
 Allotment, Herning Museum, Herning, Denmark
1996 *New Work*, Obala Art Center, Sarajevo, Bosnia
 Inside the Inside, Xavier Hufkens, Brussels, Belgium
 Outside the Outside, Arts 04, St-Rémy-de-
 Provence, France
 Still Moving, Museum of Modern Art, Kamakura,
 Japan/Nagoya City Art Museum, Aichi, Japan/
 Takaoka Art Museum, Toyama, Japan/Iwaki City
 Museum of Art, Fukushima, Japan/Museum of
 Contemporary Art, Sapporo, Japan/Museum of
 Modern Art, Tokushima, Japan
 Field for the British Isles, Hayward Gallery, London,
 England
 Body and Light and Other Drawings 1990–1996,
 Independent Art Space, London, England
1995 *Drawings*, The Pace Foundation for Contemporary
 Art, San Antonio, USA
 Critical Mass, StadtRaum Remise, Vienna, Austria
1994 *Lost Subject*, White Cube, London, England
 Field for the British Isles, Oriel Mostyn, Llandudno,
 Wales/Scottish Museum of Modern Art, Edinburgh,
 Scotland/Orchard Gallery, Derry, Ireland (1995)/
 Ikon Gallery, Birmingham, England/National Gallery
 of Wales, Cardiff, Wales/Greensfield BR Works,
 Gateshead, England (1996)
1993 Galerie Thaddaeus Ropac, Paris, France
 Antony Gormley, Konsthall Malmö, Malmö, Sweden/
 Tate Gallery, Liverpool, England/Irish Museum of
 Modern Art, Dublin, Ireland (1994)
 European Field, Centrum Sztuki Wspolczesnej,
 Warsaw, Poland/Moderna Galerija, Ljubljana,
 Slovenia (1994)/Muzej Suvremene Umjetnosti,
 Zagreb, Croatia/Ludwig Museum, Budapest,
 Hungary/Prague Castle, Prague, Czech Republic
 (1995)/National Theatre, Bucharest, Romania/
 Arsenals, Riga, Latvia (1996)/Museum of
 Contemporary Art, Vilnius, Lithuania/Art Hall,
 Tallinn, Estonia/Magasin 3, Stockholm, Sweden/
 Galerie Nordenhake, Stockholm, Sweden
1992 *American Field*, Centro Cultural de Arte
 Contemporaneo, Mexico City, Mexico/Museum
 of Modern Art, Fort Worth, USA/Museum of
 Contemporary Art San Diego, La Jolla, USA/

Corcoran Gallery of Art, Washington, DC, USA
(1993)/Montreal Museum of Fine Arts, Montreal,
Canada
Learning to Think, British School, Rome, Italy
1991 *Sculpture*, Galerie Nordenhake, Stockholm, Sweden
 Sculpture, Miller Nordenhake, Cologne, Germany
 American Field and Other Figures, Museum of
 Modern Art, Fort Worth, USA
1989 Louisiana Museum of Modern Art, Humlebæk,
 Denmark
 Scottish National Gallery of Modern Art, Edinburgh,
 Scotland
 A Field for the Art Gallery of New South Wales,
 A Room for the Great Australian Desert, Art Gallery
 of New South Wales, Sydney, Australia
1988 Contemporary Sculpture Centre, Tokyo, Japan
 The Holbeck Sculpture, Leeds City Art Gallery,
 Leeds, England
1987 *Man Made Man*, La Criée Halle d'Art Contemporain,
 Rennes, France
 Five Works, Serpentine Gallery, London, England
1985 Städtische Galerie, Regensburg, Germany/
 Frankfurter Kunstverein, Frankfurt, Germany
1984 Riverside Studios, London, England/Chapter,
 Cardiff, Wales
1981 Whitechapel Art Gallery, London, England

SELECTED BIBLIOGRAPHY

2006 *Fai Spazio, Prendi Posto/Making Space, Taking Place*, Gli Ori, Prato/Associazione Arte Continua, San Gimignano; texts by James Putnam, Achille Bonito Oliva, Vincenzo Ruggiero, Alphonso Lingis, Mario Cristiani and Antony Gormley

Antony Gormley: Asian Field, Institute of Contemporary Arts Singapore, Singapore; texts by Eugene Tan and Tsutomu Mizusawa (translated by Kikuko Ogawa)

Intersezioni 2: Time Horizon, Parco Archeologico di Scolacium, Roccelletta di Borgia, Catanzaro; texts by Alberto Fiz, Maria Grazia Aisa, Bruno Corà and Colin Renfrew

Asian Field: Makers & Made, Hand Books, London

Antony Gormley: Breathing Room, Galerie Thaddaeus Ropac, Paris; texts by Antony Gormley, Ann Hindry, Marc Hindry, Catherine Ferbos-Nakov, Michael Doser, Paolo Molaro and David Quéré

2005 *Making Space*, Hand Books, London; texts by Richard Sennett, Darian Leader and Andrew Renton; Antony Gormley interviewed by Adrian Searle

Antony Gormley: Inside Australia, Thames & Hudson, London; texts by Hugh Brody, Shelagh Magadza, Finn Pederson and Anthony Bond

2004 *Mass and Empathy*, Fundação Calouste Gulbenkian, Lisbon; texts by Maria Filomena Molder and Paolo Herkenhoff; Antony Gormley interviewed by Jorge Molder

Broken Column, Wigestrand Forlag, Stavanger/Rogaland Museum of Fine Arts, Stavanger; texts by Kjartan Fløgstad, Trond Borgen, Stephan Bann and Siri Meyer

2003 *Antony Gormley: Standing Matter*, Galerie Thaddaeus Ropac, Salzburg; texts by Norman Rosenthal and Eckhard Schneider

Asian Field, The British Council, London; texts by Richard Noble and Hu Fang

Domain Field, Baltic Centre for Contemporary Art, Gateshead; text by Darian Leader

2002 *Antony Gormley*, Centro Galego de Arte Contemporánea, Santiago de Compostela; texts by Lisa Jardine and Michael Tarantino; Antony Gormley interviewed by Enrique Juncosa

Antony Gormley: Workbooks I, 1977–1992, artist's book to accompany solo exhibition, Centro Galego de Arte Contemporánea, Santiago de Compostela; texts and drawings by Antony Gormley

Antony Gormley Drawing, The British Museum, London; text by Anna Moszynska

2001 *Antony Gormley*, Contemporary Sculpture Centre, Tokyo

Some of the Facts, Tate St Ives, Cornwall; texts by Will Self, Stephen Levinson and Iwona Blaswick

States and Conditions, Orchard Gallery, Derry; texts by Brendan McMenamin, Declan McGonagle and Caoimhín Mac Giolla Léith

2000 *Quantum Clouds and Other Work*, Galerie Thaddaeus Ropac, Paris; texts by Anne Hindry and Ian Tromp

Antony Gormley, Phaidon Press, London (revised edition); Antony Gormley in conversation with E. H. Gombrich; texts by John Hutchinson, Lela B. Njatin and Antony Gormley; Antony Gormley interviewed by Declan McGonagle; additional essay by W. J. T. Mitchell

1999 *Total Strangers*, Edition Cantz, Cologne; texts by Antje von Graevenitz and Ingrid Mehmel; Antony Gormley interviewed by Udo Kittelman

Antony Gormley: a conversation with Klaus Theweleit and Monika Theweleit-Kubale, Kerber Verlag, Bielefeld; edited by Hans-Werner Schmidt

1998 *Making an Angel*, Booth-Clibborn Editions, London; texts by Antony Gormley, Iain Sinclair, Beatrix Campbell, Stephanie Brown, Neil Carstairs and Gail-Nina Anderson

1996 *Still Moving: Works 1975–1996*, Japan Association of Art Museums, Tokyo; texts by Antony Gormley, Tadayasu Sakai, Kazuo Yamawaki, Stephen Bann and Daniel Birnbaum

1995 *Critical Mass*, StadtRaum Remise, Vienna; text by Andrew Renton; Antony Gormley interviewed by Edek Bartz; excerpts from *Crowds and Power* by Elias Canetti

1993 *Learning To See*, Galerie Thaddaeus Ropac, Paris/Salzburg; text by Yehuda Safran; Antony Gormley interviewed by Roger Bevan

1989 *Antony Gormley*, Louisiana, Museum of Modern Art, Humlebaek; texts by Richard Calvocoressi and Oystein Hjort

Field, The Montreal Museum of Fine Arts, Montreal/Oktagon, Stuttgart; texts by Pierre Théberge, Antony Gormley, Gabriel Orozco and Thomas McEvilley

Antony Gormley, Malmö Konsthall, Malmö; text by Karsten Thjurfell

Konsthall, Malmö/Tate Gallery, Liverpool/Irish Museum of Modern Art, Dublin; texts by Lewis Biggs and Stephen Bann; Antony Gormley interviewed by Declan McGonagle

Field For The British Isles, Tate Gallery, Liverpool

1988 *Antony Gormley*, Contemporary Sculpture Centre, Tokyo, text by Tadayasu Sakai

1987 *Antony Gormley Five Works*, Serpentine Gallery/Arts Council of Great Britain, London

1985 *Antony Gormley Drawings*, Salvatore Ala Gallery, Milan/New York

1984 *Antony Gormley*, Salvatore Ala Gallery, Milan/New York (Italian and English editions); text by Lynne Cooke

ILLUSTRATION CREDITS

p. 49 Antony Gormley, *Pore*, Winnipeg, Canada. 1988. Lead, fibreglass, plaster, air. 84 x 66 x 80 cm.

p. 50 Antony Gormley, *A Corner for Kasimir*, 1992. Lead, fibreglass, plaster, air. 193 x 162 x 100 cm.

p. 50 Filippo Brunelleschi, Crucifix, 15th century. Wood. Santa Maria Novella, Florence, Italy / The Bridgeman Art Library.

p. 50 Saint Manikkavachakar, c.1100, Chola, India. Bronze. 50.2 x 21.8 x 20.8 cm. Courtesy National Museum, New Delhi. Photo: Aditya Arya.

p. 50 Buddha, early or mid 5th century, Mathura, India. Paris, Musée Giumet, Musée National des Arts asiatiques © Photo RMN / © Hérve Lewandowski.

p. 51 Kasimir Malevich, *Last Futurist Exhibition 0,10*, (detail), St Petersburg, Russia, 1915.

p. 52 Constantin Brancusi, *Bird in Space* (*L'Oiseau dans l'espace*), 1932–40. Photographed by Brancusi in 1933. © ADAGP, Paris and DACS, London, 2007.

p. 52 Juan Muñoz, *Double Bind*, Tate Modern Turbine Hall commission, 2001. © The Juan Muñoz Estate. Photo: © Tate Images.

p. 54 Antony Gormley, *Breathing Room I*, 2006. 25mm square aluminium square tube. Phosphor H15 and plastic spigots. 500 x 1000 x 780.

p. 54 Prototype for *Blind Light* installed at The Hayward, January 2007. Photo: Antony Gormley.

p. 55 Antony Gormley, *Hatch* (detail), 2007. Photo: Antony Gormley.

p. 57 Antony Gormley, *Allotment II* (detail), 1996. Photo: Colin Davidson.

p. 57 Antony Gormley, *Space Station* (interior detail), 2007. Photo: Antony Gormley.

p. 58 Moshe Safdie, *Habitat* Montreal Expo building, 1967, Quebec, Canada. Photo: © Timothy Hursley 2007.

p. 58 First World War cemetery, Ypres, Belgium. Photo: Paloma Gormley.

p. 58 Manhattan, 2005. Photo: Antony Gormley.

UNCANNY SCULPTURE
ANTHONY VIDLER

p. 78 Antony Gormley, *Drawn*, 2000, London. Cast iron. 8 elements, each 154 x 133 x 187. 5 cast iron suspensions from the installation. Jay Jopling/White Cube², London

p. 78 Rachel Whiteread, *House*, 1993, London. Mixed media. Courtesy the artist and Gagosian Gallery. Photo: Sue Omerod.

p. 81 Antony Gormley, *Another Place*, 1997, Cuxhaven, Germany. Cast iron. 100 figures: 189 x 53 x 29 cm each.

p. 81 Caspar David Friedrich, *Monk by the Sea*, (*Mönch am Meer*), 1809. Oil on canvas. Staatliche Museen, Berlin, Germany / The Bridgeman Art Library.

p. 82 Antony Gormley, *Field for the British Isles*, 1993, IMMA / Irish Museum of Art, Dublin, Ireland. Terracotta. Variable size: approx. 40,000 figures, each 8–26 cm tall.

p. 85 Diller Scofidio + Renfro, Blur Building, 2002. Yverdon-les-Bains, Switzerland.

THE SCULPTOR AS FIRST FINDER
SUSAN STEWART

p. 95 Antony Gormley, *Angel of the North*, 1998, Gateshead, England. Reinforced steel. 54 x 20 m. Permanent installation. Photo: Colin Cuthbert.

p. 95 The Mausoleum of Qin Shi Huangdi, 3rd century BC, Xian, China. Courtesy UNESCO Photolibrary.

p. 97 The Hayward's plant room, 2007. Photo: Stuart Smith.

p. 98 *The Ludovisi Throne or Throne of Venus*, c.470–60 BC. Marble Relief from the Villa Ludovisi / Palazzo Altemps, Rome, Italy. Alinari / The Bridgeman Art Library.

p. 98 Plaster reproduction of an inhabitant who died during the eruption of Vesuvius in AD 79, Museo Vesuviano, Pompeii, Italy. Courtesy Museo Vesuviano, Pompeii, Italy / The Bridgeman Art Library.

p. 98 *Laocoön*, Hellenistic original, 1st century BC, Rome. Marble. Vatican Museums and Galleries, Vatican City, Italy. Lauros / Giraudon / The Bridgeman Art Library.

p. 100 Antony Gormley, *Another Place*, 1997, Crosby Beach, England. Cast iron. 100 figures: 189 x 53 x 29 cm each.

p. 100 Soap bubbles. Photo: Daniel Sambraus / Science Photo Library.

ARCHITECTURE AS SCULPTURE AS DRAWING
W. J. T. MITCHELL

p. 113 William Blake, *Europe a Prophecy*, frontispiece (*The Ancient of Days*), 1794. Courtesy the Library of Congress.

p. 114 William Blake, *The Song of Los*, plate 8, 1795. © The Trustees of the British Museum.

p. 114 William Blake, *The First Book of Urizen*, plate 17, 1794. Relief etching British Museum, London / The Bridgeman Art Library.

p. 115 Antony Gormley, *Home*, 1984. Collection Museum Moderner Kunst Stiftung Ludwig Wien, Vienna. Lead, terracotta, plaster, fibreglass. 65 x 220 x 110 cm.

p. 115 Iron Maiden of Nuremberg (Vierge de fer de Nuremberg, instrument de supplice), 19th century. © Roger-Viollet.

p. 117 Antony Gormley, *Sovereign State 1*, 1993. Pigment on paper. 19 x 14 cm. Photo: Stephen White.

p. 117 Antony Gormley, *Float II*, 1991. Pigment on paper. 14 x 19 cm.

p. 118 Antony Gormley, *Interior*, 1991. Pigment on paper. 14 x 19 cm. Courtesy W. J. T. Mitchell.

p. 118 Antony Gormley, *Quantum Cloud*, 1999, Greenwich, London. Stainless steel bar. Bars: 1.5 m each. 30 x 16 x 10 m.

p. 122 Antony Gormley, *Learning to Think*, 1991, Charleston City Jail, South Carolina. Lead, fibreglass, air. Five figures: 173 x 106 x 31 cm each. Photo: John McWilliams.

p. 122 Antony Gormley, *Critical Mass*, 1995, StadtRaum Remise, Vienna. Cast iron. 60 life-size figures.

Published on the occasion of the exhibition
Antony Gormley: Blind Light
The Hayward, London
17 May–19 August 2007

Exhibition curated by Ralph Rugoff and Jacky Klein
Assisted by Rachel Kent, Charu Vallabhbhai and Dana Andrew

Exhibition sponsored by Eversheds LLP

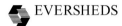

With additional support from
**The Henry Moore
Foundation**

Art Publisher: Charlotte Troy
Publishing Co-ordinator: Oriana Fox
Sales Manager: Deborah Power

Design by SMITH
Victoria Forrest
smith-design.com

Interior photography by Stephen White © Stephen White
Photography of *Event Horizon* by Gautier Deblonde
© Gautier Deblonde

Jacket image: *Blind Light* (detail)
Photography by Stephen White © Stephen White

Printed in the UK by BAS Printers

Published by Hayward Gallery Publishing,
Southbank Centre, London SE1 8XX, UK
southbankcentre.co.uk

ISBN 978 1 85332 259 4

Distributed in the United States of America through D.A.P. / Distributed
Art Publishers, 155 Sixth Avenue, 2nd Floor, New York, N.Y. 10013,
tel. +212 627 1999, fax + 212 627 9484, artbook.com

Distributed outside North and South America by Cornerhouse
Publications, 70 Oxford Street, Manchester M1 5NH, tel. +44 (0)161
200 1503, fax. +44 (0)161 200 1504, cornerhouse.org/books

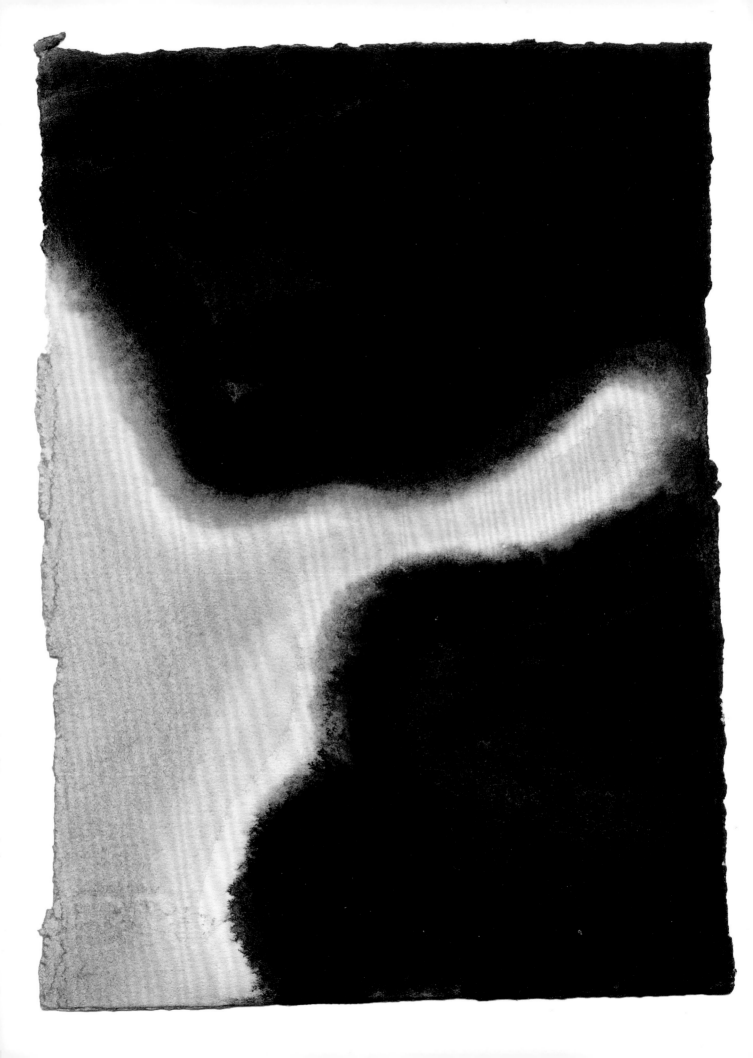

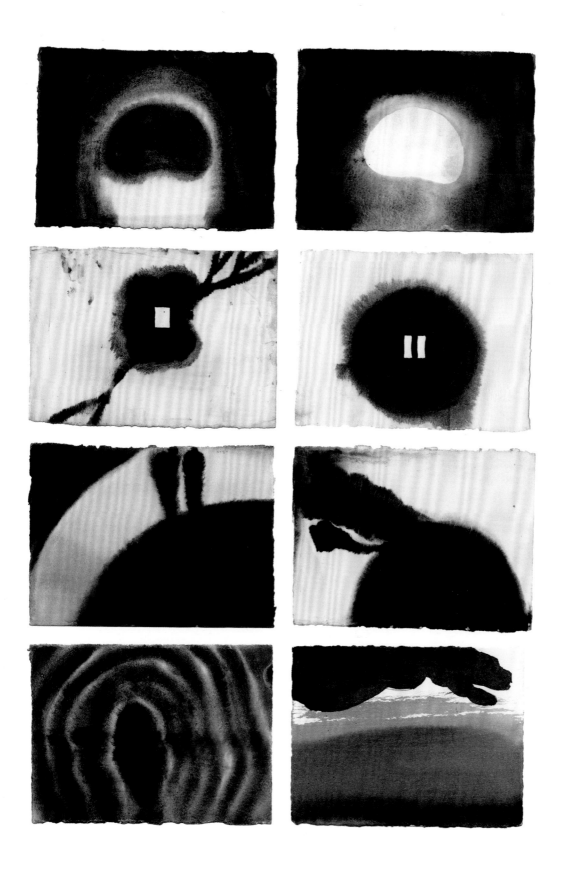

Body & Light, 1991—96

left: *Inlet*, 1991
Clockwise from top left:
Hover, 1991
Elect, 1992
Bar One, 1992

Vector, 1991
Hand Over Water, 1996
Brain Wave, 1992
To, 1991
Open Window, 1991

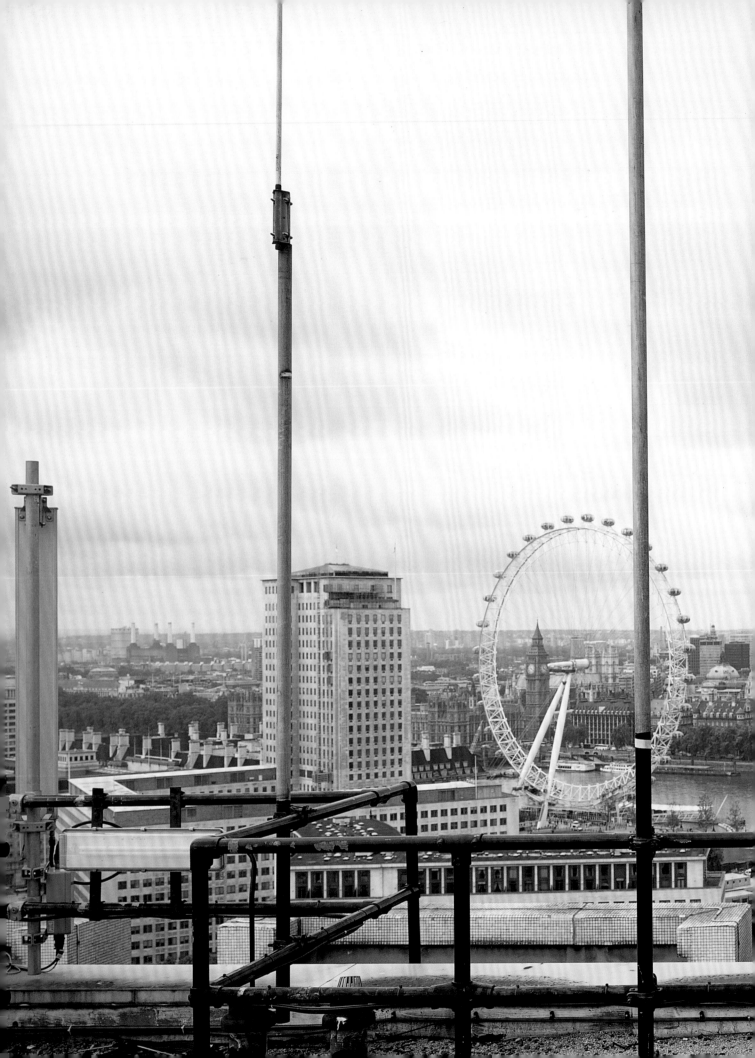

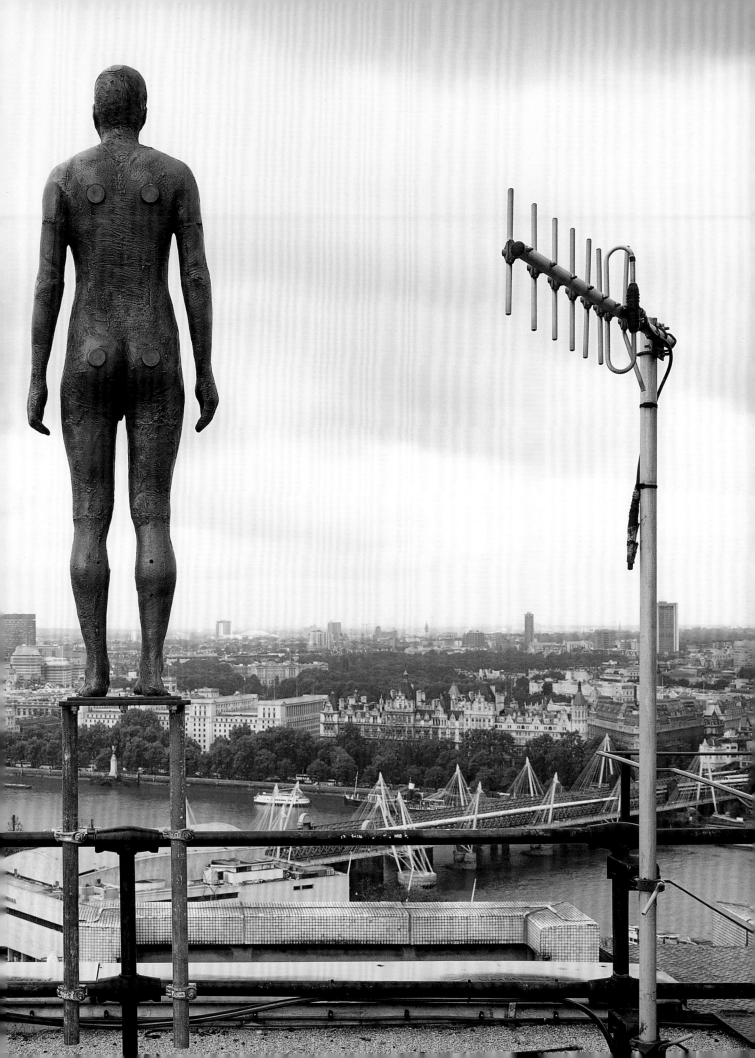

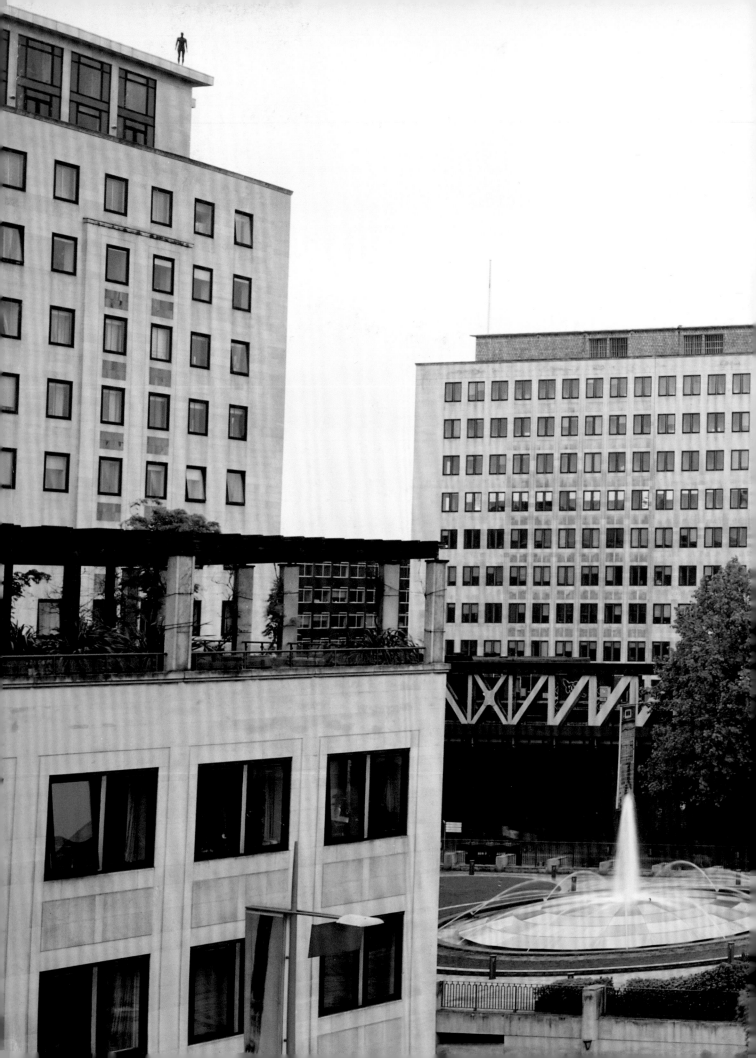

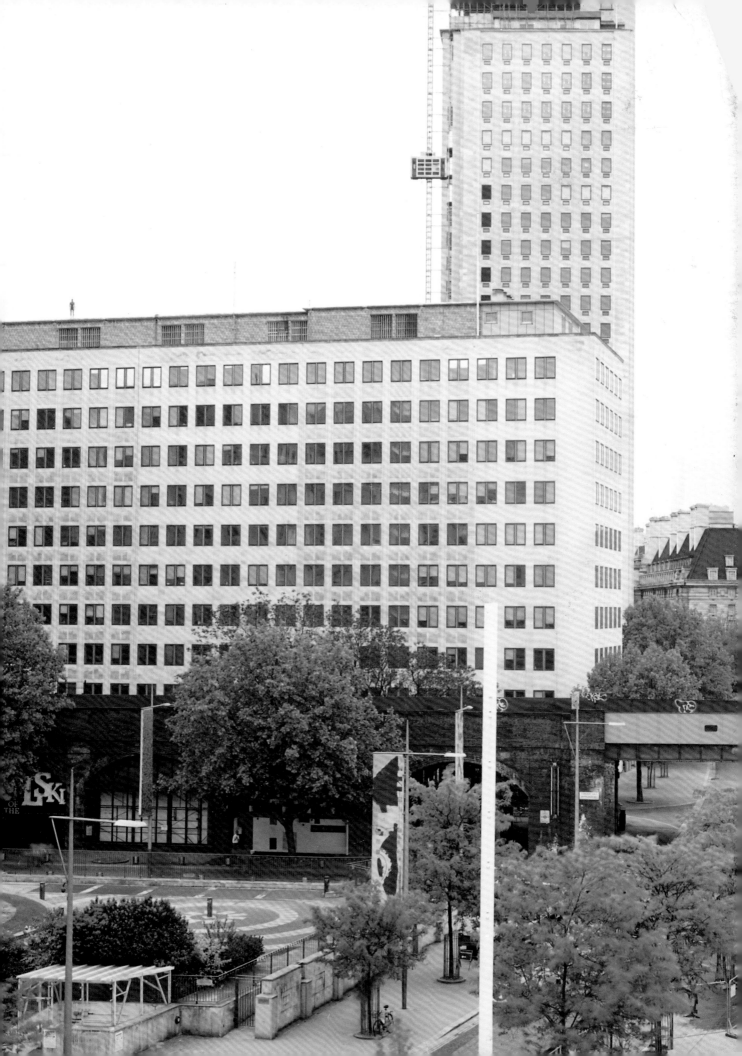

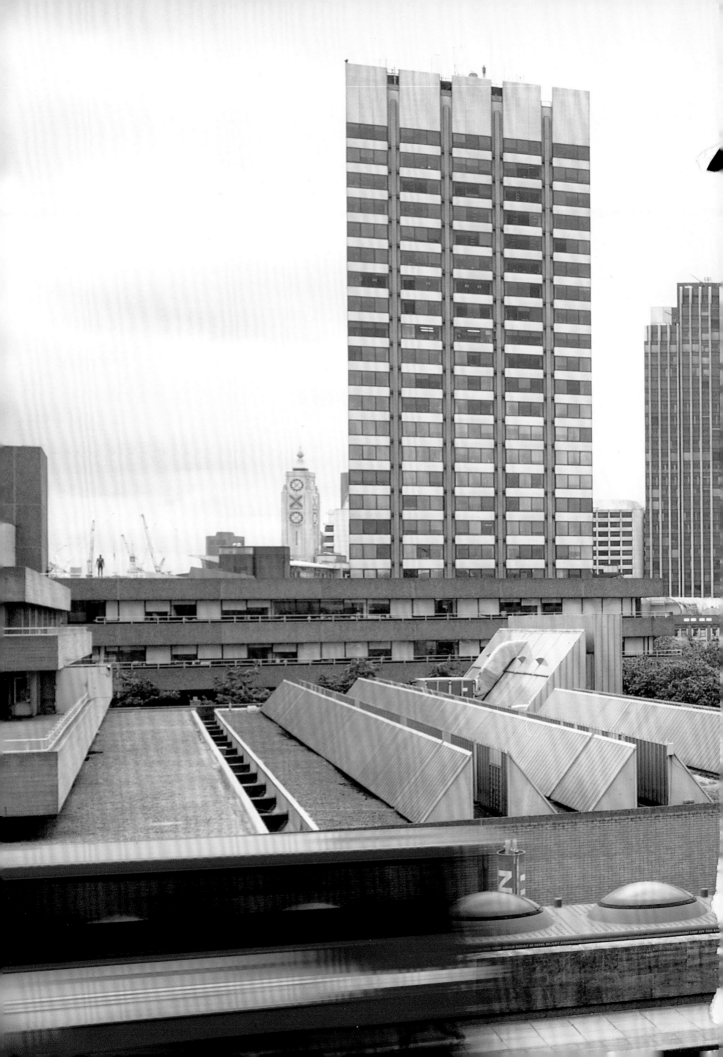

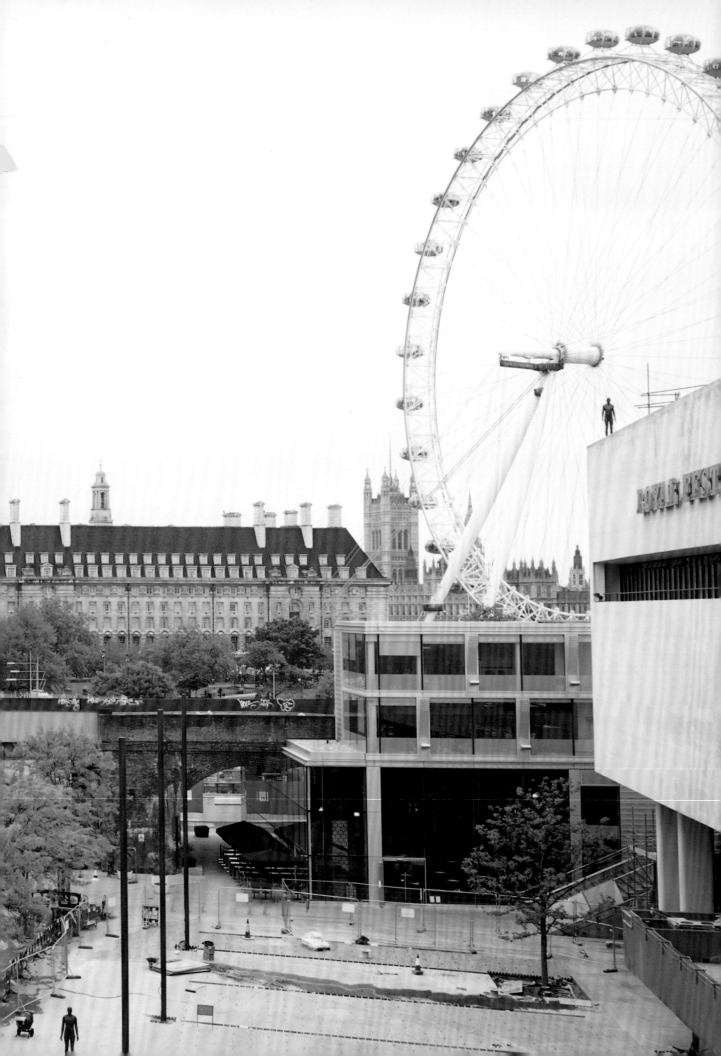

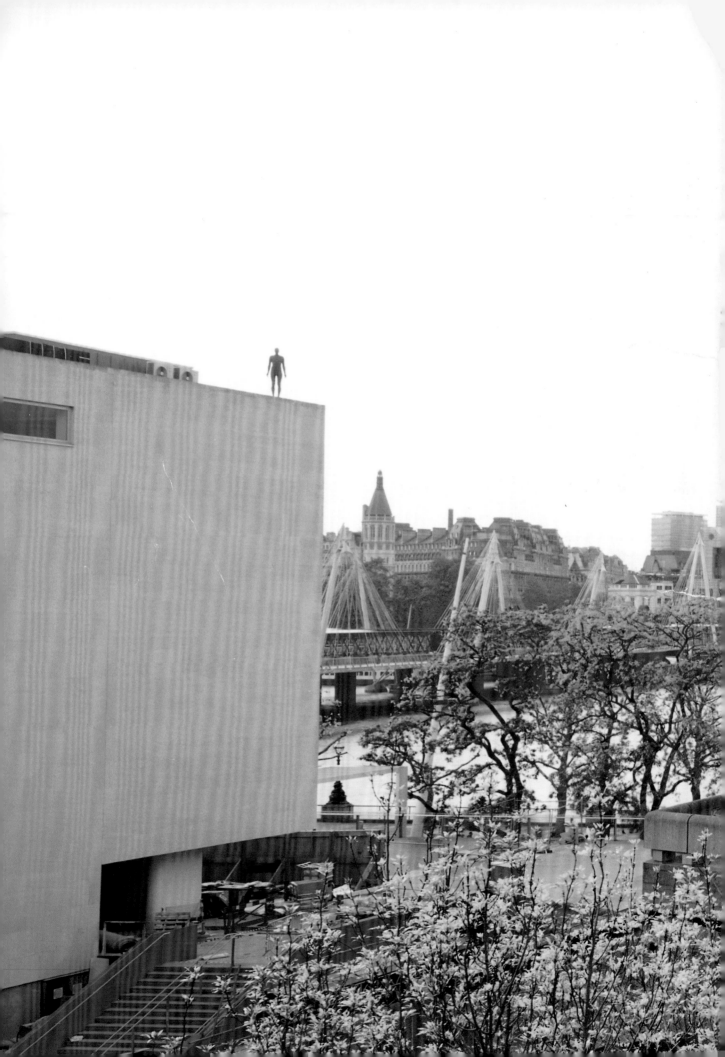

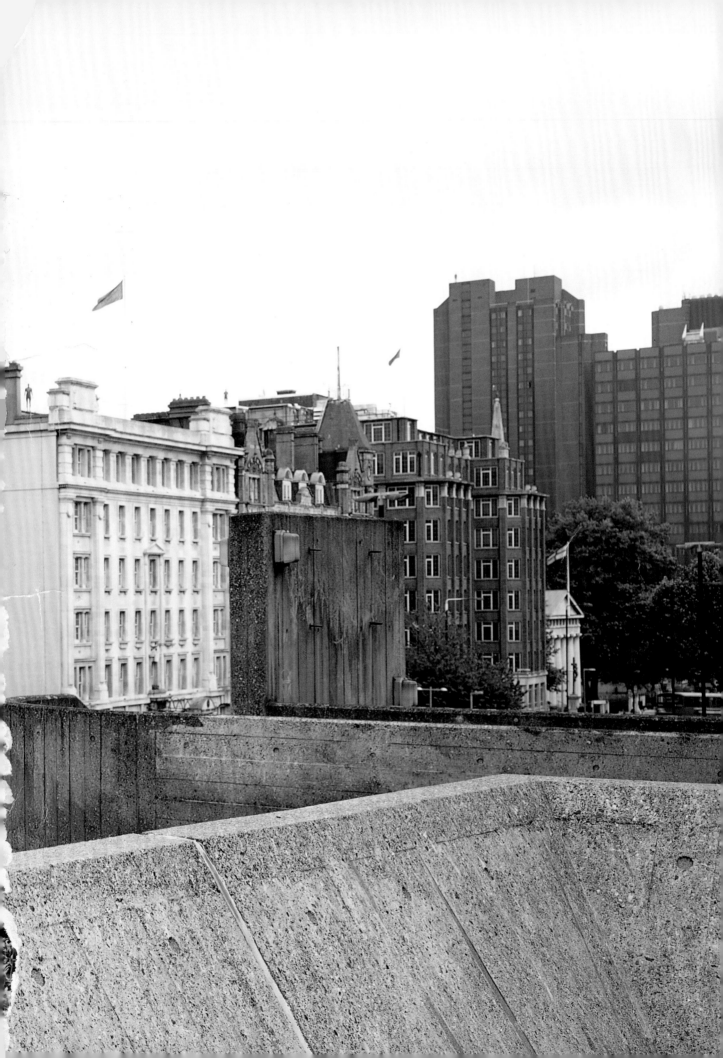

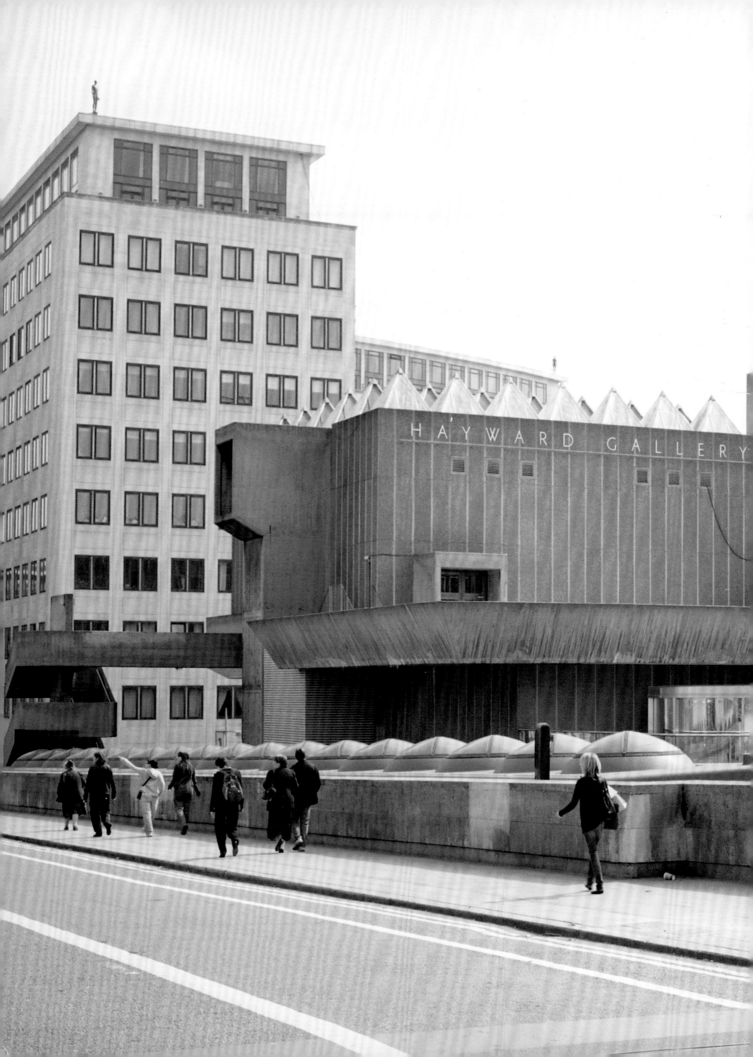

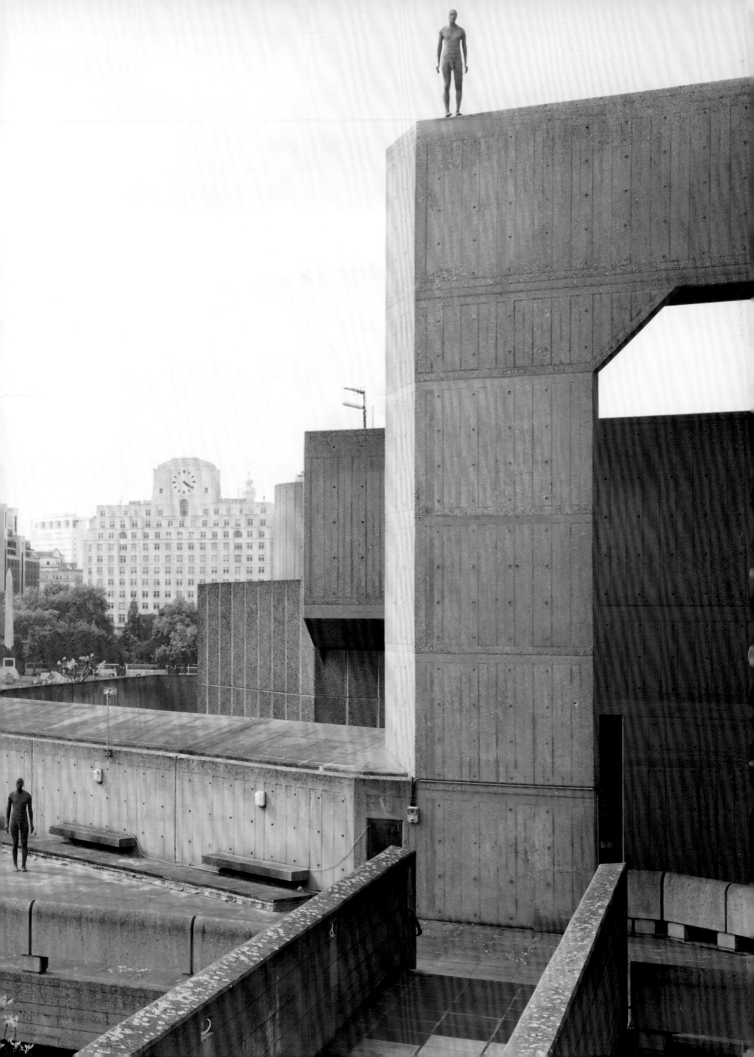

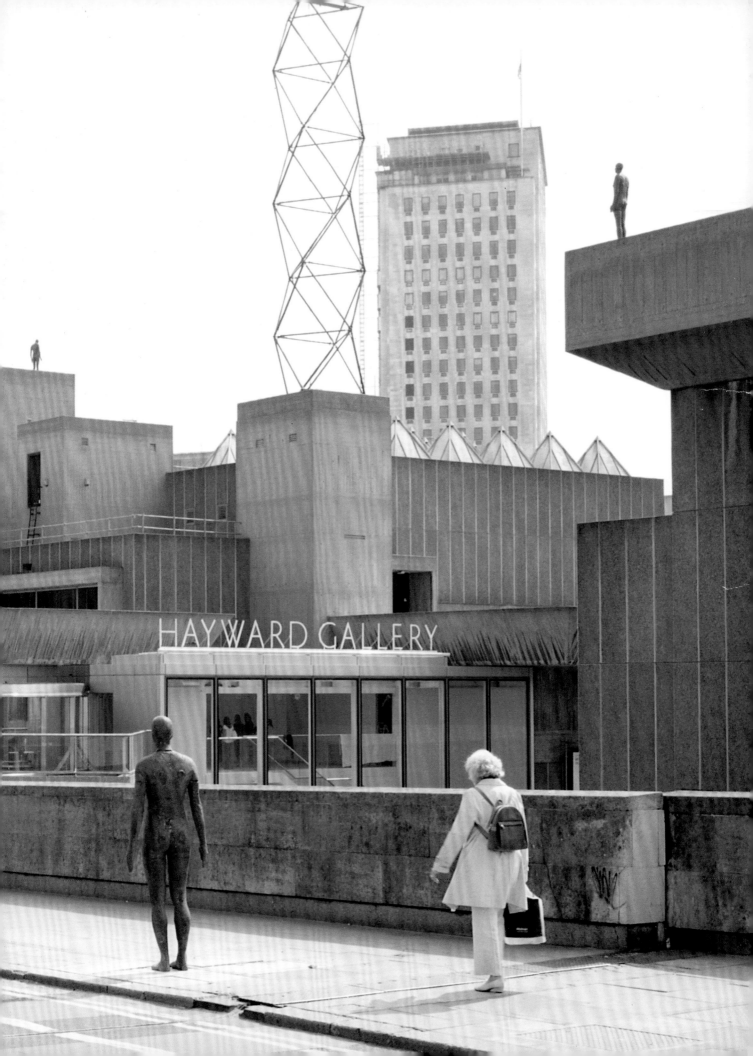

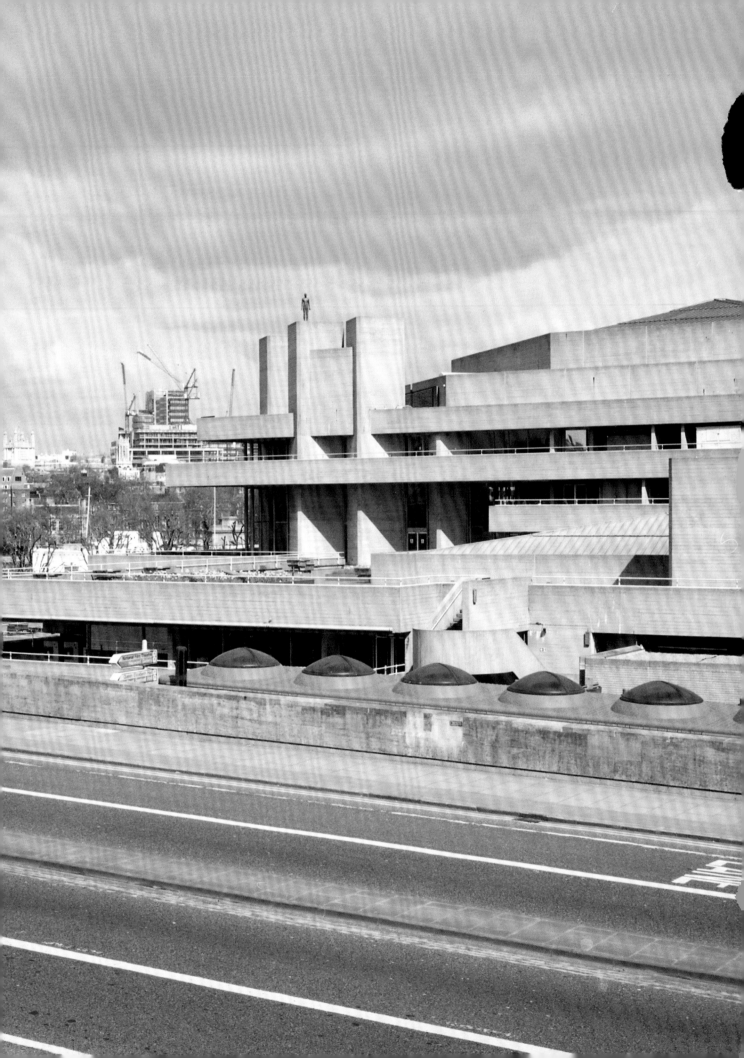

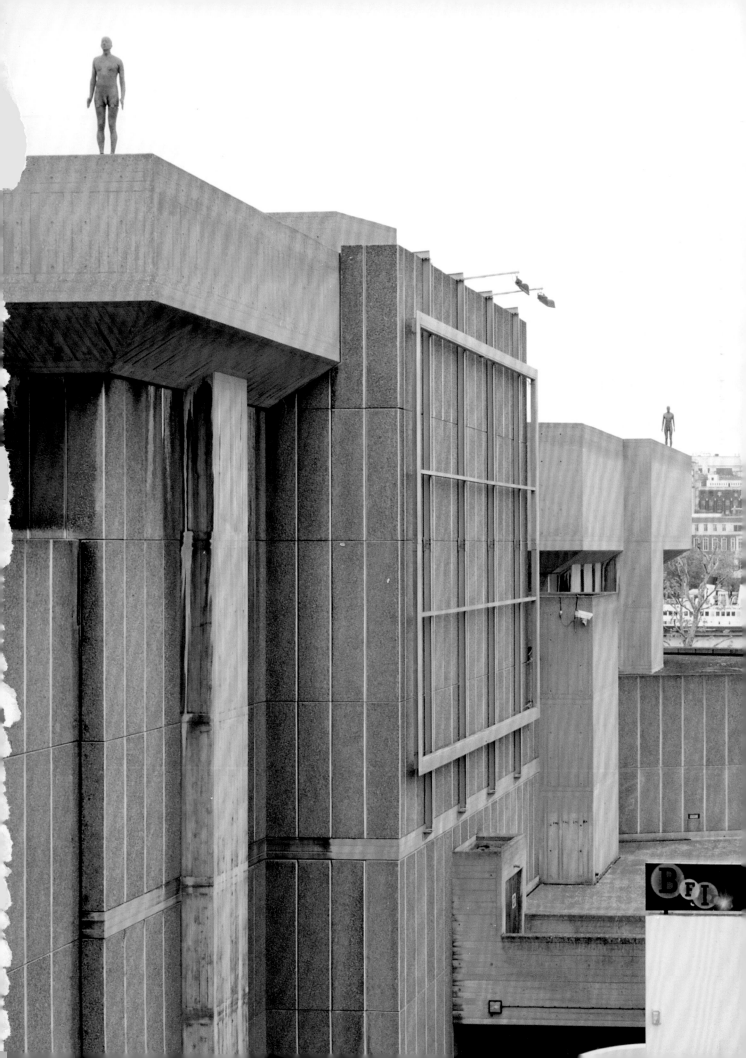

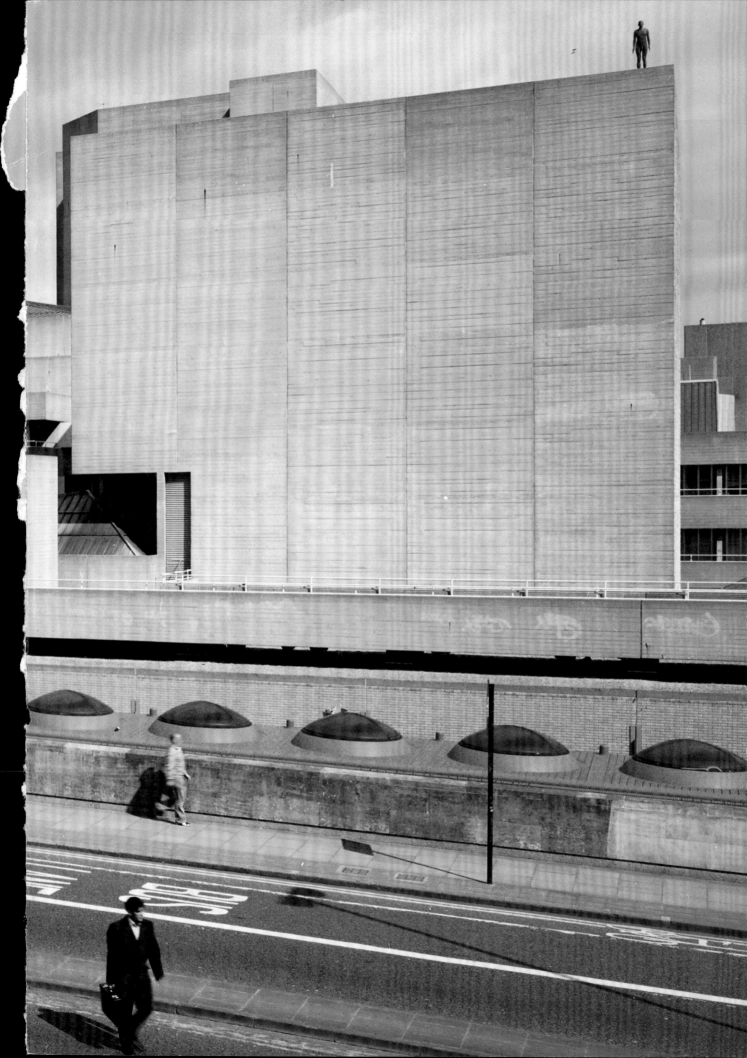

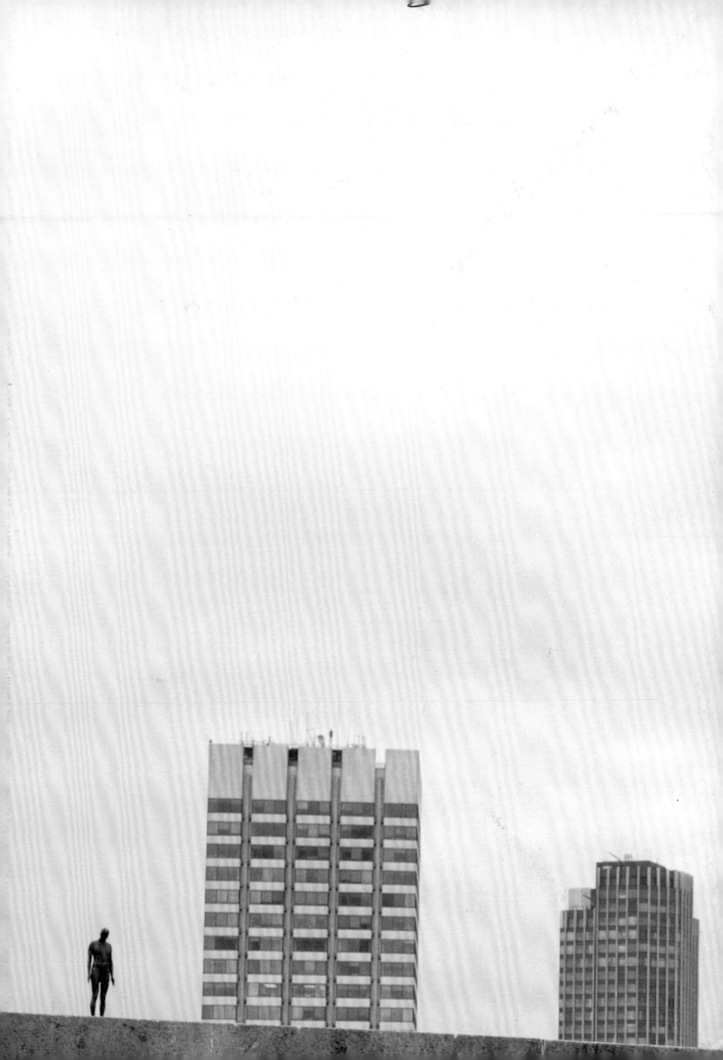

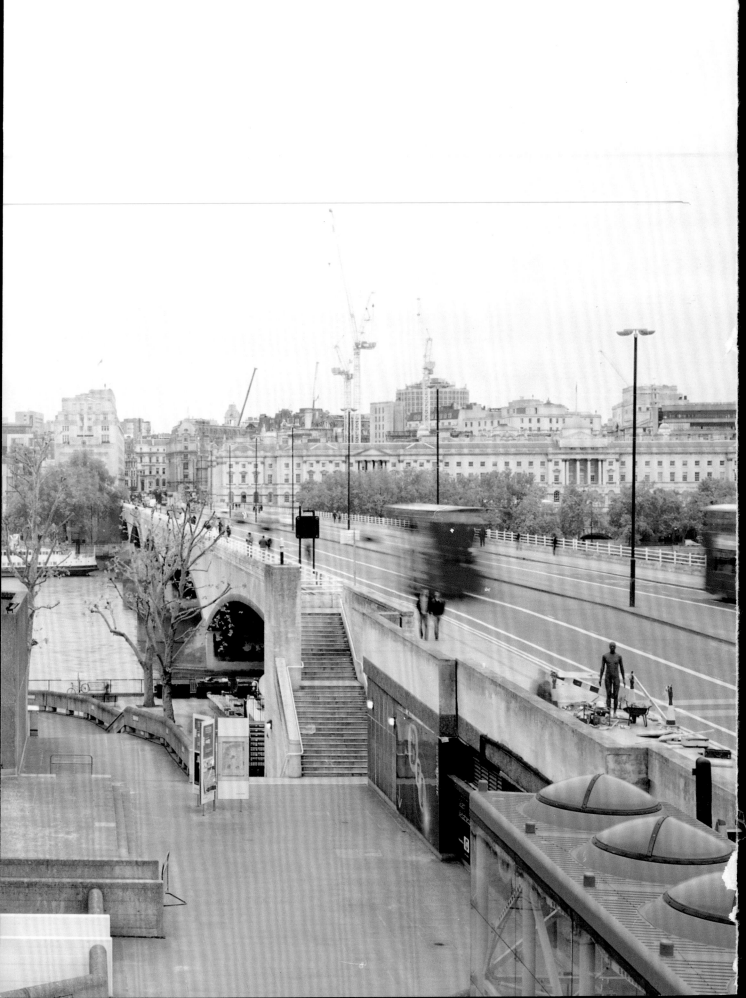

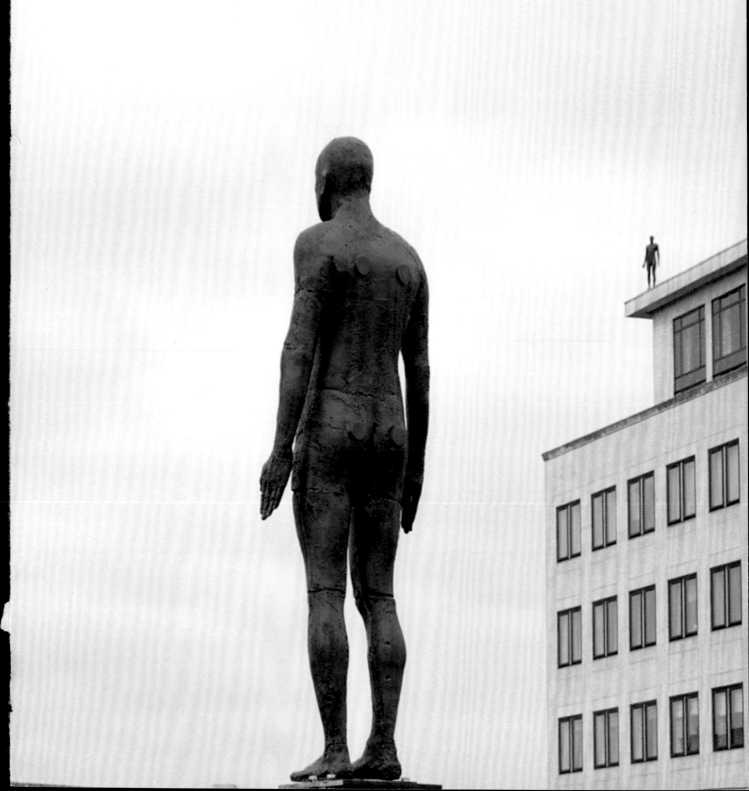